Travel & Nature

RotoVision

A RotoVision Book

Published and distributed by RotoVision SA
Route Suisse 9
CH-1295 Mies
Switzerland

RotoVision SA
Sales and Editorial Office
Sheridan House, 114 Western Road
Hove BN3 1DD, UK

Tel: +44 (0)1273 72 72 68
Fax: +44 (0)1273 72 72 69
www.rotovision.com

10 9 8 7 6 5 4 3 2 1

ISBN: 978-2-940378-39-5

Art Director: Jane Waterhouse
Design: JC Lanaway
Lighting diagrams: Rob Brandt

Reprographics in Singapore by ProVision Pte.
Tel: +65 6334 7720
Fax: +65 6334 7721

Printed in Singapore by Star Standard (Pte) Ltd.

Travel & Nature

Andy Steel

Contents

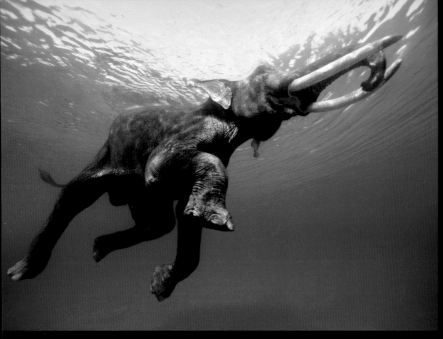

The subject matter may be familiar, but the stunning images contained in this book beautifully capture nature's ability to surprise and delight. *The World's Top Photographers' Workshops: Travel & Nature* details the roles and evolving goals of its 10 contributors, presenting insights on how their work both reflects and influences the ways we see our changing world, and the many species we affect.

Captivating photographs and exclusive interviews with those who truly deserve the mantle of world's top photographer mean that this title is an essential guide for two exhilarating photographic genres—and it has been written for people of all technical levels and abilities to enjoy.

Detailed captions explain how the shots were taken, and provide information on the cities, landscapes and animals portrayed. Whether unique images of the underwater world or charismatic portraits of animals from around our wonderful globe, it's the promise of variety and action that draws many photographers to their profession, and no other title offers a better example of this.

And, as contributing photographer Chris Caldicott observes, "The eclectic variety of exotic landscapes, people, architecture, animals and details are an endless source of inspiration … "

This beautiful book offers the proof.

Andy Steel

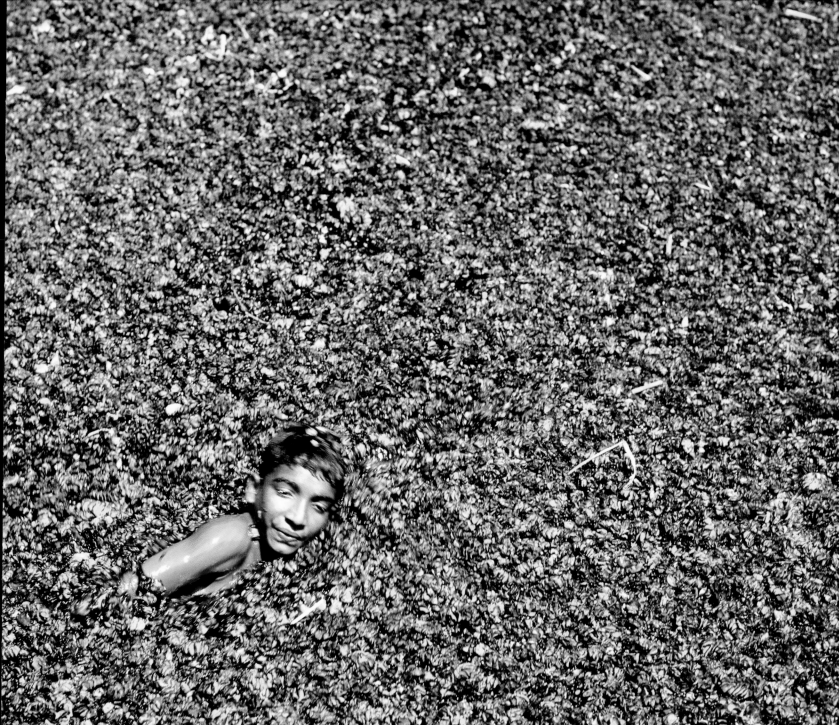

Heather Angel

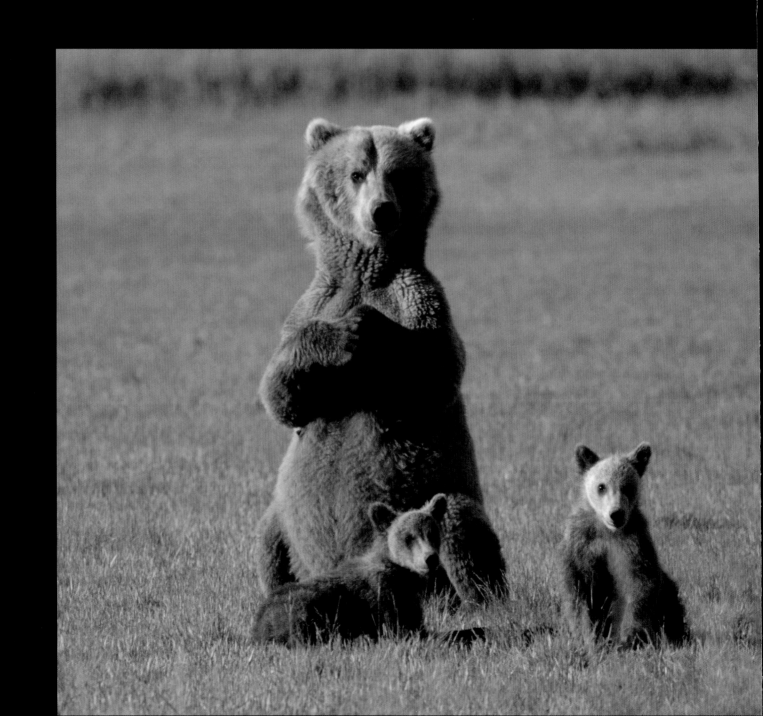

Composing in camera

Heather Angel is one of the world's few legendary wildlife photographers—and certainly one of the most widely traveled. For more than a quarter of a century she has been at the forefront of nature photography, and her work has been recognized by many professional awards from around the world. Born Heather Hazel Le Rougetel, she attended 14 schools in England and New Zealand before obtaining a BSc Hons degree in zoology at Bristol University, UK.

Former President of the Royal Photographic Society (1984–1986), Angel currently owns the Natural Visions photographic dynasty, and specializes in running photographic workshops and lectures.

Brown bears on the alert, Katmai National Park
There can be few more exhilarating experiences than photographing wild brown bears out in the open, with nothing between them and you except for a tripod. Alaska's Katmai National Park has a high density of brown bears and the only way to access Hallo Bay is by boat or float plane. Here I stayed on a boat and each morning I had a long wade through the shallow sea, to reach an extensive area of salt flats where many bears emerged from the forest in order to feed. Periodically a mother with her cubs would stop feeding and sit, or even stand up to check there were no male bears within striking range.

CAMERA: Nikon F5
LENS: 500mm
ISO: 100
APERTURE: f/8
SHUTTER SPEED: 1/250 sec
LIGHT CONDITIONS: Direct sidelighting

Interview

AS: What was your first ever camera?

HA: An Exakta SLR given to me by my father on my twenty-first birthday.

AS: Where do your ideas for innovative pictures come from?

HA: From observing the way animals move and reacting to a given situation. With plants, I often portray how structure is related to function, or experiment with ways to capture the biological process, to make my pictures look more exciting. In this way I visualize the image long before I shoot it. I may use multiple exposures to produce an image like an impressionist painting, or a slow shutter speed to portray an animal shaking water from its fur.

AS: Why did you decide not to do other types of photography, such as fashion or studio work, for example?

HA: Since early childhood I have had a passion for the natural world. This led to doing research in marine biology, so nature and wildlife photography was a natural progression. Apart from being impossible to mix the two genres, there are more than enough animals and plants to keep me busy for a lifetime!

AS: Is it fair to say, like many successful photographers, that you had a "lucky break" at some stage?

HA: I was lucky because I began my career in the early 1970s, when there were few wildlife photographers around. Now the world is super-saturated with professionals and enthusiasts. My whole life changed when my first book, *Nature Photography: Its Art and Techniques*, was published in 1972. Overnight the photographic press discovered a photographer who could also write. As a result I became a regular contributor to *The British Journal of Photography* and *Amateur Photographer* magazines.

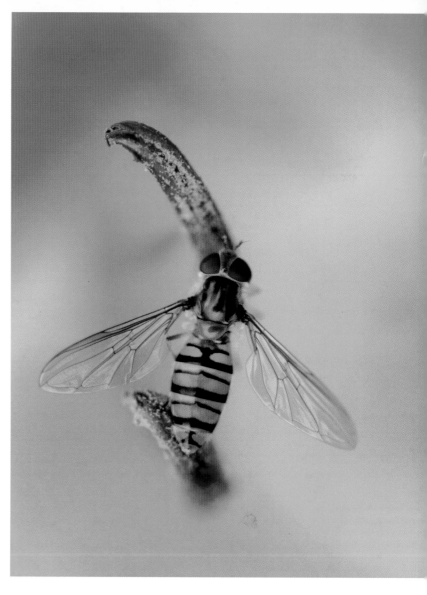

Above: **Evening hoverfly on a lily**
I grow many plants in my garden specifically to attract insects for photography. Early evening, as light begins to fade in late summer, hoverflies home in on lilies to feed on pollen. To create a pink, out-of-focus backdrop, and make the insect 'pop' from the flower, I chose to shoot with a wide aperture without flash.

CAMERA: Nikon D2x
LENS: 105mm macro
ISO: 200
APERTURE: f/4.5
SHUTTER SPEED: 1/250 sec
LIGHT CONDITIONS: Overcast

Right: **Preparing the ground**
Over the years my garden has been a rich source for a variety of wildlife pictures. The pond attracts newts, frogs, and dragonflies. Early in the morning, during spring and summer, I take a net to remove floating debris and cut off dying lily pads and blooms. In this way the pond never has any distracting objects, should a frog or a dragonfly choose to rest on a lily or flower.

CAMERA: Hasselblad 500CM
LENS: 80mm
ISO: 100
APERTURE: f/8
SHUTTER SPEED: 1/250 sec
LIGHT CONDITIONS: Early morning sun

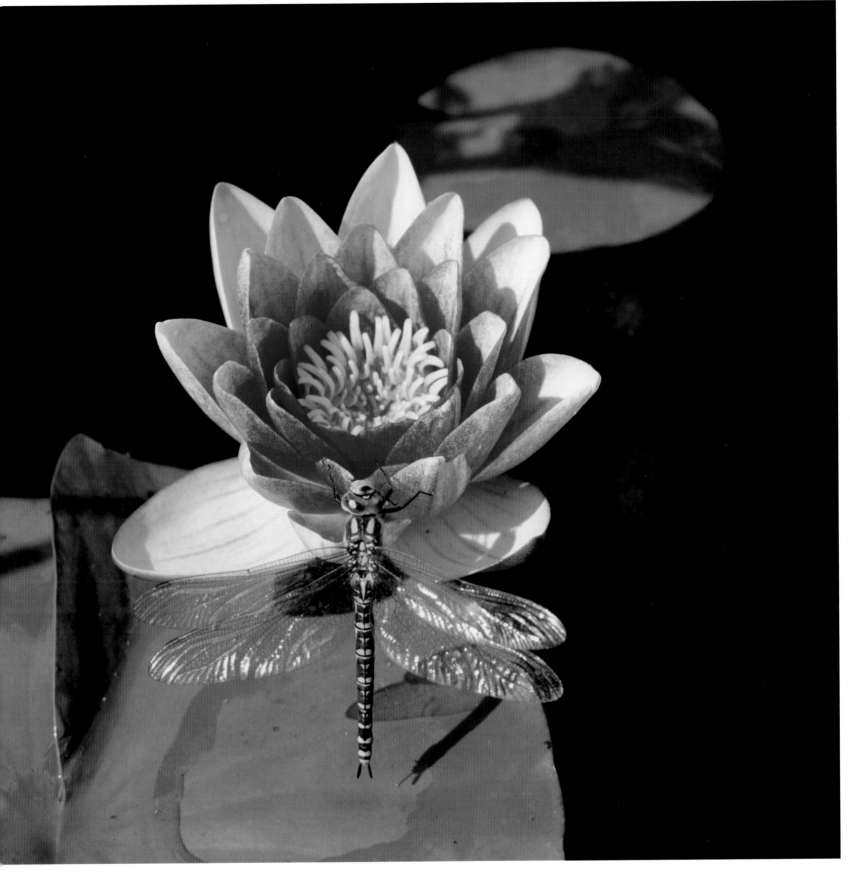

Heather Angel: Composing in camera

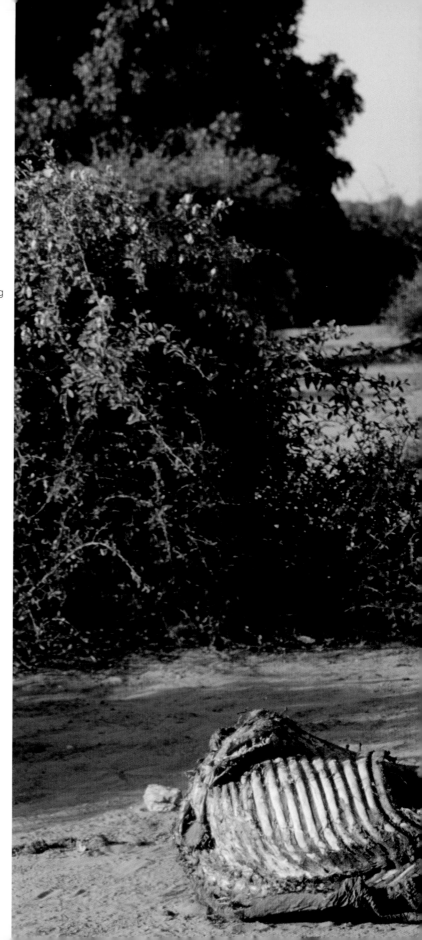

AS: Do you shoot what you want or do others generally define what's required of you?

HA: I've virtually always shot what appeals to me, aside from the odd commission, when I have been art-directed. Even when shooting the 1987 *Kodak Calendar* I did the research and photographed everything as I saw it.

AS: Where are you mostly based? Where are your most popular locations?

HA: My base is in Farnham, England, but throughout my working life I have been a peripatetic photographer, traveling the world. Where I work depends on the project I am currently involved in.

AS: Which country do you like to photograph in the most? Why?

HA: My favorite locations are Botswana and Antarctica. Botswana, unlike Kenya, has so few tourists that often my jeep is the sole one watching a cheetah or leopard. I never fail to get interesting behavioral shots of mammals in Botswana. Antarctica, too, is like no other location—pruned down to a minimalist landscape of sky, ice, and sea. In the austral summer the light can be quite magical.

A moving moment in Chobe National Park
Many of my best elephant pictures have been taken in Botswana—far and away my favorite country for working on safari. I spent a week in Chobe National Park taking pictures of elephants moving back and forth across the river. Moving inland one day, I spotted the skeleton of a baby elephant and asked my driver to stop, in the hope an elephant would be attracted to it. We only had to wait 10 minutes before an elephant arrived and began to investigate the skeleton, by touching it repeatedly with its trunk. It was a moving moment.

CAMERA: Nikon F5
LENS: 300mm
ISO: 100
APERTURE: f/8
SHUTTER SPEED: 1/250 sec
LIGHT CONDITIONS: Early morning sun

12

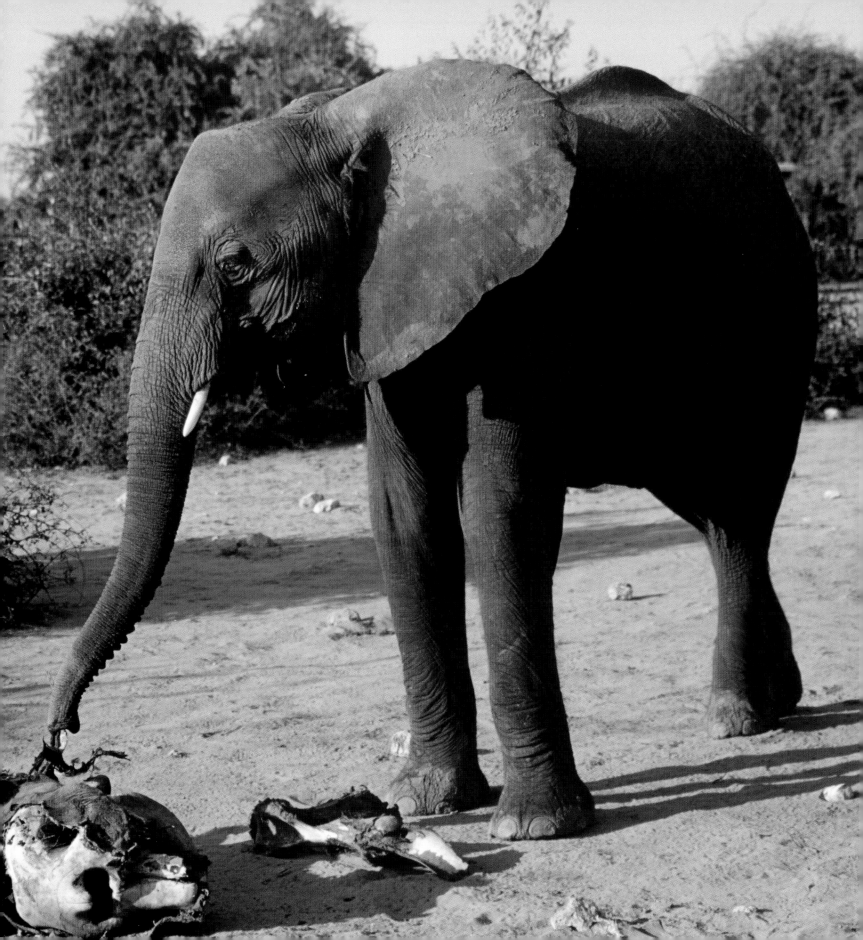

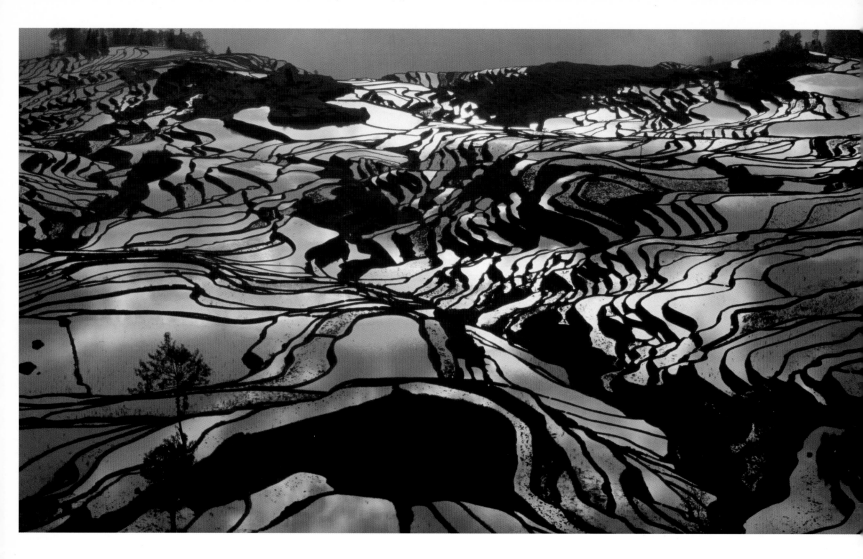

AS: What things do you enjoy most about your job?

HA: Working in the field away from phone calls and emails requesting urgent deadlines! Being in any wilderness when the first or last light is spectacular is something I will savor forever.

AS: From a technical aspect, what are the most difficult things about your photography?

HA: I don't find anything particularly difficult. If a problem arises I just find a way round it by trial and error, or call experts until it is solved.

Above: **Dawn over the rice terraces**
The broad vistas of China's ancient rice terraces at high elevations at Yuanyang, in Yunnan Province, attract many photographic enthusiasts. After the harvest, the fields are flooded for several months and, for just a few days, amazing multi-colored dawn and dusk skies are reflected in the water. This dawn shot, defining the sinuous silhouetted field boundaries, is my best to date after rising for a total of 10 sunrises on two separate trips.

CAMERA: Nikon F5
LENS: 35–70mm
ISO: 100
APERTURE: f/11
SHUTTER SPEED: 1/30 sec
LIGHT CONDITIONS: First dawn light; sun through clearing mist

Right: **Golden plumes**
While working on a book devoted to puffins, I spent several days shooting these charismatic, tufted creatures, with their bright orange bills, and golden plumes sweeping back behind the eyes. This shot was taken late in the day as the low-angled sun beamed onto the black plumage, with the head reflected in the dark water

CAMERA: Nikon D2x
LENS: 200mm
ISO: 200
APERTURE: f/8
SHUTTER SPEED: 1/250 sec
LIGHT CONDITIONS: Low sun

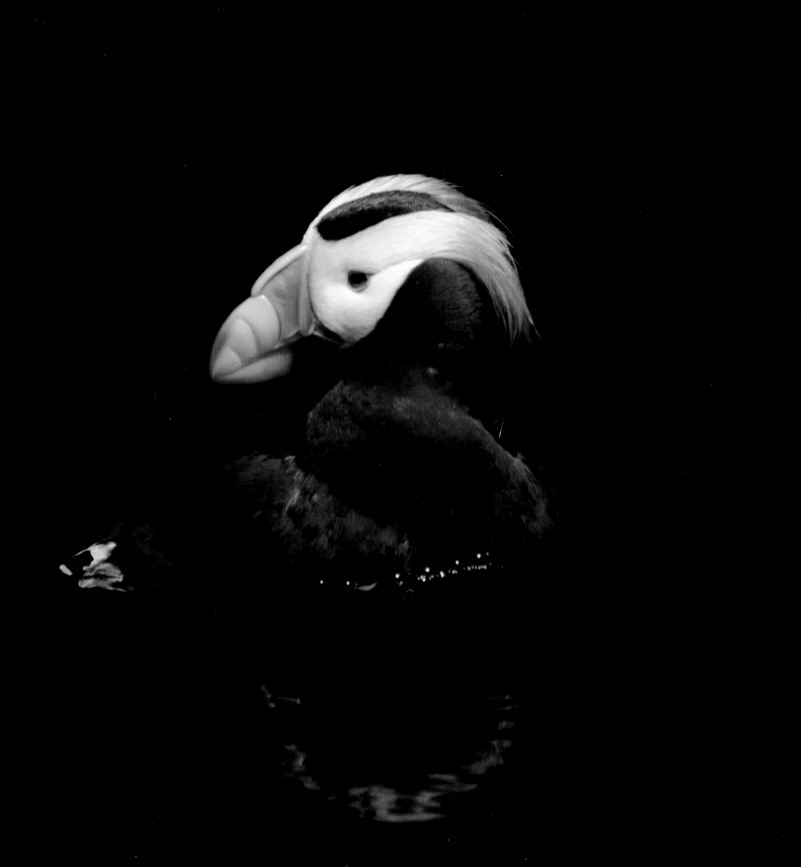

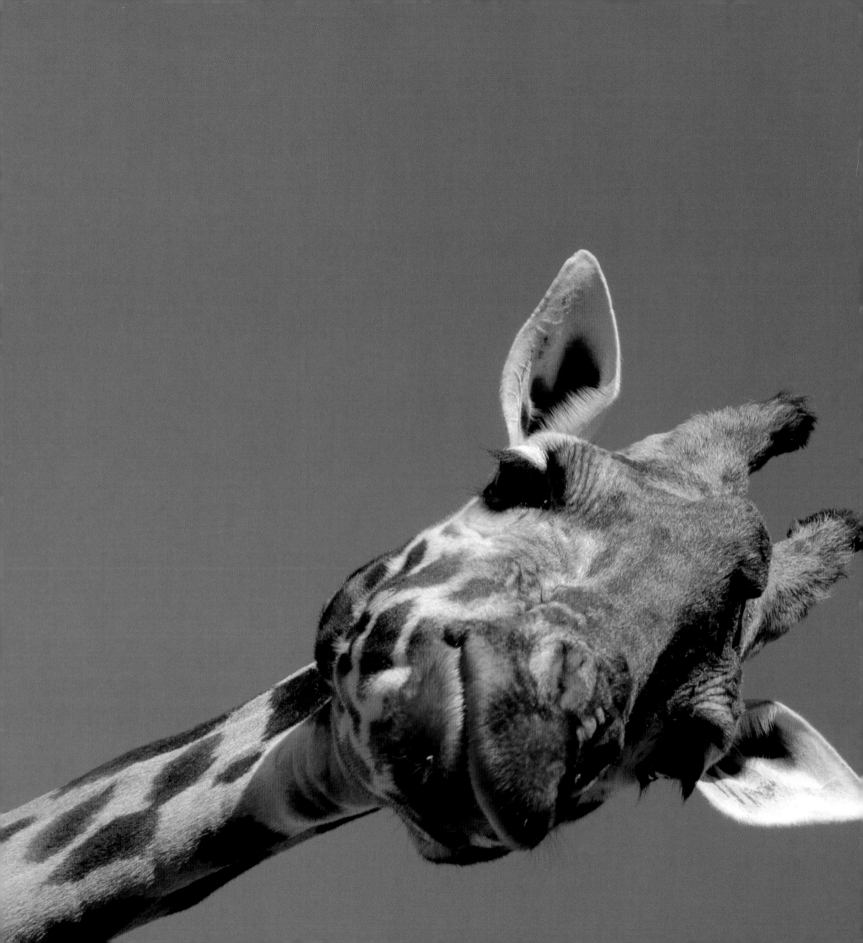

AS: How would you describe your personal style or technique of photography?

HA: My aim is to simplify the image by shooting with uncluttered backgrounds and foregrounds, and striving to compose within my camera.

AS: What's in your kit bag? Which camera system do you use and why?

HA: I currently use two Nikon D2x bodies. Having shot with Nikon for decades I have a plethora of lenses and have run Nikon workshops in the UK for many years. My lenses are 12–24mm, 24–120mm, 70–300mm (for fast action hand-held shots), 200–400mm, and 500mm. I sometimes use a 1.4× teleconverter with my 200–400mm and 500mm lenses. For macro shots my favorite lens is the 105mm micro-Nikkor. I also use an 80–200mm zoom lens for precise framing of insects, amphibians, or reptiles who won't tolerate a close-up approach. I love using the 24–120mm for climbing mountains and taking scenics and larger flowers. For true macro work it has to be the 105mm micro-Nikkor. For studio work using controlled lighting for small aquatic life and plant structures, I use a digital medium format camera—a Hasselblad H1D—tethered to a laptop. This gives me instant feedback on light, shadows, and depth of field. All my images are shot in RAW format and converted to TIFF files for quality reproduction.

AS: Do you try to make sure your work appeals to the widest possible audience?

HA: I shoot what appeals to me, but always work hard to get rid of clutter. I like to keep the foreground and background clean, so that the image appeals to other people as well.

AS: When are the busiest times of the year for you?

HA: This depends on the latitude in which I'm working. In the UK, May is a superb month for buds opening, butterflies, and wild flowers. In the USA, April is best for wild flowers, particularly in Texas. I like to visit Botswana in early December, which coincides with the start of the rainy season. The ground has a distinct green cast as the new grass shoots appear, while the antelopes are dropping their babies and there are amazing termite hatches on which birds and mammals gorge themselves.

AS: Which places do you dislike traveling to?

HA: Big cities where—apart from botanical gardens—there is little for me to photograph. I find pollution a problem in some Chinese cities, notably Chengdu, where I have to wear a mask.

A giraffe askew
I have photographed giraffes drinking and feeding in Africa countless times. But when I wanted a modern, simple approach to a popular animal, I asked a zookeeper to get me behind the scenes for an uncluttered shot of a giraffe looking down over a high fence. The askew composition—known as 'shooting on the piss'—was a deliberate decision. This shot has been used on Rooibos tea packaging.

CAMERA: Nikon D2x
LENS: 24–120mm
ISO: 200
APERTURE: f/10
SHUTTER SPEED: 1/320 sec
LIGHT CONDITIONS: Sunny, clear

AS: What types of pictures do you find the most difficult to take?

HA: Animal behavior shots in which I have to work with whatever light is present. I never know when the behavior I want to catch will cease, so I have to go with whatever available light there is.

AS: Which do you prefer—digital or film—and why?

HA: I've been shooting digital since 2005. In the year before I switched, every time I returned from an overseas trip, I would find my current processing lab had closed down. After this happened three times I made the decision to abandon film for digital. Shooting digital gives confirmation that an action shot has worked—the LCD screen is an instant Polaroid. However, I do resent the time I spend in front of a computer converting RAW files to TIFF and managing the digital editing process.

AS: How much of your work do you manipulate using imaging software?

HA: Very little. I shoot everything in RAW and I may tweak the contrast slightly. Additionally, if the light is poor, because I don't like shooting with an ISO rating above 200, and if I need a fast shutter speed, I will intentionally underexpose; I then have to adjust the levels. I may cut out subjects so clients can use them on a white background.

AS: What have been your greatest photographic achievements?

HA: Being commissioned to shoot the 1987 *Kodak Calendar* on the River Thames, and documenting the biodiversity of the Himalayas for the British Council, in Delhi. My solo exhibition, Natural Visions, toured the UK and was also on show in Cairo, Kuala Lumpur and Beijing, which was a great honor.

AS: What does the future hold for you?

HA: Who knows? No one would have predicted in 1998 that we would have abandoned film for digital capture. I shall relish seeking out new locations and revisiting familiar ones in differe seasons. I'd like to build on my many previous trips to China an concentrate on that vast country. I expect to become known a a leading supplier of Chinese wildlife images to the West.

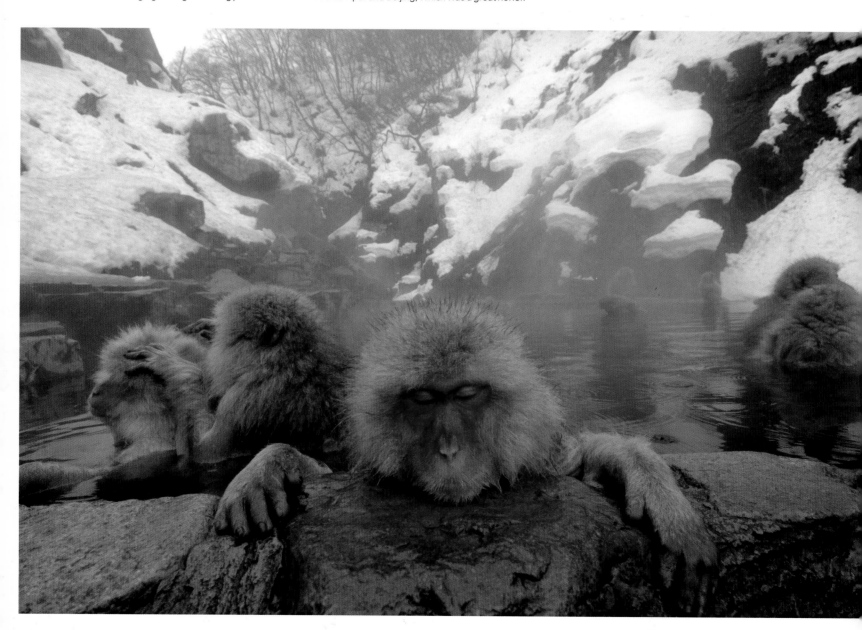

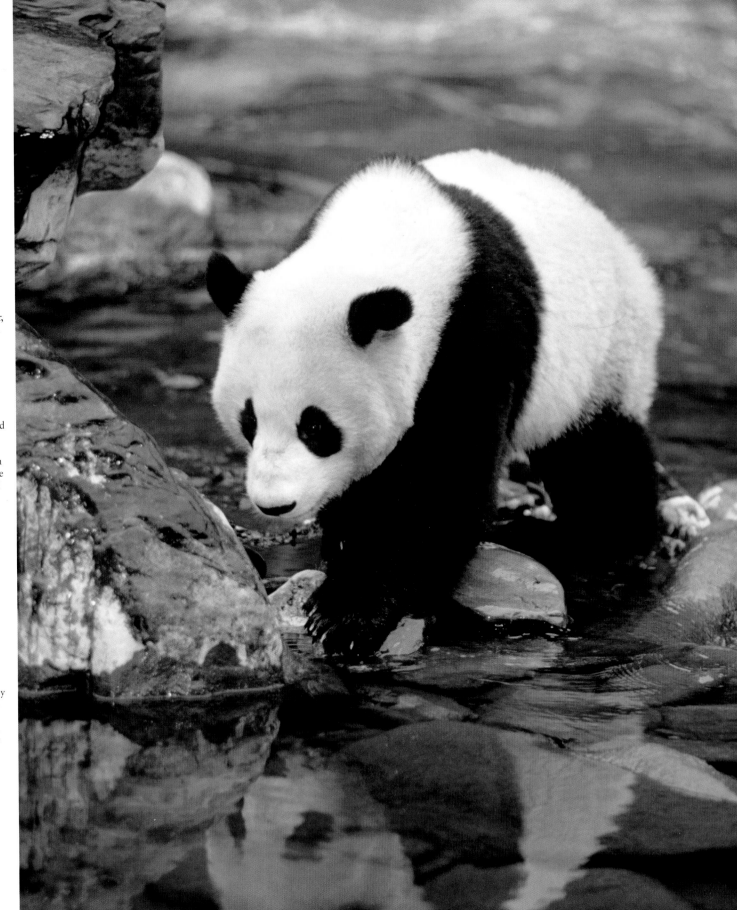

ft: **Japanese snow monkeys**
ving worked with Japanese
ow monkeys before, in winter,
new the best lens and camera
gle to use for this shot of
m relaxing in a hot pool in
okudani Monkey Park. The
v angle and ultra-wide angle
view were essential elements
show the macaques filling
e front of the frame, with the
ow-covered slopes behind and
am rising from the natural
rmal inflow. I arrived early
the morning so I had uniform
ht on the backdrop before the
n rose to light part of it—and
fore the tourists appeared.

MERA: Nikon D2x
NS: 12–24mm
: 200
ERTURE: f/8
UTTER SPEED: 1/125 sec
GHT CONDITIONS: Overcast
th fill-flash

ght: **Panda reflected**
e written many articles and
ree books about pandas. They
end so much time feeding on
mboo each day, it's difficult
get interesting shots of them
t feeding, so I was pleased to
t this one reflected in a pool
it walked beside a river, at
olong, during one winter.

AMERA: Nikon F5
NS: 80–200mm
: 200
ERTURE: f/5.6
UTTER SPEED: 1/250 sec
GHT CONDITIONS: Overcast
th fill-flash

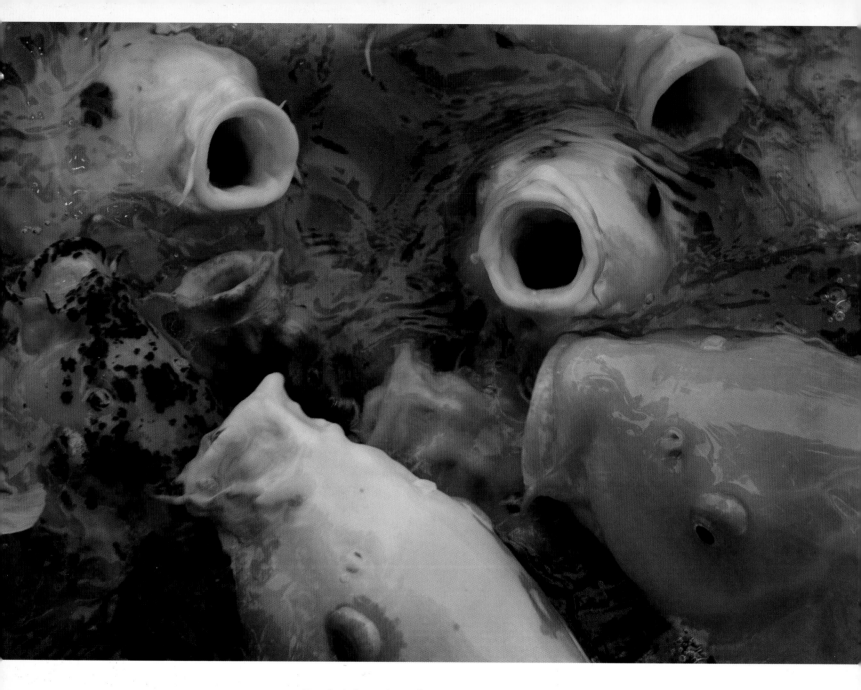

Zooming in for maximum effect
In China, when confronted with a mêlée of over-fed koi carp which were conditioned to rise whenever they saw a hand raised above a lake, I decided to zoom in on a few gaping mouths. I shot many frames because it's impossible to compose a shot where every element is rapidly moving within the frame. I knew that flash was not an option— I would get too many distracting reflections from the writing, wet bodies.

CAMERA: Nikon D2x
LENS: 100–300mm
ISO: 200
APERTURE: f/6.3
SHUTTER SPEED: 1/350 sec
LIGHT CONDITIONS: Bright, but hazy

Tips for Success

1. Research your destination and subjects

Animals have a short time-slot when they are exhibiting interesting behavior, such as courting, fighting, or with their young. Similarly, flowers are at their prime for a day or two at most—sometimes only a matter of hours. If I'm traveling to the other side of the globe it's essential to know where and when the prime time is to visit.

2. Contact local naturalists and rangers

Try to call or email any useful contacts if you're going overseas; a local naturalist or ranger can get the most up-to-date information about your target species. If they're a keen photographer they'll be able to give you valuable advice about how close you can approach, and what the most appropriate lenses to take may be.

3. Check local weather conditions

It's essential to be adequately dressed when in the field, because if you are wet and cold, you won't be able to concentrate on your photography. I always check out the average weather for the time I'm visiting any location.

4. Long lenses aren't just for animals

Long lenses are invaluable for taking photographs of inaccessible plants. I regularly use my 200–400mm and 500mm lenses to take pictures of aquatic plants flowering far out in deep lakes, or for flowers in trees high up on branches.

5. The early bird gets the worm

It pays to rise early. Light is often more dramatic at this time and many species are more active, feeding after resting at night. Early morning conditions are often calm, too, so there's a better chance of getting clear reflections in calm water before wind begins to ripple the surface.

6. Scan at different eye levels

When I'm walking through tropical rainforests I look for clues on the forest floor. I scan ahead at different levels, making sure to check what lies underfoot—before I step on it. There may be animal tracks, processionary caterpillars, a line of termites, or fallen flowers from an overhead tree or creeper. A glance upwards will confirm if it is worth getting out a long lens for a long-range shot.

7. Buy a map and postcards

Whenever I visit a new location I buy a map and check out the postcards for prime viewpoints, which are often marked on the map. This can save me a lot of time so I don't end up driving around at random.

8. Take plenty of shots

When animals are interacting in a fast and furious way, it's impossible to compose. You have to keep shooting and hope you get the action, coupled with a reasonable composition. Extra shots with digital cost no more and you can easily delete the ones you don't want.

9. Take visual references for local guides

If I want to photograph an unusual animal or plant, I print out copies of drawings or photos to take abroad. Even if a local guide doesn't recognize the subject, the pictures can be passed around until someone does. Visual references have the advantage of breaking through any language barrier.

10. Use a transparent umbrella in the rain

When taking close-up shots in the rain, I hold a transparent umbrella over the camera, mounted on a tripod, so it doesn't cut out any light falling onto the subject.

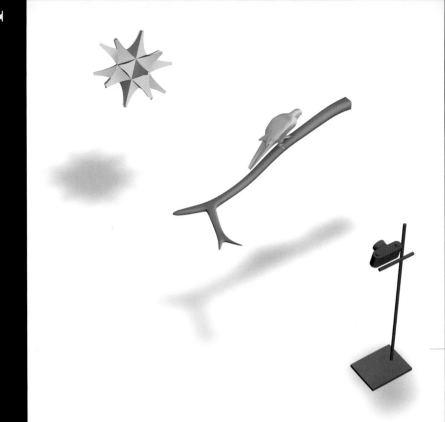

King parrot silhouette

I'm always striving for ways to produce simple, eye-catching shots of animals without foreground or background clutter. Having photographed Australian king parrots with their spectacular multicolored bodies by day, I wanted to try a simple silhouette with a setting sun. By baiting with nuts on a branch the birds had visited by day, I was rewarded with a parrot that appeared in the right place at the right time.

Specification

CAMERA: Nikon D2x

LENS: 300mm

ISO: 200

APERTURE: f/11

SHUTTER SPEED: 1/320 sec

LIGHT CONDITIONS: Natural, backlit, clear

Essential Equipment

- Two Nikon D2x camera bodies

- Hasselblad H1D medium format camera (studio work)

- 12–24mm f/4 zoom lens

- 24–120mm f/3.5–5.6 zoom lens

- 70–300mm f/4.5–5.6 zoom lens

- 80–200mm f/2.8 zoom lens

- 105mm micro-Nikkor f/2 lens

- 200–400mm f/4 zoom lens

- 500mm f/4 lens

- 1.4× teleconverter

- Nikon Speedlight SB-800 flashgun

- Spare lithium-ion batteries

- Range of CF media cards

- Gitzo tripod

- Benbo tripod

- Collapsible light reflectors/ diffusers

- Laptop computer

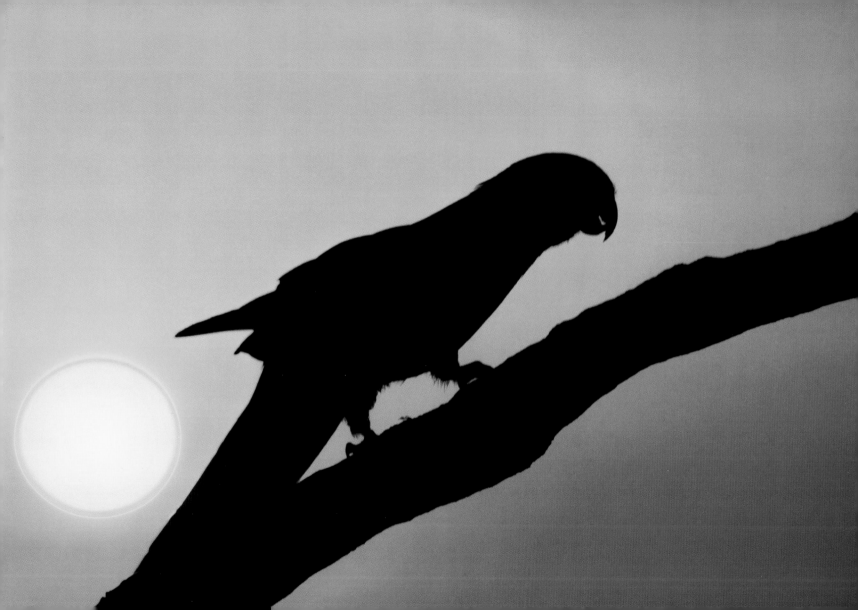

Sue Bishop

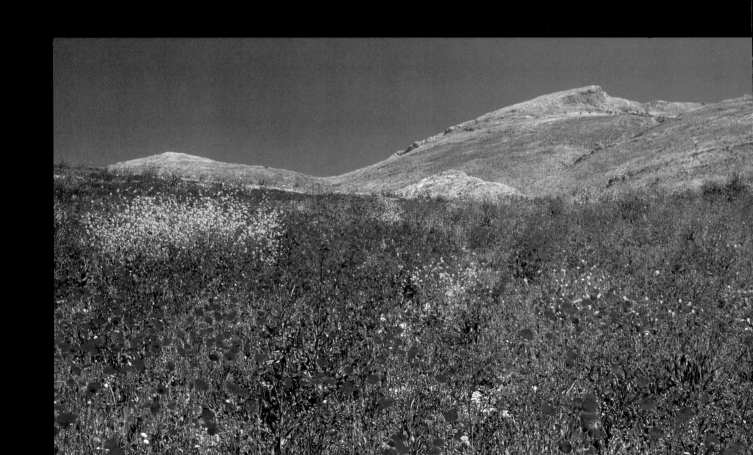

Juxtaposing color

Sue Bishop is a true professional who creates images that go beyond a mere record of their subjects, some would say becoming art in the process. Her unique compositions are a celebration of color and form, often impressionistic and even abstract. She has exhibited her work many times, and in 2004 held a prestigious six-week solo exhibition at the Royal Horticultural Society's Lindley Library, in London. As well as selling prints of her images, she has contributed photographs to leading magazines and has sold work for use in calendars, travel brochures, and books.

In 1994 Sue founded Light & Land, a company that runs photographic tours to various destinations all over the world. In 2000, her range of photographic greetings cards was shortlisted for the Henries Awards, and in the same year, her photograph of a wildflower meadow in Andalucia was awarded "highly commended" in the prestigious BG Wildlife Photographer of the Year Competition, and was subsequently exhibited worldwide.

ildflower meadow
ildflowers are not as common
Andalucia as they used to be,
d I had spent a couple of days
iving around the area without
ding more than a couple
roadside poppies. When
ounded a bend, I beheld
e most glorious wildflower
eadow I had ever seen! And
ove the contrast between
e lushness and delicacy of the
wers, and the harsh, barren
ck of the mountain behind.
vas glad there weren't any
ouds in the sky, as the pure
ue added to the graphic nature
the composition.

AMERA: Nikon F3
NS: 28–105mm
LM: Fuji Velvia 50
ERTURE: f/16
UTTER SPEED: 1/30 sec
GHT CONDITIONS: Bright
nlight, polarizing filter

AS: What was your first ever camera?

SB: A tiny little compact which used just half a 35mm negative film per picture. I went on a sailing holiday on a windjammer, off the coast of Maine in the USA, and took lots of photos with it. I attempted to have a couple of them enlarged. The extremely grainy results persuaded me it was time to get an SLR!

AS: Where do your ideas for innovative pictures come from?

SB: I look at interesting juxtapositions of shapes or colors. I also enjoy looking at contemporary paintings and, of course, at other photographers' work, although I never copy an idea—seeing other people's images is always an inspiration. When I'm on location I try to avoid the "obvious" picture and look for a more subjective interpretation.

AS: Why did you decide not to do other types of photography, such as fashion or studio work, for example?

SB: I've always been attracted by natural subjects in natural light—I would hate to work with flash. I also like to take my time over my photography and become absorbed in it—I wouldn't like the pressure of a fashion shoot.

AS: Is it fair to say, like many successful photographers, that you had a "lucky break" at some stage?

SB: I don't think there was one particular lucky break—my photography has evolved gradually over the past 20 years.

AS: Do you shoot what you want or do others generally define what's required of you?

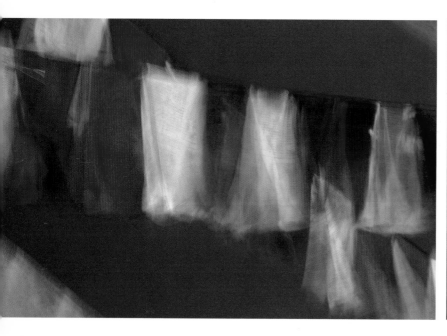

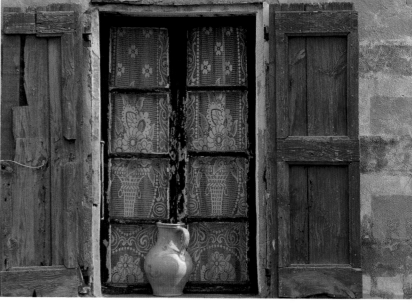

Prayer flags
Bhutan is one of the most interesting countries I've visited. I took many photographs of monasteries, dzongs, and the distinctive Bhutanese houses, but one of my favorite images was this one of Buddhist prayer flags blowing in the wind at Dochula Pass. I loved the vivid primary colors of the flags against the blue sky, but I felt a static picture of them didn't capture their essence as they fluttered in the breeze. I put my camera on a tripod and used a slow shutter speed to blur the flags as they moved.

CAMERA: Nikon F100
LENS: 200mm
FILM: Fuji Velvia 50
APERTURE: f/22
SHUTTER SPEED: 1/15 sec
LIGHT CONDITIONS: Bright sunlight, polarizing filter

Jug in a Provence window
This window was on the shady side of a house, but the sun was just creeping around the edge of the building, touching the handle of the jug in a sliver of light. The color and position of the jug was perfect, and the soft light enhanced the lovely gentle colors of the wall and shutters. I just had time to set up my camera and tripod to take a couple of photos before the sun came further round.

CAMERA: Nikon F3
LENS: 200mm
FILM: Fuji Velvia 50
APERTURE: f/11
SHUTTER SPEED: 1/60 sec
LIGHT CONDITIONS: In shade on a sunny day

26

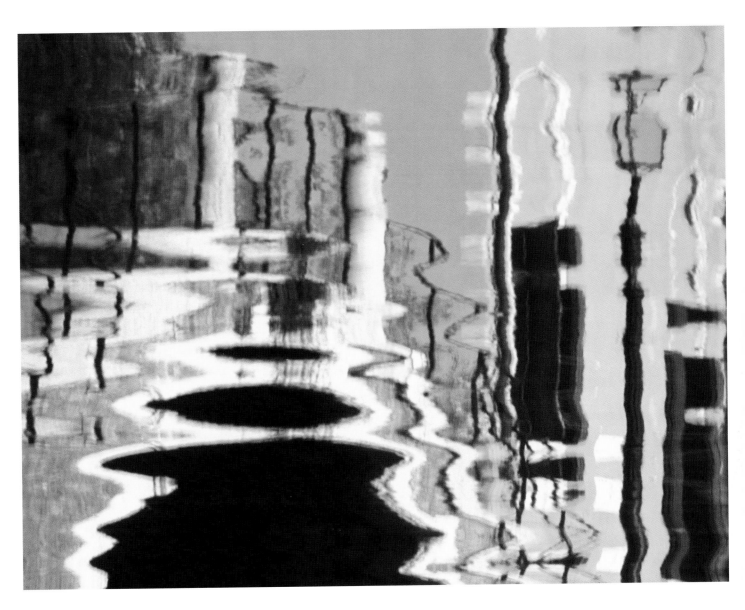

Venetian reflection

Venice has been photographed so much it's quite a challenge to make an image different from hundreds of others. I always like to find a new way of looking at things and I had great fun making a set of images by photographing the reflections of buildings without including their subjects in the frame, then turning the resulting photograph upside down to create a more impressionistic image. The most vivid colors are obtained when the building itself is in sunlight, but the water in which it's being reflected is in shadow.

CAMERA: Nikon F100
LENS: 28–105mm
FILM: Fuji Velvia 50
APERTURE: f/11
SHUTTER SPEED: 1/60 sec
LIGHT CONDITIONS: In shade on a sunny day

SB: Usually I shoot what I want, although sometimes I do commissioned work in which I have to shoot to a predetermined brief. I much prefer to be completely free to take whatever photographs I want.

AS: Where are you mostly based? Where are your most popular locations?

SB: I'm based in Surrey, England, but I travel all over the world. I go where the photography takes me.

Sue Bishop: Juxtaposing color

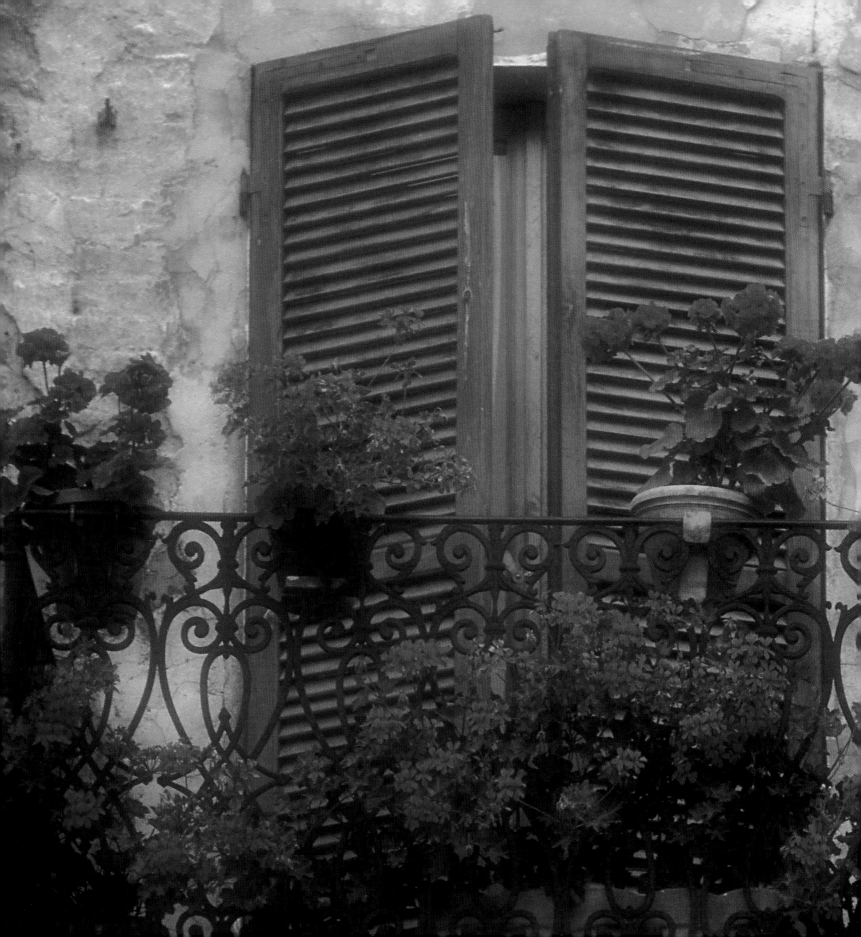

AS: Which country do you like to photograph in the most? Why?

SB: I like to work in verdant, lush locations with plenty of flowers, such as Tuscany or Provence—in these areas the countryside and the villages provide plenty of wonderful subjects and the light is very special. I also love wilderness locations, such as the Sossusvlei sand dunes in Namibia.

AS: What things do you enjoy most about your job?

SB: When I'm really absorbed in taking a photograph, everything else falls away—I just stop thinking or worrying about anything else. It's very therapeutic. It's a wonderful feeling when I achieve an image which I'm really pleased with.

AS: From a technical aspect, what are the most difficult things about your photography?

SB: Getting the right light, in the right place, at the right time. No amount of forethought and planning can guarantee that on a trip. Moreover, planning a trip in advance that depends on something like blossom being at its peak is always difficult, because weather conditions can mean the peak time varies from one year to another.

AS: How would you describe your personal style or technique?

SB: I aim for clean, uncluttered images, and I often tend towards a fairly abstract picture. Color is usually what attracts me to take a particular image, hence the use and juxtaposition of color is important to me. I look for beauty in color, light and form—never for gritty realism. I like areas of soft focus and impressionistic color, sometimes achieved by using a shallow depth of field and sometimes by camera or subject movement.

Umbrian balcony

I'm always on the lookout for lovely windows and doorways when I travel to Italy and France, but so often a possible picture is spoilt by something obtrusively modern, such as wires or garish plastic flower pots. I was delighted to find this beautiful balcony with no such distractions, and with the additional bonus of the lovely red geraniums. The window was in shadow on a sunny day, which can cause a cool blue cast on film, so to restore the lovely warm Italian feel, I used a warm-up filter, and a soft-focus filter to add a touch of romance.

CAMERA: Nikon F3
LENS: 28–105mm
FILM: Fuji Velvia 50
APERTURE: f/16
SHUTTER SPEED: 1/30 sec
LIGHT CONDITIONS: In shade on a sunny day

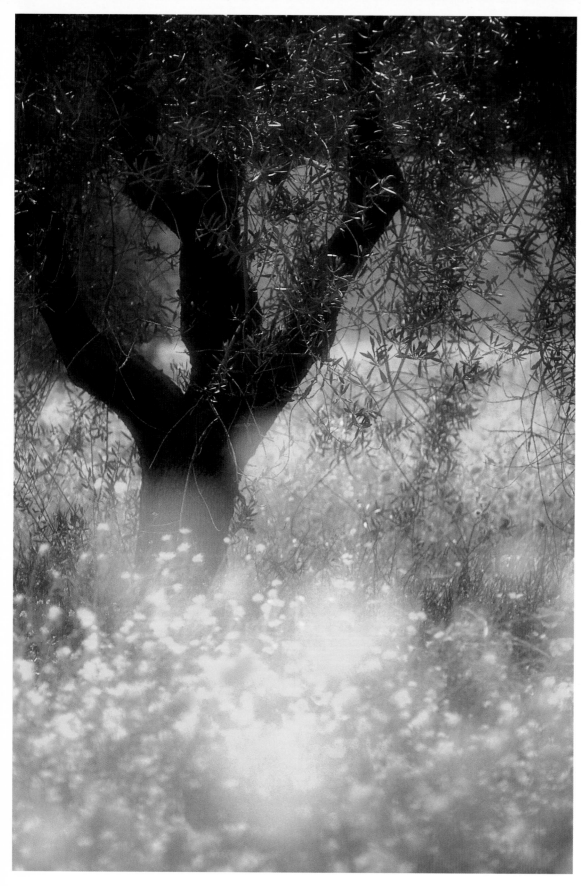

Olive tree and flowers

I love the combination of flowers and trees, and I was very excited to discover a small olive grove with poppies and rape-seed growing among the trees. I decided to make a more subjective, impressionistic image by using a telephoto lens and picking out just one tree, and by positioning my camera so that some of the yellow flowers were very close to the front of my lens—this resulted in the gentle wash of yellow in the lower half of the frame. I also used a shallow depth of field to make the flowers and grass look softer and lusher.

CAMERA: Nikon F100
LENS: 200mm
FILM: Fuji Velvia 50
APERTURE: f/5.6
SHUTTER SPEED: 1/125 sec
LIGHT CONDITIONS: Sunlight

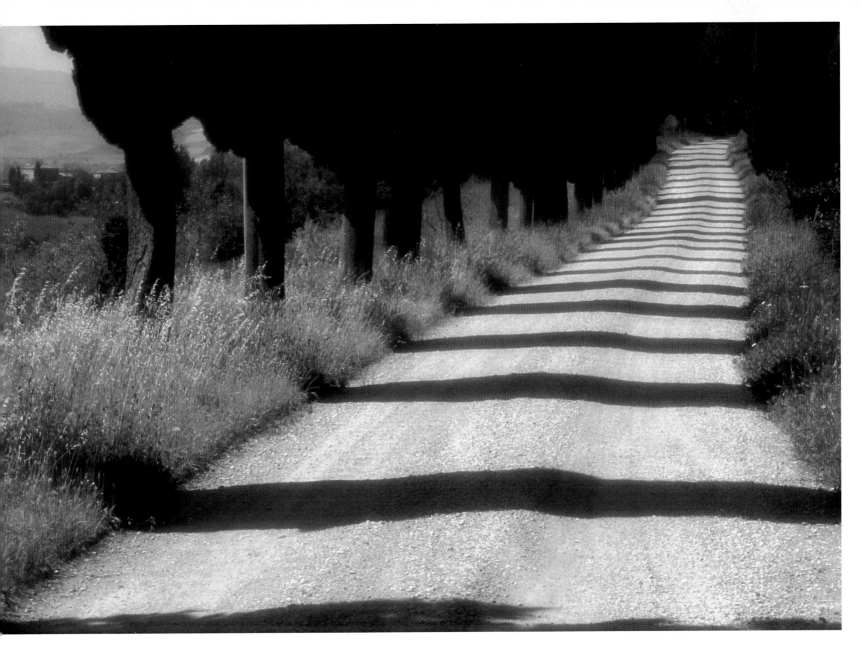

Tuscan avenue

A beautiful tree-lined avenue is always a tempting subject for a photograph, and this one in Tuscany, with its cypress trees, was no exception. I took this shot in the morning when the sun was fairly low, and coming directly from the side as I looked down the avenue, which meant the shadows of the trees fell horizontally across the road. I made sure there was a patch of shadow, rather than sunlight, at the bottom of the frame, as this helps to 'hold the picture in.'

CAMERA: Nikon F100
LENS: 28–105mm
FILM: Fuji Velvia 50
APERTURE: f/22
SHUTTER SPEED: 1/30 sec
LIGHT CONDITIONS: Bright sunlight

Sue Bishop: Juxtaposing color

AS: What's in your kit bag? Which camera system do you use and why?

SB: I have a Nikon D1x, plus Nikon lenses comprising 12–24mm, 28–105mm and 80–400mm, as well as a micro-Nikkor 105mm. I also carry two spare batteries, a backup body (Nikon D70), plus polarizing filters and soft-focus filters, and a small Lastolite diffuser/reflector. All three zooms lenses are useful for travel work, although I probably use the telephoto end of the focal range most. My favorite lens is actually the micro-Nikkor—it's a useful short lens and it's wonderful for flower photography.

AS: Do you try to make sure your work appeals to the widest possible audience?

SB: I usually only think about whether the image appeals to me. Obviously it's wonderful if other people like my work, but it's not something I think about at the time of creating an image. Sometimes, after I've taken the photos I want, I will also take another stock-type photograph, if it looks likely to sell commercially.

AS: When are the busiest times of the year for you?

SB: Definitely spring—with the fresh green leaves, flowers appearing, blossom on the fruit trees, and the sun not too high overhead. Often I want to be in several different places at the same time, so that I can photograph it all!

AS: Which places do you dislike traveling to?

SB: I'm lucky because generally I choose where to travel and I don't have to go to places I dislike. I wouldn't like to photograph anywhere very urban or crowded.

AS: What types of pictures do you find the most difficult to take?

SB: Pictures of people, particularly in developing countries. I don't feel comfortable.

AS: Which do you prefer—digital or film—and why?

SB: I resisted changing to digital for quite some time, but now that I have, I do prefer it to film. It's reassuring, especially when traveling, to be able to see that your camera is functioning properly—with film you never know until you're back home editing pictures. It's also nice not to worry about taking film through x-ray machines at airports. For commissioned work the ability to check the image at the time of taking it is a real bonus.

Woman in doorway
I visited this town on a coach tour—not usually a good recommendation for travel photography. I hadn't expected to do much serious photography, so I had traveled with only my compact camera. Our party filed into this building, and I looked back and saw the vibrant colors of the door and the wall and window opposite. I took a couple of shots, but wanted another one to be sure of success. Suddenly this lady stepped into the doorway.

I got just one chance at the picture. Although I seldom photograph people, in this case, I felt the woman's presence made the photograph.

CAMERA: Panasonic Lumix LX2
LENS: 28mm wide-angle
ISO: 100
APERTURE: f/8
SHUTTER SPEED: 1/30 sec
LIGHT CONDITIONS: Natural light inside, clear blue sky outside

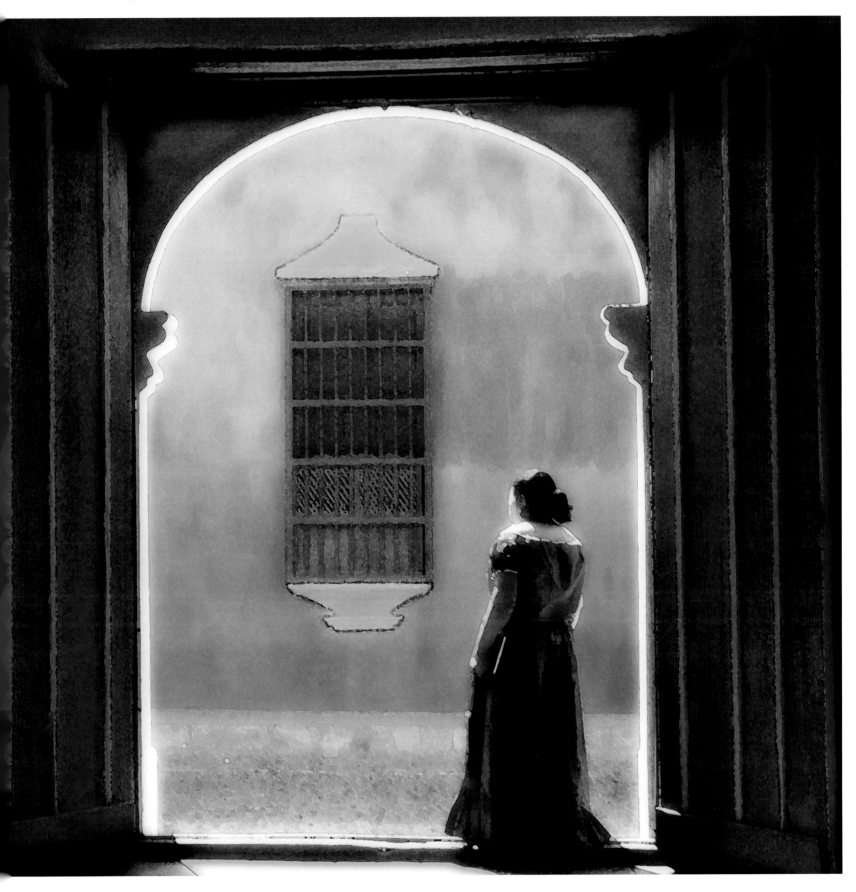

Sue Bishop: Juxtaposing color

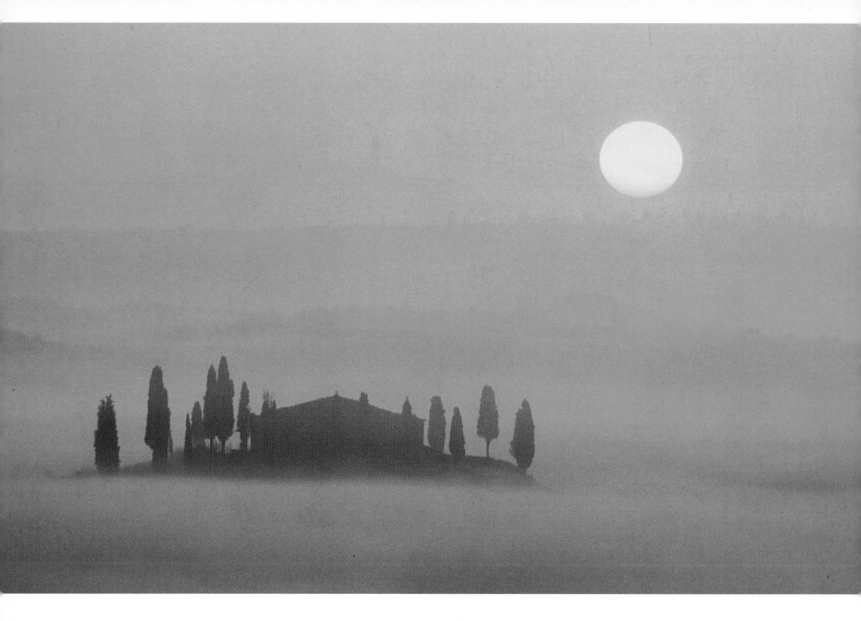

Tuscan sunrise

I had gone out early in the hope of photographing the beautiful Tuscan landscape as the sun rose, but as I waited in the pre-dawn gray I realized my hopes were going to be thwarted by a thick mist. Suddenly a villa with its cypress trees appeared out of the mist, as a silhouette, so I photographed it—but there was no sun in the scene. A few minutes later the silhouette was swallowed by the mist again, and then over to the east I saw the sun suddenly appear, so

I took a photograph of that too, surrounded by mist. Back home I sandwiched the two pieces of film together and then rephotographed them in a slide copier, which gave me this image—the Tuscan sunrise I had wished for.

CAMERA: Nikon F3
LENS: 200mm
FILM: Fuji Velvia 50
APERTURE: f/5.6
SHUTTER SPEED: 1/15 sec
LIGHT CONDITIONS: Pre-dawn, misty

AS: How much of your work do you manipulate using imaging software?

SB: I usually do very little manipulation—I just tweak the color and levels, if necessary. Occasionally I will clone something small out, such as a fence post, but I prefer it if I can manage to take the picture without those things in the first place. I have recently, however, enjoyed experimenting with making several layers on a photograph and adding different effects—it's great fun, but extremely time-consuming.

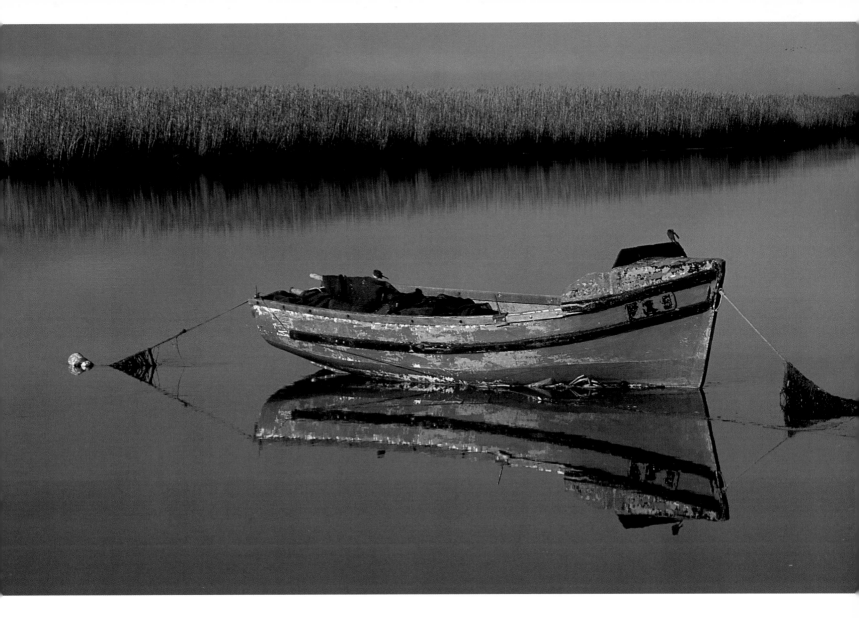

The boat

...ad gone to the edge of [a s]mall river in South Africa [jus]t before dawn—there was [t]hick mist and a strong smell [of] salted fish drying nearby, and [I b]egan to wonder whether it [wo]uld be worth the early start. [Th]e gray shades began to lighten [gra]dually, but for a while there [wa]s still very little visibility— [wh]en all of a sudden the sun [ro]se, the mists lifted and [...]appeared, and this serene, [tra]nquil scene appeared in front

of me. There often seems to be a short time just at sunrise when there's no wind, and this was the case here—the water was totally calm, allowing a completely clear reflection of the boat and reeds behind it.

CAMERA: Nikon F3
LENS: 28–105mm
FILM: Fuji Velvia 50
APERTURE: f/16
SHUTTER SPEED: 1/60 sec
LIGHT CONDITIONS: Early morning sunlight

AS: What have been your greatest photographic achievements?

SB: My first real achievement that brought me a great deal of pleasure was having a photograph highly commended in the British Gas Wildlife Photographer of the Year competition, 2000. Since then I've had my first book published (*Photographing Flowers*, in 2004), and I'm currently working on my second book, *Digital Flower Photography*.

AS: What does the future hold for you?

SB: If it holds lots more trips to beautiful places, to take the kind of photographs that I love, then I will be happy.

Sue Bishop: Juxtaposing color

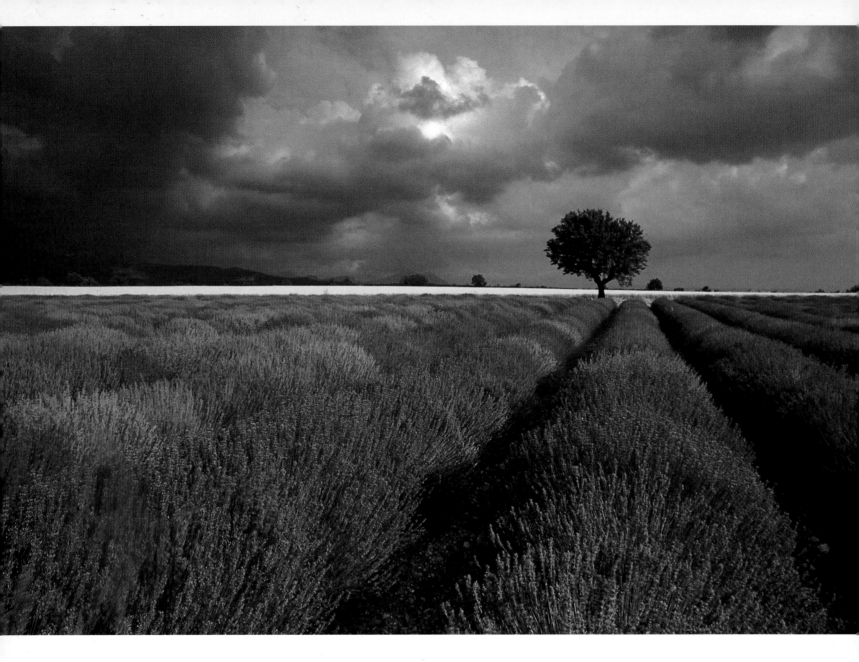

Lavender field

The lavender fields in Provence are at their peak at the end of June, and the sight of glorious purple vistas coupled with the heady scent of the lavender is quite an experience. Shortly after I arrived I saw storm clouds gathering, and for a brief moment I saw the wonderful light that happens when the sun is still shining as dark clouds loom. I worked quickly as I knew it wouldn't last long. I chose a wide-angle lens to emphasize the rows of lavender leading towards the horizon, and placed the tree as the focal point on a rule-of-thirds, showing the foreground, subject and horizon, each making a third of the same image. The sliver of a field of golden corn just showing between the lavender and the sky was a real bonus.

CAMERA: Nikon F100
LENS: 24mm
FILM: Fuji Velvia 50
APERTURE: f/16
SHUTTER SPEED: 1/30 sec
LIGHT CONDITIONS: Sun through storm clouds

Tips for Success

1. Define the appeal
When you see a scene that attracts you, try to define what it is about it that appeals to you—then emphasize that in your photograph, by means of lens choice, aperture, and composition.

2. Apply the personal touch
If you're in a much-photographed location, take the "obvious" picture first, then look for different, more personal images.

3. Use a tripod
Whenever possible, use a tripod. As well as freeing you to use longer shutter speeds, it enables you to really consider your image and fine-tune your composition.

4. Work with available light
Light is an all-important factor in any type of photography. If you have the luxury of being able to revisit a location when the light is better, take advantage of it. If not, consider what type of photograph will work best with the light available to you, and work with it.

5. Consider the background
The background to your subject is just as important as the subject itself—a cluttered background can spoil an image. Try to avoid distracting elements in your picture, especially if they're bright, as they will draw the eye away from your subject.

6. Apply depth of field
Choice of field depth is often crucial to the success or failure of a photograph. If there are distracting elements which cannot be avoided, try to throw them out of focus by using a wide aperture.

7. Research your photography
Be prepared to walk or drive around to look for possible images. Most of my favorite photographs could not have been taken just by studying guide books.

8. Small detail is crucial
As well as photographing the larger view, don't forget to look for small details—these often say as much about a place as a grand vista can.

9. Use the sky in your shots
If the sky is bland, don't include too much of it, or perhaps leave it out altogether. If it's a really good sky, allow it to take up a large amount of the final image.

10. Think abstract
Consider the balance of color, line and form in your image. Try thinking abstract and graphic!

Silver birches, Lake District, UK
Driving through the Lake District on a drizzly autumn day, I came across this lovely stand of silver birch trees. I decided to use one of my favorite ways of creating an impressionistic image, which is panning the camera—moving it vertically during a longer exposure. It's a very experimental technique and I always take a lot of pictures in the hop of getting one which I feel is right. The weather was overcast, which was good, as bright sunlight would have caused far too much contrast, and a lot of bright streaks in the image. The panning technique has eliminated distracting elements in the scene such as bare twigs and stalks, and emphasized the lovely colors of the foliage and bracken.

Specification

CAMERA: Nikon F100

LENS: 28–105mm

FILM: Fuji Velvia 50

APERTURE: f/11

SHUTTER SPEED: 1/8 sec

LIGHT CONDITIONS: Overcast

Essential Equipment

- Nikon 35mm D1x camera body

- Nikon 35mm D70 camera body (backup)

- 12–24mm f/4 zoom lens

- 28–105mm f/2.8 zoom lens

- 105mm micro-Nikkor f/2 lens

- 70–200mm f/4–5.6 zoom lens

- 80–400mm f/4.5–5.6 zoom lens

- Lens hoods for all lenses

- Two spare lithium-ion batteries

- 1GB Lexar CF media cards

- Polarizing filters

- Soft-focus filters

- Lastolite diffuser/reflector

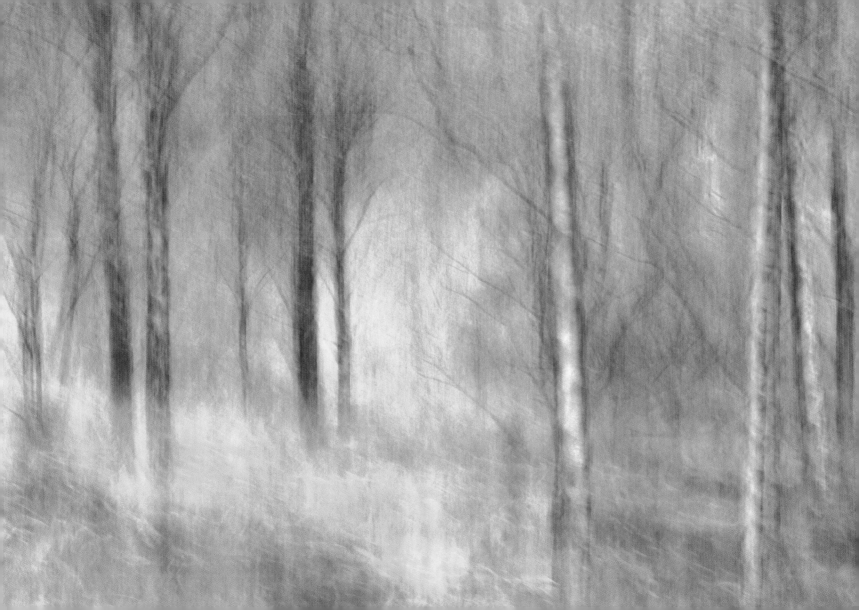

Steve Bloom

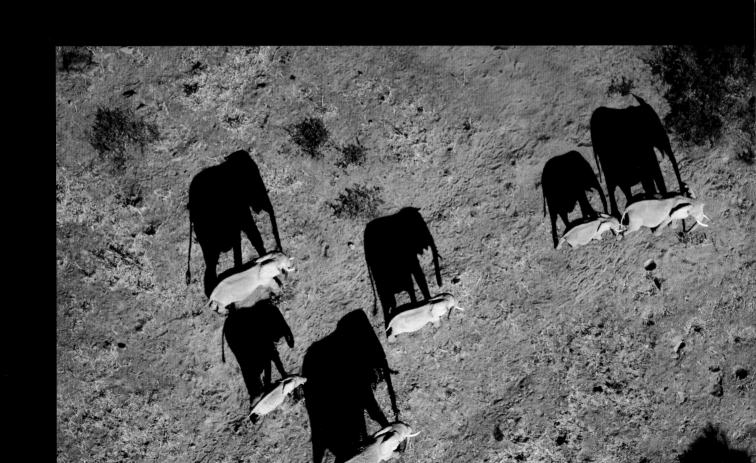

Interacting with nature

Elephants' shadows
This was one of those rare
pictures I had in my mind
before doing the shoot. I was
the passenger in a two-person,
light aircraft, and we set off
into the Amboseli National
Park, Kenya, as the sun was
rising. It was a lucky shot
because the elephants were
moving from the dense bush
towards the water, and there
was a small area of dry earth
they had to cross. They did so,
quickly, and if I had not been
there at the right moment
I would have missed the shot.
I had to lean as far out of the
aircraft as I could, and shoot
straight down.

CAMERA: Canon EOS-1N
LENS: 70–100mm
FILM: Fuji Provia 100
SHUTTER SPEED: 1/100 sec
LIGHT CONDITIONS: Sunny

Steve Bloom, a South African–born
naturalist, has won many photographic
awards, borne from his unique approach
to the natural world, and his unique
pictures. Steve's evocative imagery can
be seen around the world in posters,
calendars, advertising, and editorial
features, as well as a multitude of other
professional arenas—predominantly
a world-renowned photo agency and
gallery which represents his collection.
He first used a camera to document life
in South Africa during the 1970s, before
moving to England in 1977, where he
worked in the graphic arts industry.
In the early 1990s, during a visit to South
Africa, he became interested in nature
photography, and within a short time had
swapped his established career for the
precarious life of a wildlife photographer.

Steve's concern for the environment
is strongly evident in his pictures.
"Photography is the means by which
I strive to engender in others a feeling
of unity with the natural world. There
remains the ongoing challenge to portray
life in all its manifestations, and create
images that reveal the very essence of
what it is to be a living being."

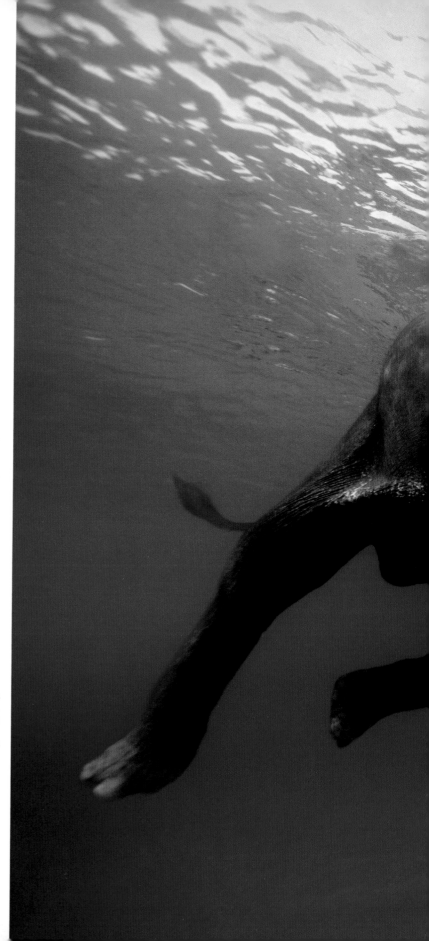

Interview

AS: What was your first ever camera?

SB: A Kodak Box Brownie, a simple box-shaped camera with two separate viewfinders, one for landscape (horizontal) and one for portrait (upright) images. Color film was unavailable or too expensive, but I was fascinated by the little black-and-white pictures it produced.

AS: Where do your ideas for innovative pictures come from?

SB: Sometimes they're ethereal, but at other times I'm influenced by what I see. I may watch a TV documentary and be drawn to a particular location. With some pictures I have a clear idea in my head about what I'm hoping to find, but there are also surprises which present themselves in an instant, and then, with a rush of adrenalin, I try to capture the essence of what I've found.

AS: Why did you decide not to do other types of photography, such as fashion or studio work, for example?

SB: I'm drawn to the living world, that is, wildlife, people, cultures. But I'm always open to change and try not to constrain myself to any particular genre. Fashion is related to selling products, and right now I prefer to concentrate purely on the image, rather than associate my work with a product. There's something about interacting with nature, being there while events beyond my control are unfolding, that I find really appealing.

Underwater elephant
This was an extremely difficult shot. Elephants swim fast. I had to get very close to this one to get the picture. Water is more dense than air, so I had to use a fisheye lens and wait a long time for the right conditions. Because of the refractive qualities of water, I was much closer than it seems in the photo. Safety was paramount, so I had a team of four in the water with me, always mindful of the elephant's fast-kicking legs.

CAMERA: Canon EOS-1Ds MKII
LENS: 15mm fisheye
ISO: 320
APERTURE: f/8
SHUTTER SPEED: 1/60sec
LIGHT CONDITIONS: Underwater, through Subal waterproof camera housing

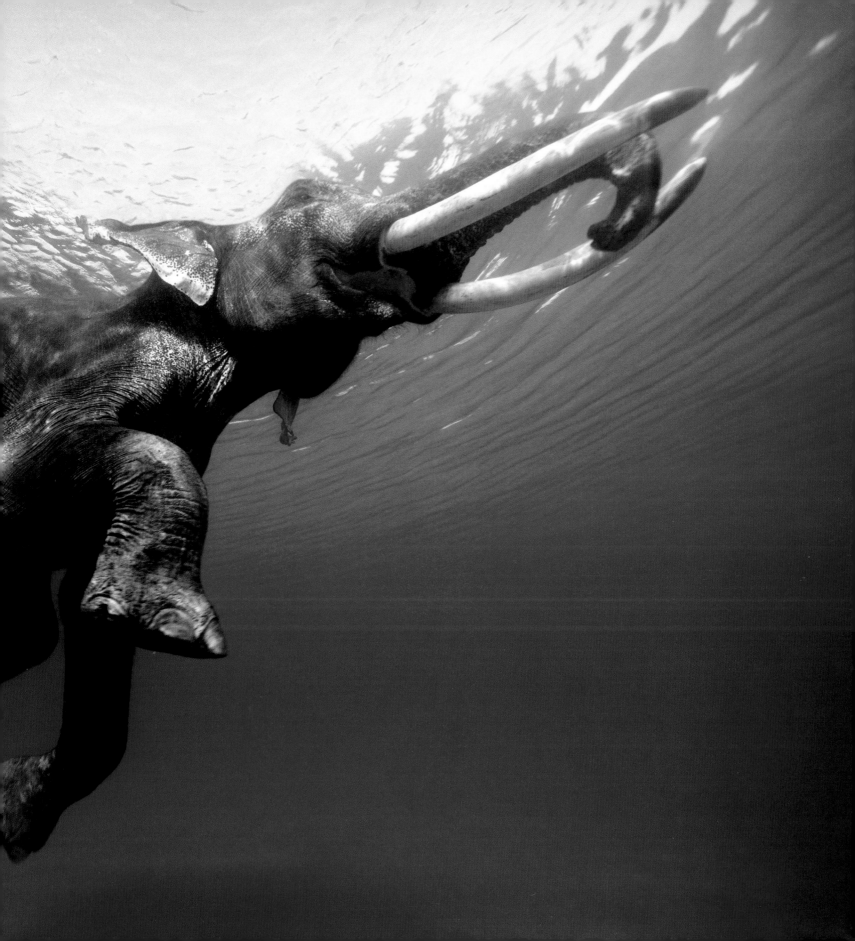

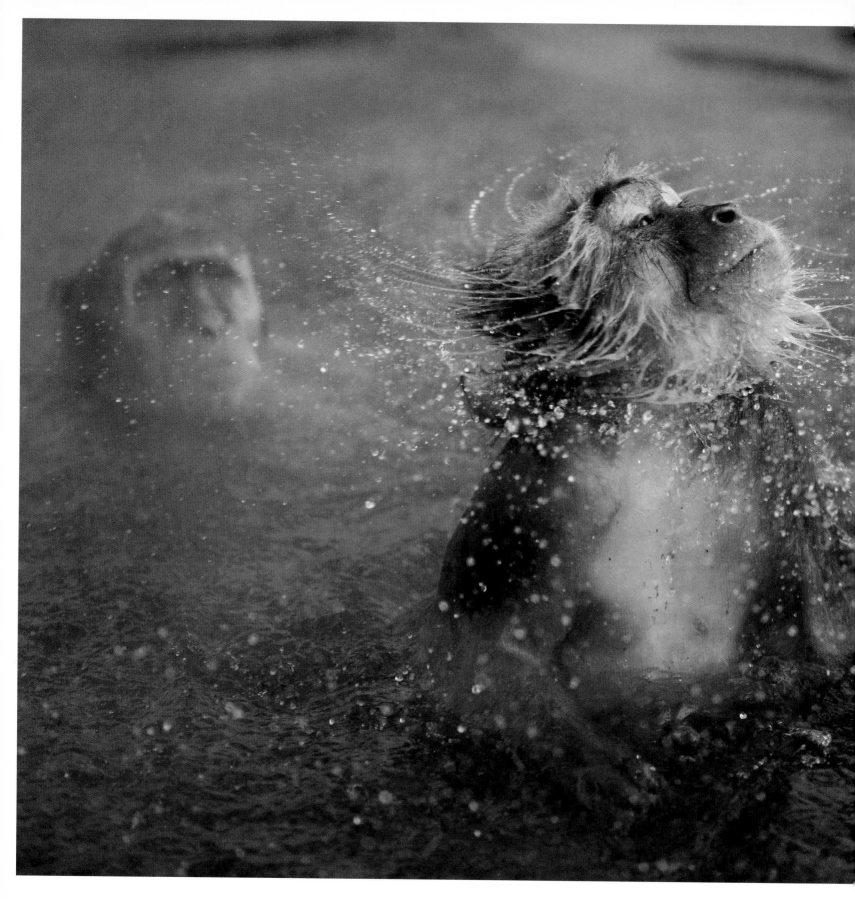

Left: **Snow monkeys bathing**
The famous snow monkeys of Jigokudani National Park in Japan are the only primates besides humans who enjoy a hot bath. Temperatures are sub-zero during the winter months and the Japanese macaques come down from the mountain to the hot springs, where they bathe in scalding-hot water. The steam presents great photographic challenges. An essential tip for subjects in steam is not to over-use flash—sometimes turn the flash off completely—because the steam acts like a mirror, reflecting light from the flash back into the lens.

CAMERA: Canon EOS-1Ds
LENS: 300mm
ISO: 320
APERTURE: f/5.6
SHUTTER SPEED: 1/125 sec
LIGHT CONDITIONS: Overcast with mist

Below: **Elephant and lions drinking**
I was working in Savuti, Botswana, where lions are known to hunt elephants. The night before, a family of lions had killed a young elephant and feasted on the carcass. They were extremely thirsty in the morning but were unable to get to the waterhole, because it was occupied by elephants. At one point all but one elephant moved away, and the lions, desperate for a drink, nervously approached. To get this shot I hand-held the camera and used a 500mm lens with image stabilizer.

CAMERA: Canon EOS-1Ds
LENS: 500mm
ISO: 200
APERTURE: f/5.6
SHUTTER SPEED: 1/125 sec
LIGHT CONDITIONS: Sunny

AS: Is it fair to say, like many successful photographers, that you had a "lucky break" at some stage?

SB: Yes. I came to wildlife photography at exactly the right time. The first stock catalogs were being produced, and if a photographer was featured in one of these, then a viable income was likely. It gave me the confidence to do speculative photography full-time. It's a lot tougher for beginners to climb the ladder now. Photography is a fast-changing medium and it's important to try to keep up with it.

AS: Do you shoot what you want or do others generally define what's required of you?

SB: Generally I shoot what I want, but there's also an element of commercial need. If I'm working on a book I'll seek out situations which will get me the images I need. When I'm on location I also try, for example, to assess whether an image will be good for a calendar or a greetings card.

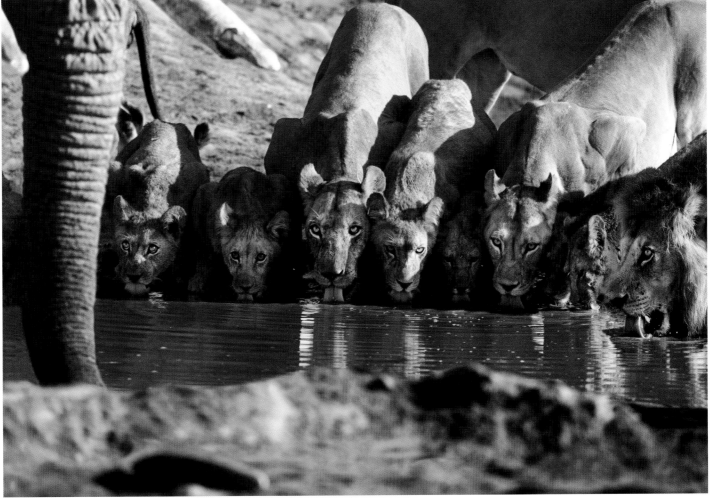

Steve Bloom: Interacting with nature

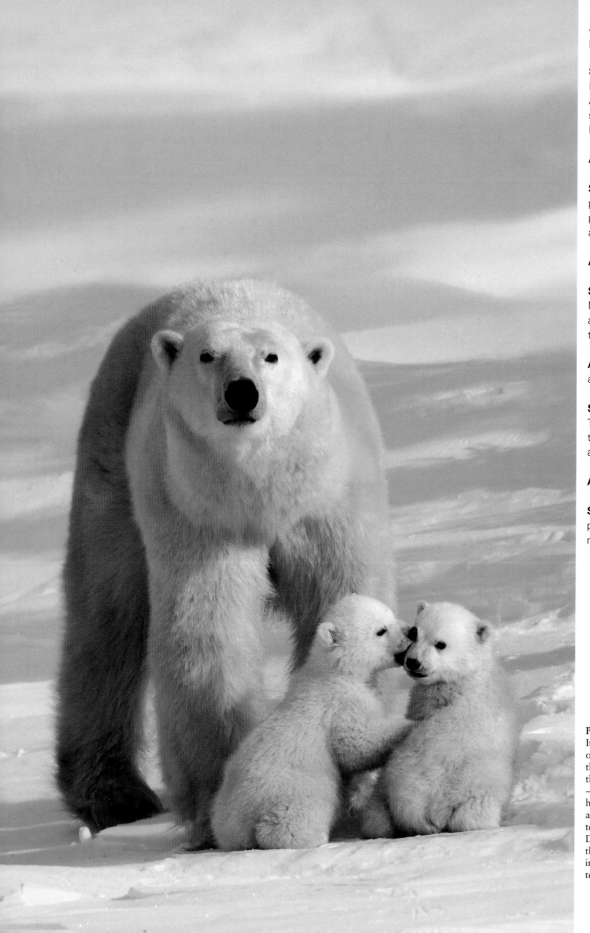

AS: Where are you mostly based? Where are your most popular locations?

SB: I'm based in the UK but my current project means that I'm traveling extensively to many different African countries. All the places I visit are fascinating, but Antarctica was a very special experience, because it's so different to anywhere else I've ever been.

AS: Which country do you like to photograph in the most? Why

SB: The country I'm photographing at the time. If I'm in one place, wishing I was somewhere else, it would be a counter-productive attitude. I'm attracted to anywhere that fills me with a sense of awe.

AS: What things do you enjoy most about your job?

SB: Seeing my books in print, or bringing my exhibitions to citie My Copenhagen exhibition in 2006 had 1.4 million visitors. For anybody who creates anything in the arts, the real pleasure has to be in bringing it to an audience.

AS: From a technical aspect, what are the most difficult things about your photography?

SB: Digital—worrying about data storage, backup, cataloging. Then there's the weight of my equipment. No matter how light the manufacturers try to make it, it always seems to present a problem with air travel!

AS: How would you describe your personal style or technique?

SB: Eye contact is important to me and I try to get it in my pictures. Otherwise I try not to think too analytically about my shooting style and respond instinctively to what I see.

Polar bears

It was –40°C and it had taken our group several days to find the bears, in conditions so cold that at one point it dropped to –50°C. My EOS-1Ds camera had just been released by Canon, and I don't think anybody had tested it in such conditions. Digital worked better for me than film—film becomes brittle in such conditions. Cold temperatures tend to reduce noise on image sensors, so I was able to shoot at a good aperture with a high ISO sensitivity setting.

CAMERA: Canon EOS-1Ds
LENS: 500mm with 2× teleconverter
ISO: 400
APERTURE: f/11
SHUTTER SPEED: 1/30 sec
LIGHT CONDITIONS: Bright with ice and snow

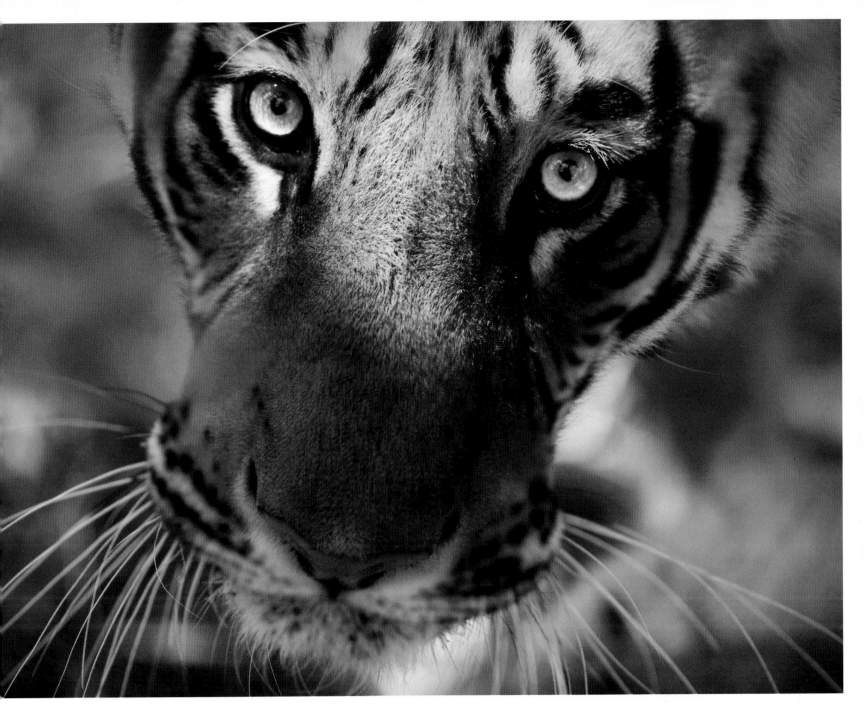

Bengal tiger

There are said to be more tigers in captivity than the wild, so I set out to capture the expression of a wild tiger. I spent about two weeks in India's Bandhavgarh National Park but sightings were rare, and often distant. I was on elephant-back and as we passed a sleeping tiger, we startled her. She looked up towards the camera giving me just enough time to capture a couple of frames before she moved off into the bush. For a brief moment she looked straight into the lens, revealing the powerful, yet poignant expression in her eyes.

CAMERA: Canon EOS-1Ds
LENS: 70–200mm
ISO: 400
APERTURE: f/5.6
SHUTTER SPEED: 1/125 sec
LIGHT CONDITIONS: Sunny

Steve Bloom: Interacting with nature

AS: What's in your kit bag? Which camera system do you use and why?

SB: I've used Canon all along, and I try to keep up to date with the latest high resolution digital cameras. My current SLR is an EOS-1Ds MKII and my lenses range from 15mm fisheye to 500mm. My 70–200mm f/2.8 Canon lens has a very versatile zoom, with fabulous optics. With distant wildlife I prefer the 500mm lens.

AS: Do you try to make sure your work appeals to the widest possible audience?

AS: To an extent, but I primarily try to take pictures I feel good about, and hopefully the rest follows. I like experimenting a lot with techniques, such as motion blur.

AS: When are the busiest times of the year for you?

SB: My work on life in Africa is taking up much of my time right now: visiting remote tribes, seeking out the most dynamic wildlife locations, or going down the gold mines. When I'm not shooting I'm working with our team in the office, preparing exhibitions. Recently we had five giant outdoor events running in different city-center locations, at the same time. Visiting them all took up a lot of time.

AS: Which places do you dislike traveling to?

SB: Places with extreme climates: I hate being too cold or too hot. Having grown up in Africa I generally prefer to be hot, not cold. The heat can make me lethargic, however, which makes photography more difficult. And I don't like insects that bite.

AS: What types of pictures do you find the most difficult to take?

SB: Animals in zoos. They look bored and frustrated. And of course if I go somewhere and there isn't much wildlife around, it can be very frustrating.

AS: Which do you prefer—digital or film—and why?

SB: Digital. Anybody who is used to carrying 300 rolls of film onto an airplane will welcome CompactFlash cards. The ability to review images immediately is a big bonus, as it allows photographers to make important, creative decisions while on location.

AS: How much of your work do you manipulate using imaging software?

SB: I do use it in my work. Ansel Adams' analogy—likening the negative to a musical score, and the print to the performance—holds true in the digital age, too.

SB: What have been your greatest photographic achievements?

SB: Two things: having coffee-table books published in several languages and the big exhibitions. Bringing my work to so many people is greatly rewarding.

AS: What does the future hold for you?

SB: If only I knew—I've had many experiences and I'm driven to have many more.

Left: **Surma tribeswoman**
The women of the Surma tribe live in a remote and inaccessible part of Ethiopia. They stretch their lips as part of tribal traditions and the practice is said to date back to the days of slavery, when the women performed the act in order to repel slave traders. This has, however, recently become one of those legends viewed with skepticism by some historians.

CAMERA: Canon EOS-1Ds MK
LENS: 70–200mm
ISO: 200
APERTURE: f/11
SHUTTER SPEED: 1/30 sec
LIGHT CONDITIONS: Sunny

Right: **Samburu tribesman**
Every seven years boys in this Samburu village in Kenya are circumcised in one ceremony. I was there to photograph the village, and as part of the ceremony the adults perform traditional dances in which they jump as high as they can. It was an ideal scenario for a slow shutter speed, so I made sure I moved the camera up and down, in time with the man who was jumping, so that the background would blur and emphasize movement.

CAMERA: Canon EOS-1Ds MK
LENS: 70–200mm with ND filte
ISO: 50
APERTURE: f/16
SHUTTER SPEED: 1/8 sec
LIGHT CONDITIONS: Bright

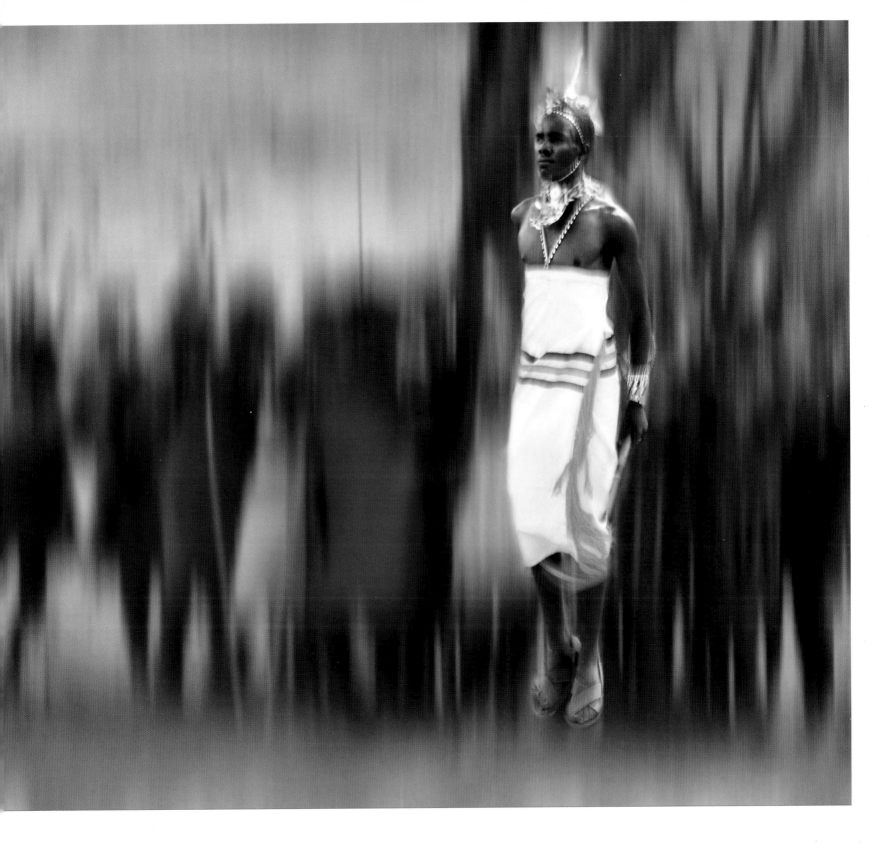

Steve Bloom: Interacting with nature

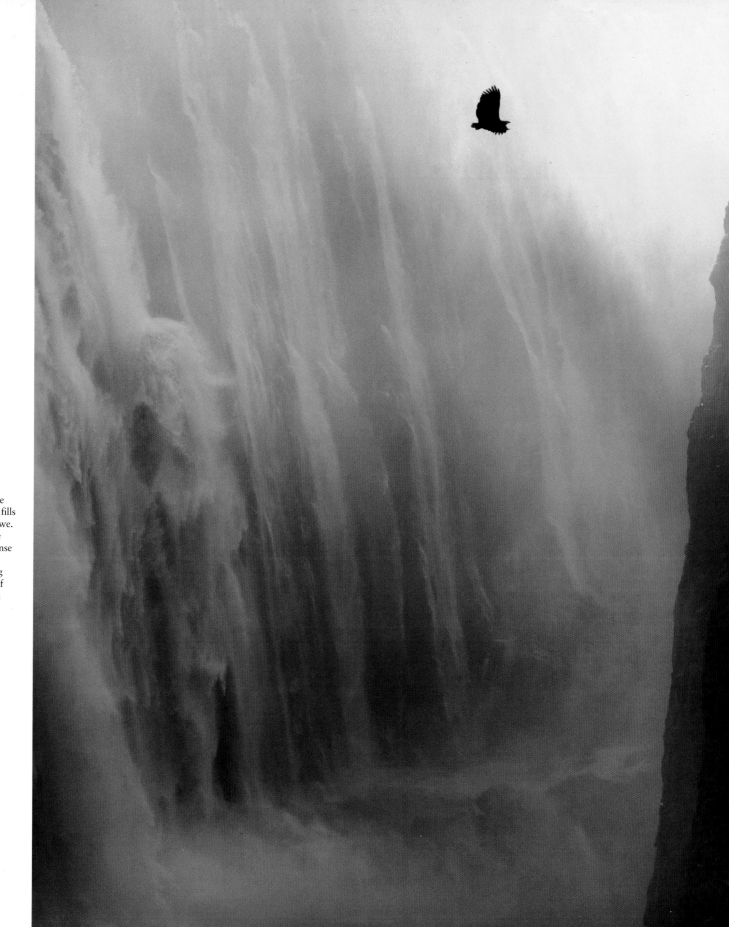

Fish eagle in flight
Victoria Falls is one of the great symbols of Africa, one of those magical places that fills the visitor with a sense of awe. The fish eagle flew into the frame, giving the image a sense of scale. It was a beautiful morning and I was standing dangerously near the edge of the cliff. As a sufferer from vertigo I was relieved when I had taken the picture.

CAMERA: Canon EOS-1Ds
LENS: 70–200mm
ISO: 200
APERTURE: f/8
SHUTTER SPEED: 1/60 sec
LIGHT CONDITIONS: Sunny with mist

Tips for Success

1. Improvise with equipment
Beanbags, or a small pillow filled with beans on a car window ledge, makes an ideal tripod when shooting from a vehicle.

2. Think about height
Shoot from a high vehicle when photographing animals far away, and take the longest lenses you can.

3. Pack spare batteries
Always carry plenty of spare batteries in case electricity supplies are disrupted, and charging the batteries is not possible. In cold climates keep your batteries warm, wrapped against your body. They will be more durable and you will have more power.

4. Keep a low profile in the wild
You are in the animals' territories and you must behave with respect. A stressed animal is not a good subject to photograph. If you want to capture their personalities it is important to ensure they are relaxed in your presence.

5. Many pockets are useful
Wear a photographer's vest with plenty of pockets.

6. Carry as many lenses as possible
You never know when you might need a particular lens. You might be photographing lions in the distance and notice that the landscape is spectacular—in which case a wide-angle lens will give you the best possible shot.

7. Shoot from the heart
Master your technique so that the camera becomes a subconscious extension of your feelings. Treat the camera and subject in the way you would treat a musical instrument, and keep looking for visual harmony.

8. Transport the basics—it's essential
Carry spare underwear, a warm fleece and your essential, basic photography kit in your airline hand luggage. You never know when you may be diverted to a different destination, or lose your checked-in baggage.

9. Try to be different
Put your personal slant on the picture. Experiment freely and discover unique ways of capturing your surroundings.

10. Protect your gear from dust
In dusty conditions place a towel over the cameras and lenses. They will be ready for easy access while being kept relatively dust-free.

Steve Bloom: Interacting with nature

Leopard walking

Use of slow shutter speeds is a hit-and-miss affair but it worked for this picture. It was fairly late, the light was low, and under normal circumstances it would have been impossible to get a decent picture. So I used an image stabilizer lens in the panning mode and followed the leopard, making sure I was watching her eye all the time, while keeping the camera steadily focused on her head.

Specification

CAMERA: Canon EOS-1N

LENS: 300mm with image stabilizer

FILM: Fuji Velvia 100

APERTURE: f/4

SHUTTER SPEED: 1/125 sec

LIGHT CONDITIONS: Late evening light

Essential Equipment

- Two 35mm Canon EOS-1Ds MKII camera bodies

- Canon 400D camera body, as backup

- 15mm f/2.8 fisheye lens

- 16–35mm f/2.8 lens

- 24–70mm f/2.8 lens

- 70–200mm f/2.8 lens

- Selection of ND filters

- 1.4× teleconverter

- Lens hoods for all lenses

- Spare lithium-ion batteries

- Canon 580-EX flashgun

- 10 8GB CF cards

- Laptop computer

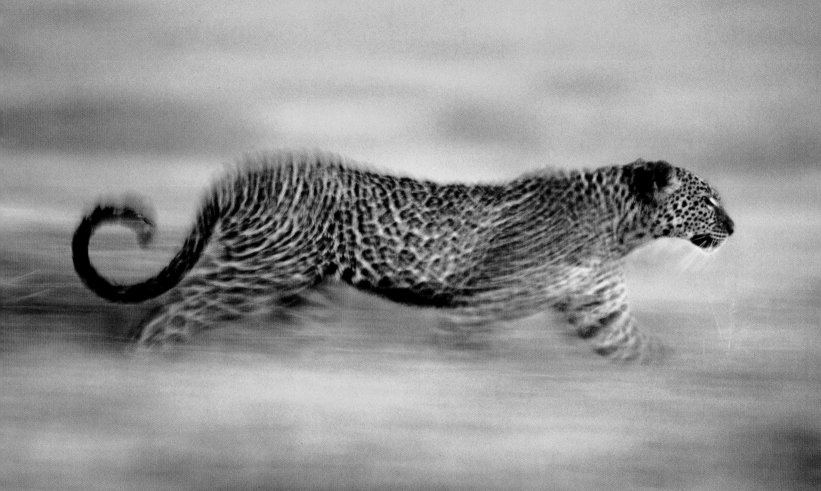

Chris Caldicott

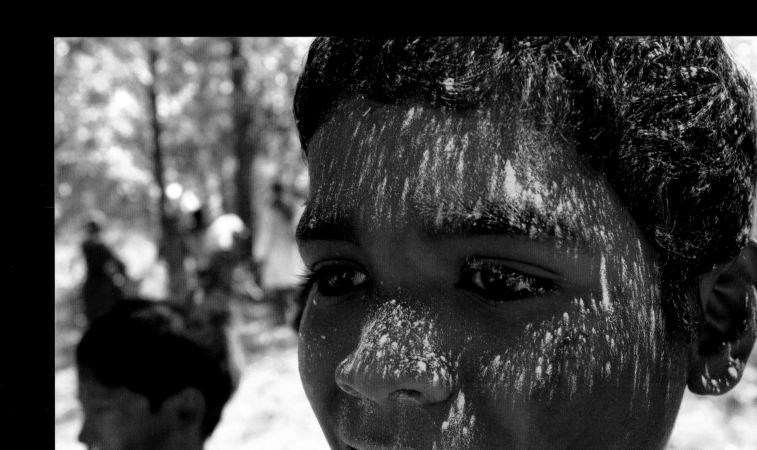

Otherworldly atmospheres

Make-up for the Holi festival
The start of spring in India
is celebrated in a blaze of color,
with the festival of Holi. People
take the day off and sprinkle
each other with brightly colored
powders and water in a ritual
known as playing Holi. I was
staying at a jungle lodge in
a wildlife park in the heart of
central India and I spent the day
exploring the local villages by
bicycle. I came across this boy
and liked the way the morning
sun caught the powders on his
face. I used a narrow depth of
field so I could isolate the figure
from the background.

CAMERA: Canon EOS-1Ds
LENS: 17–40mm
ISO: 100
APERTURE: f/3.5
SHUTTER SPEED: 1/500 sec
LIGHT CONDITIONS: Soft
morning sunlight

The entrance to Chris Caldicott's North London home is cluttered with cultural artifacts, accumulated through years of travel. It's apparent that he's seen and photographed much of the world. The color-blind Briton's career as a travel specialist began in the late 1970s, at the age of 21. He'd obtained a degree in photographic arts from the Central London School of Communication—the only prestigious institution of its kind in Europe at that time. "I went straight from college to see the world and I just photographed everything I saw!" he remembers enthusiastically. "I liked to travel on my own for long periods— three to six months at a time—going to different places. I'd go to India for six months and then decide I wanted to delve into South America."

Nowadays he's no less adventurous. His vocation as one of the world's leading travel photographers still takes him all over the globe, chasing the best landmarks, the most colorful faces, and the most challenging picture opportunities.

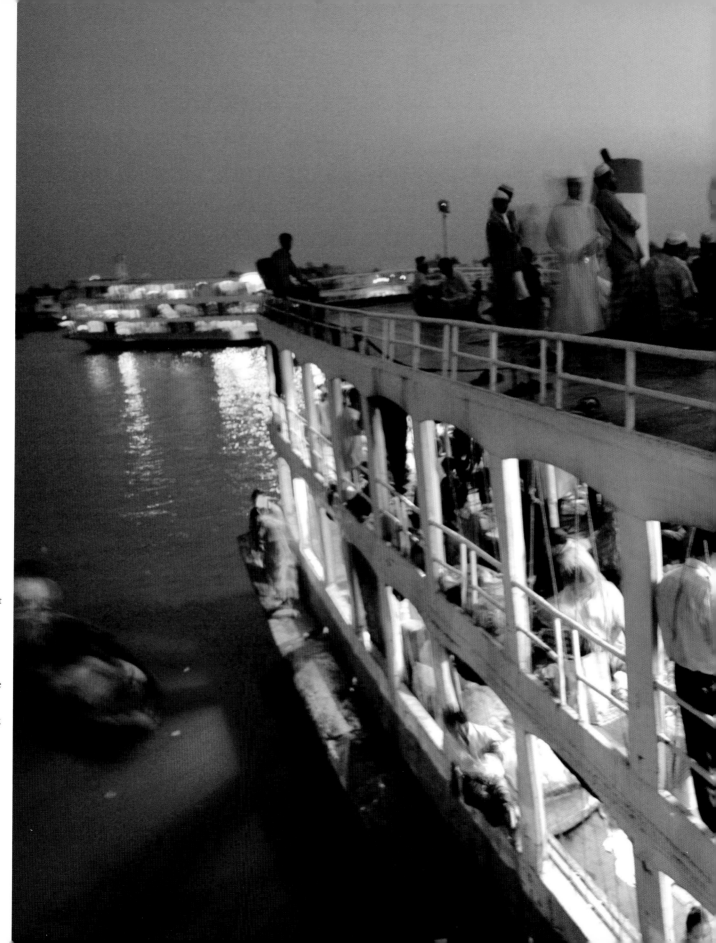

Men at prayer on a river ferry
Southern Bangladesh is a land of hundreds of rivers. Almost everybody travels everywhere by boat. Sadarghat is the main ferry terminal in the capital, Dhaka. All through the day and night river ferries crowded with passengers arrive and depart. I was on board one of the 'rocket paddle steamers' about to set off on a two-day journey, down to the Sunderbans jungle in the far south. The boat next to us was also slowly filling up with passengers. When the call to prayer was issued from a mosque on the riverbank, most of the men went up on the roof to face Mecca and pray. The same thing was happening on every boat in the dock. It was almost dark so I shot at a slow shutter speed on a tripod to give a good sense of movement in the scene.

CAMERA: Canon EOS-1Ds
LENS: 17–40mm
ISO: 200
APERTURE: f/4
SHUTTER SPEED: 1/15 sec
LIGHT CONDITIONS: Almost dark with neon lights on lower decks

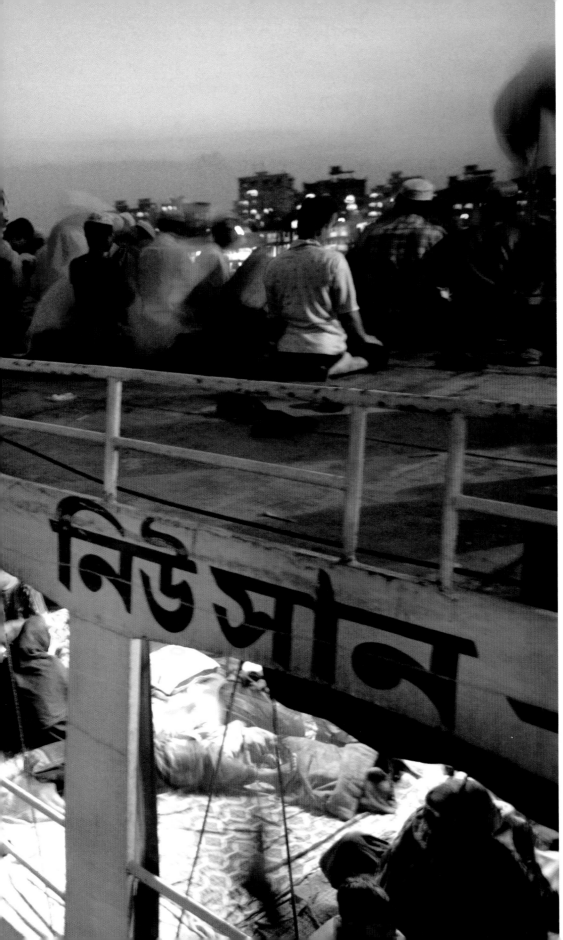

AS: What was your first ever camera?

CC: A Box Brownie 127. It was a birthday present from my parents when I was a child and I loved it. I took most of my first photographs on family holidays, so in a way that's how my travel photography began. Learning to take photographs on a Box Brownie probably gave me a better introduction to the basics of photography than any instamatic camera would have done. My first SLR was a Pentax ME Super.

AS: Where do your ideas for innovative pictures come from?

CC: A desire to produce evocative images of the extraordinary beauty and diversity of the world. I grew up in a relatively bland, predictable environment; when I started to travel I discovered a whole new world that no one had told me about. I try to take photographs that capture this and I hope they might inspire others to venture into the unknown.

AS: Why did you decide not to do other types of photography, such as fashion or studio work, for example?

CC: I found working on my own, out and about on location projects, far more appealing than the rather claustrophobic experience of working in a studio, or working in a team. My first proper job was as an assistant for a studio photographer and I soon found shooting shoe catalogs far too dull. I left and took a job as a long-distance truck driver. This gave me the chance to buy my own equipment and shoot my own work, as I delivered antiques around Europe. As soon as I had saved enough, I set off to travel the world and I have been doing so ever since.

AS: Is it fair to say, like many successful photographers, that you had a "lucky break" at some stage?

CC: Most definitely. After years of self-financed travel, I was offered a chance to exhibit my work for the Royal Geographical Society. The RGS was just about to embark on a major expedition to the Amazon rainforest in Brazil and, by chance while my exhibition was on, the photographer they had signed up for the trip dropped out. They offered me the job. On my return they were pleased enough with the results to offer me a position as expedition photographer-in-residence.

Chris Caldicott: Otherworldly atmospheres

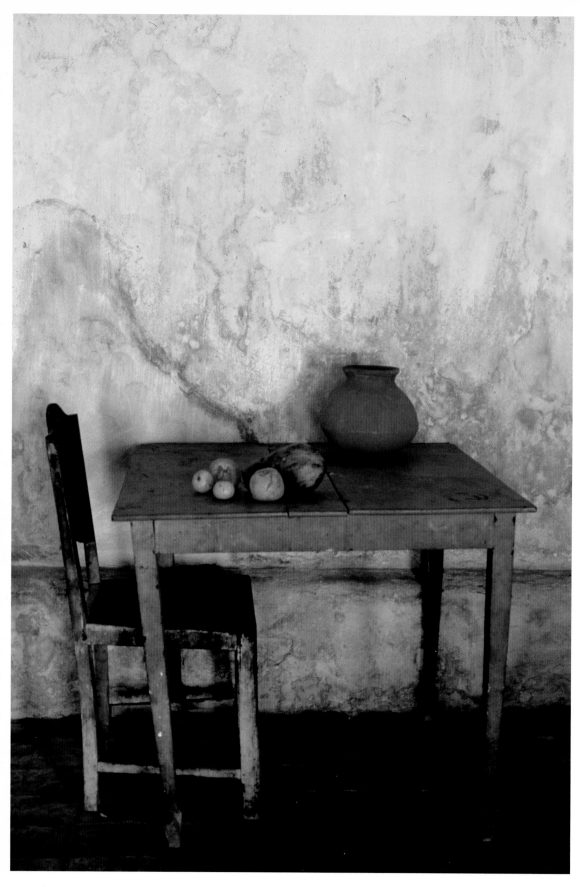

AS: Do you shoot what you want or do others generally define what's required of you?

CC: It's a bit of a mix. While I was working for the RGS I spent a lot of time photographing scientists at work, which wasn't particularly visually exciting, so I got into the habit of getting up at dawn and going off on my own to shoot landscapes and the lives of local people. I still do this everywhere I go and whatever sort of commission I'm working on, so even if I'm shooting to someone else's agenda, I shoot my own images on the same trip, and I use these in my own books and to supply stock libraries.

AS: Where are you mostly based? Where are your most popular locations?

CC: I live in London where most of the newspapers, magazines, publishers, agencies, and PR companies I work for are based. However, I spend much more time away from the city than in it. Most of my work is on long-haul location shoots in Asia, Africa, and islands of the Caribbean, South Pacific, and Indian Ocean.

AS: Which country do you like to photograph in the most? Why?

CC: It has to be India. I'm lucky enough to have been there over 50 times. I find the extraordinarily eclectic variety of exotic landscapes, people, architecture, animals, and details an endless source of inspiration.

Table and chair

I once rented a house in India and spent several months living in a small seaside town called Gopalpur-on-Sea, on the Bay of Bengal coast of Orissa. I had a huge backlog of articles waiting to be written and thought I would get through them faster there than in London, where life is so full of distractions. The house, which had once been an elegant colonial villa, was a bit run down, but it was a wonderful experience living there. On my last day I was packing to leave and put out some fruit to take for the journey. I took one last shot of the table and chair that I had sat at while writing.

CAMERA: Pentax 645 SLR
LENS: 80mm
FILM: Fuji Velvia
ISO: 50
APERTURE: f/5.6
SHUTTER SPEED: 1/60 sec
LIGHT CONDITIONS: Daylight through open windows

Bhangarh, Rajasthan

The deserted city of Bhangarh is one of India's least known architectural treasures. This once magnificent metropolis of bazaars, palaces, gardens, and temples was deserted overnight 500 years ago when a court magician deemed it to be cursed. Despite years of abandonment it is remarkably well preserved. A restoration project was in full swing when I was there and these women were carrying tins of water from the river up to the top of the hill, where the brickwork of the palace ramparts was being rebuilt. The arches above them mirror their shapes.

CAMERA: Canon EOS-1Ds
LENS: 100–400mm
ISO: 100
APERTURE: f/11
SHUTTER SPEED: 1/250 sec
LIGHT CONDITIONS: Hazy sunshine

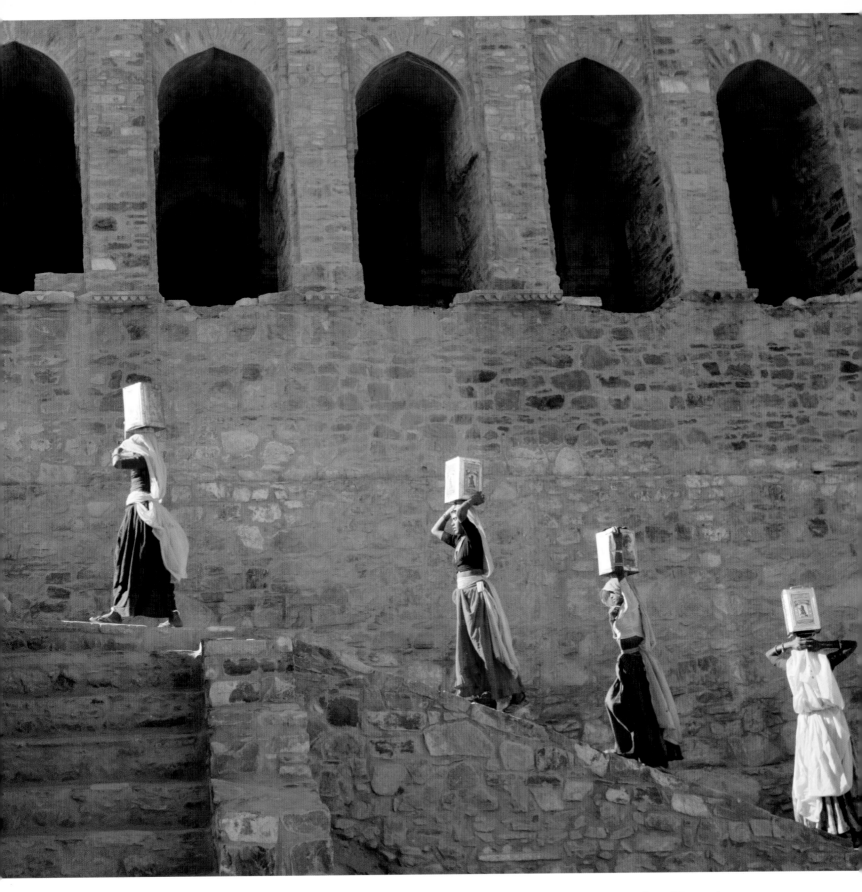

Chris Caldicott: Otherworldly atmospheres

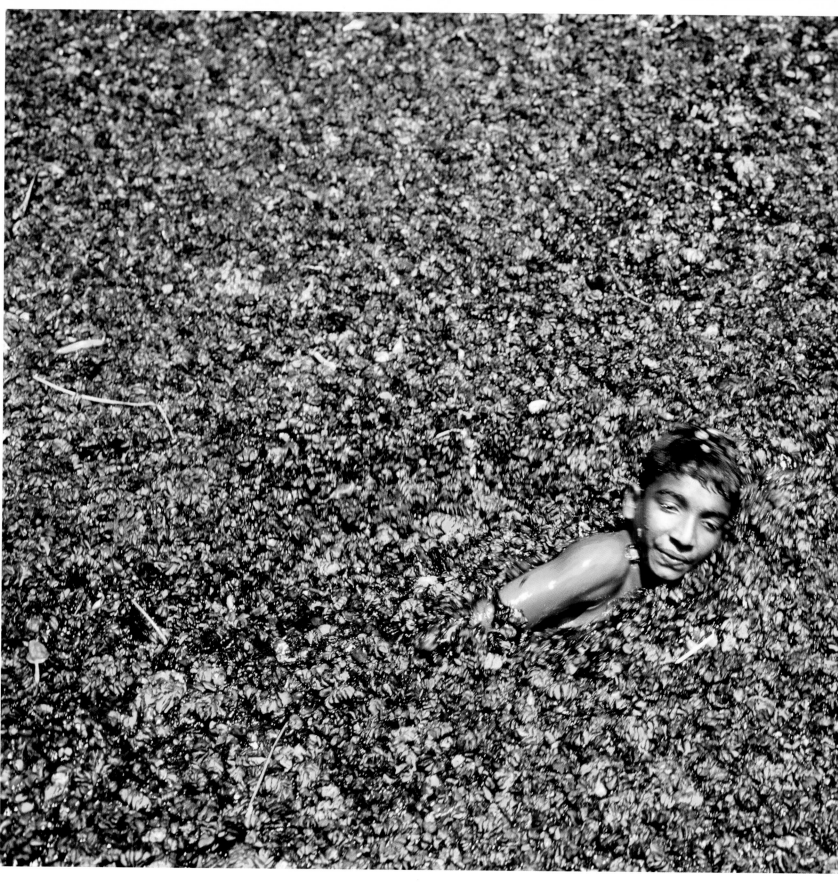

AS: What things do you enjoy most about your job?

CC: The opportunity to travel in places I have never been to before. My passion for travel never fades and I relish every trip. I also love good food and sunshine.

AS: From a technical aspect, what are the most difficult things about your photography?

CC: Getting the exposure right when shooting with film. Strong tropical sunshine can be a nightmare when shooting white, sandy beaches and people. Lighting is also tricky on interior shoots that usually require lots of Polaroids and adjustment of light. On digital shoots my biggest problem is keeping the sensor clean. Changing lenses outdoors on location is asking for trouble—just one speck of dust can mean hours of image cleaning.

AS: How would you describe your personal style or technique of photography?

CC: To try to capture the otherworldly atmosphere of the places I visit. I am color-blind so many of my photographs feature very vivid colors that are the only ones I can see.

Kerala boy swimming
The small backwater canals of Kerala get choked every year by water hyacinth. When the flowers die off the sun bakes the remaining vegetation into a thick layer of rotting matter that floats on the surface. Despite this, local boys still swim across the canals as a way of getting around. I was on a boat that was slowly trying to fight its way through the weeds when this boy swam past. It was a surreal sight as the water is completely hidden.

CAMERA: Mamiya 645 AFD
LENS: 80mm
FILM: Fuji Velvia
ISO: 50
APERTURE: f/8
SHUTTER SPEED: 1/125 sec
LIGHT CONDITIONS: Sunshine and clear sky

Chris Caldicott: Otherworldly atmospheres

AS: What's in your kit bag? Which camera system do you use and why?

CC: The camera I use most is a Cannon EOS-1Ds, which takes simultaneous RAW and JPEG versions of each image. JPEGs are perfect for emailing direct to clients, and the RAWs for converting to TIFFs, to send to stock libraries when I return home. This camera has a full-screen sensor and it takes sensational wide-angle shots at 17mm; I use this setting most of the time for landscape and interior shots. I use the 50mm macro lens for all my food photography and most portraits. On safari, for most shots, I use my 100–400mm zoom at maximum aperture. The built-in image stabilizer means I can get away without a tripod in good light. On the rare occasions I'm asked to shoot film, I use a Mamiya 645 AFD, with a variety of film backs, and Mamiya fixed focal-length lenses, comprising 35mm, 45mm, 55mm, 80mm, 120mm, and 200mm.

AS: Do you try to make sure your work appeals to the widest possible audience?

CC: Yes—by combining good composition with interesting lighting and visually exciting subject matter, I hope to inspire a "wow" factor in anyone who sees my work.

Nepal elephant and ranger/rider
The tigers and rhinos of Chitwan Park in Nepal are under constant threat from poachers. To help protect them the park is patrolled at night by rangers on elephant-back. This ranger was on his way home at dawn; I was also riding an elephant and we passed each other in the middle of the river that forms the boundary of the park. The rising sun was obscured by clouds of thick morning mist that hung eerily over the river and jungle on its banks, which created a very atmospheric effect. As the light was low I had to shoot at a much slower shutter speed than I would normally choose, while taking shots from the top of a moving elephant. Using a tripod was impossible. This was the only image from a series of six that came out sharp enough to use.

CAMERA: Mamiya 645 AFD
LENS: 35mm
FILM: Fuji Provia
ISO: 100
APERTURE: f/4
SHUTTER SPEED: 1/30 sec
LIGHT CONDITIONS: Sunlight diffused through heavy mist

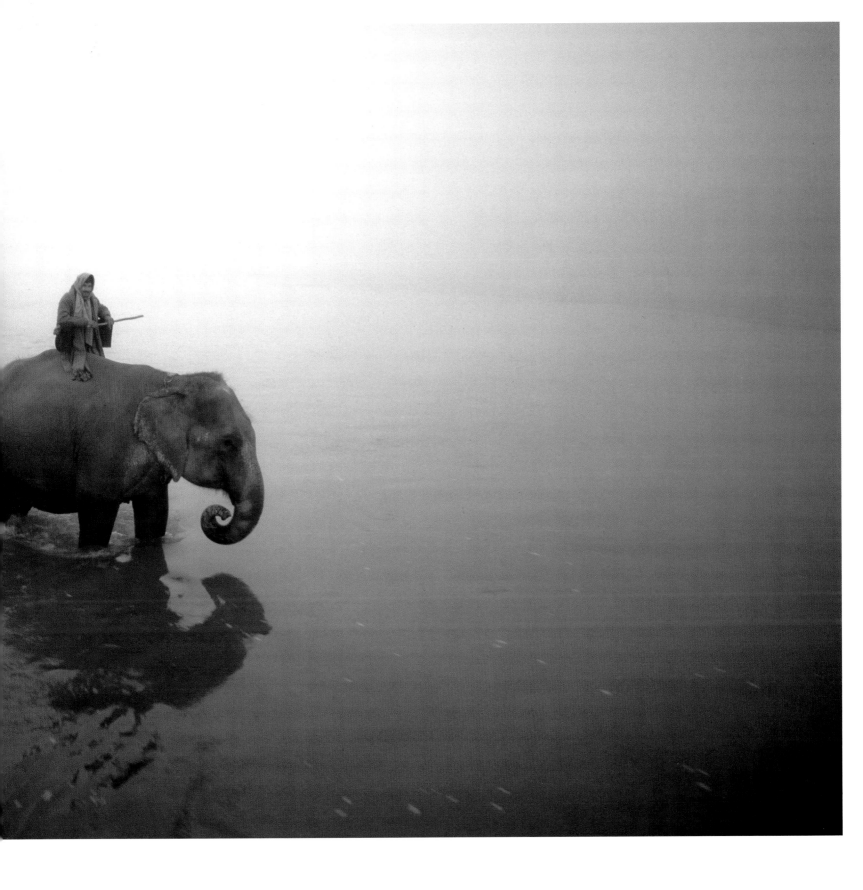

Chris Caldicott: Otherworldly atmospheres

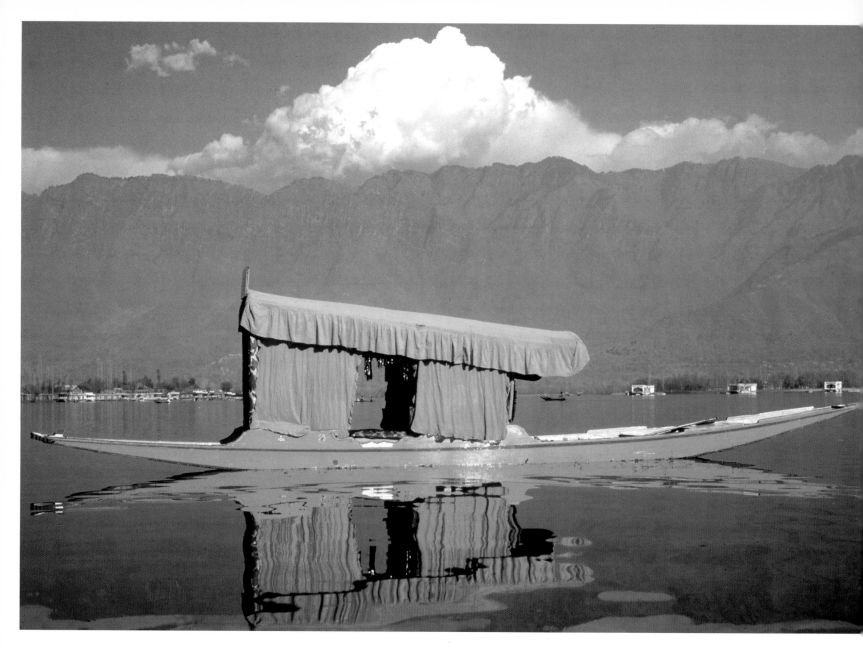

Dal Lake, Kashmir

I had an accident while trekking in the Indian Himalayas that left me unable to walk for several weeks. I spent this time being looked after by a local Kashmiri family on board a houseboat on Dal Lake in Shrinagar. They lent me their canoe so I could paddle myself around each day and take photographs of the lake. Early one morning I came across this bright yellow shikara, a water-taxi. The sun had just risen over the mountains and the shikara was bathed in direct sunlight, but still soft enough not to blast out the background of the image. The white cloud mimics the shape of the shikara and the water is so calm it makes an almost perfect reflection.

CAMERA: Pentax 645 SLR
LENS: 35mm
FILM: Fuji Velvia
ISO: 50
APERTURE: f/11
SHUTTER SPEED: 1/320 sec
LIGHT CONDITIONS: Strong morning sunlight and clear sky

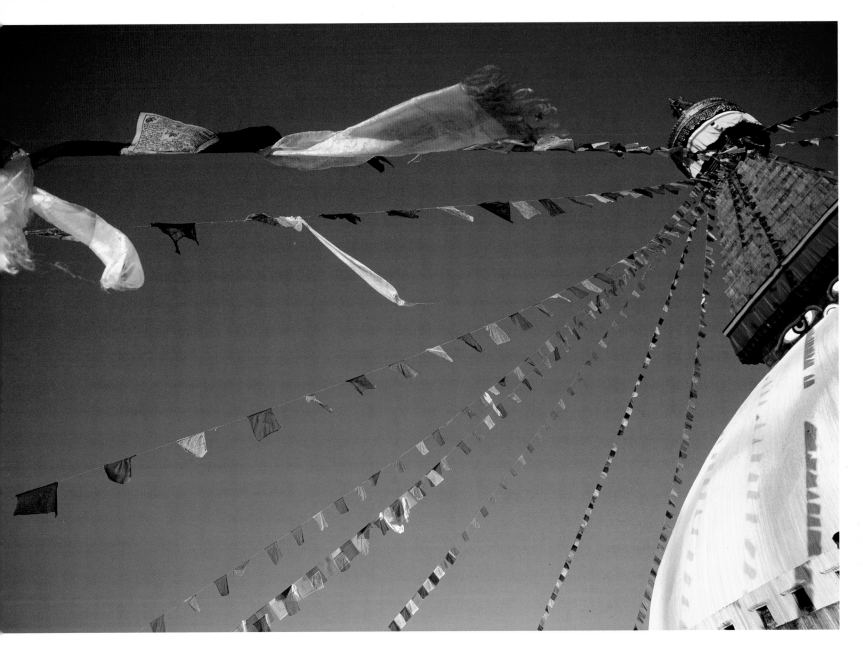

me of Buddhist stupa

is massive stupa at Bodhnath
ne of the holiest sites in the
thmandu Valley, in Nepal.
pali Buddhists and Tibetan
les travel from mountain
ages on pilgrimages to visit
site. They gain merit by
lking around the giant dome,
iting mantras and prostrating

themselves in reverence.
On top of the dome there are
four sets of 'all-seeing eyes,'
while all around it colorful
prayer flags flutter in the wind.
The rarefied air at this altitude
creates a deep blue sky that
provides a dramatic contrast
to the colors of the flags.

CAMERA: Mamiya 645 AFD
LENS: 35mm
FILM: Fuji Velvia
ISO: 50
APERTURE: f/16
SHUTTER SPEED: 1/400 sec
LIGHT CONDITIONS: Sunshine
and blue sky

Chris Caldicott: Otherworldly atmospheres

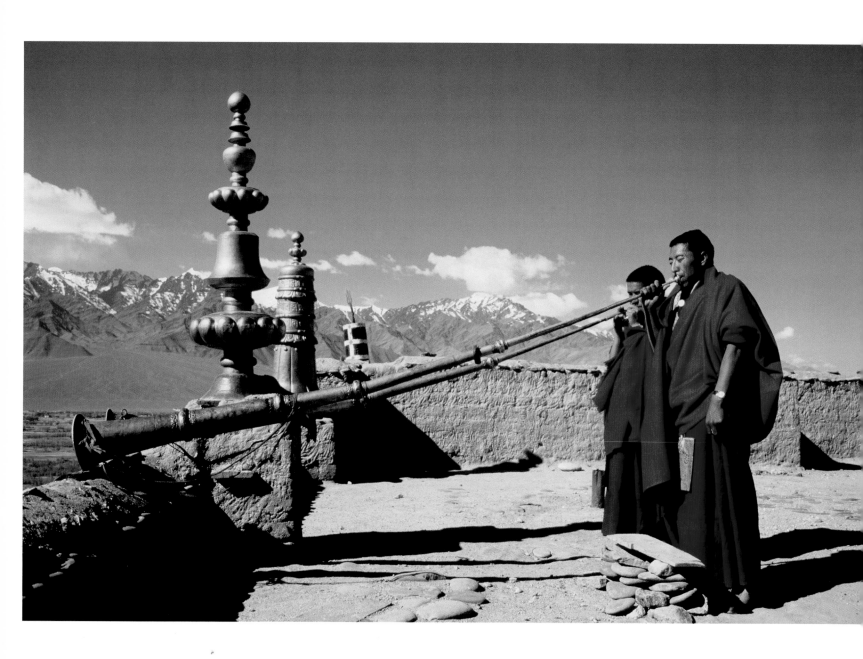

ddhist monks at Tiske
nastery, Ladakh
announce the start of the
ual mask dance festival at
se monastery in Ladakh,
lia, monks blow into these
ormous brass horns. The deep
nble echoes all around the
ley, and, as the air is so thin
his altitude, sound travels
reat distance. I could hear the
ns long before I arrived at
monastery. As soon as I did,
imbed up on the roof to take
s picture. I love the contrast
the monks' red robes against
blue sky. It's a very colorful
d photogenic event with
eductively timeless feel.

MERA: Pentax 645 SLR
s: 35mm
M: Fuji Provia
: 100
ERTURE: f/11
JTTER SPEED: 1/250 sec
HT CONDITIONS: Bright
nshine and clear sky

AS: When are the busiest times of the year for you?

CC: I work almost non-stop from September to May and these times tend to be the best seasons for shooting in the long-haul locations where I undertake most commissions. I try to only take short commissions in the UK and Europe during the summer months, to take advantage of the long daylight, while spending time in between editing images.

AS: Which places do you dislike traveling to?

CC: Rural China used to be a bit rough in terms of food, comfort, and hospitality, but it has become much easier, and the beauty of the landscapes always made up for the physical discomforts. The only place I am reluctant to travel to nowadays is the USA. The immigration and security in airports is very tiresome.

AS: What types of pictures do you find the most difficult to take?

CC: I still find wildlife photography difficult because there are so many elements I have no control over. Dedicated wildlife photographers often spend weeks waiting for the perfect shot, and some clients expect similar results from just a couple of days in the back of a jeep on a tourist safari.

AS: Which do you prefer—digital or film—and why?

CC: I want to say film because I grew up with it—if you get everything right on film the results are better than on digital. However, on a practical level, shooting digital makes life easier in many ways. As a location photographer, traveling with less kit and no film is a huge advantage, as is being able to instantly review images. Digital is also much more forgiving, because any slight error in exposure or composition can be easily corrected with a computer.

AS: How much of your work do you manipulate using imaging software?

CC: Most digital images can be improved with a few tweaks, particularly landscape shots that almost always need a bit of manipulation to improve contrast and saturation. The trick is knowing when to stop.

AS: What have been your greatest photographic achievements?

CC: I have co-authored three books with my wife, two comprising recipes we have collected on our travels, and one about the spice routes, all of them lavishly illustrated with my photographs. Having the opportunity to choose your own images and how to use them is much more satisfying than having to leave it to a picture editor.

AS: What does the future hold for you?

CC: My wife and I are about to start selecting photographs and writing for our next book of recipes from all the new places we have traveled to since our last book. Every commission in which I get to write and shoot travel pieces provides a chance to gather material for more books.

Chris Caldicott: Otherworldly atmospheres

Hill country, Sri Lanka
On the way to Adam's Peak, one of the highest mountains in Sri Lanka, I drove through the spectacular scenery of the Sri Lankan hill country. Just before sunset I stopped the car to admire this view. The sky was overcast so there is no direct sunlight in the shot, but the river reflects the brightness of the sky, keeping the composition balanced. The light was fading fast and I wanted maximum depth of field, so I had to use a slow shutter speed and tripod. The banana leaves in the foreground were moving in the breeze, so they are a little soft, but the rest of the landscape is sharp.

CAMERA: Pentax 645 SLR
LENS: 35 mm
FILM: Fuji Velvia
ISO: 50
APERTURE: f/11
SHUTTER SPEED: 1/30 sec
LIGHT CONDITIONS: Overcast with fading light

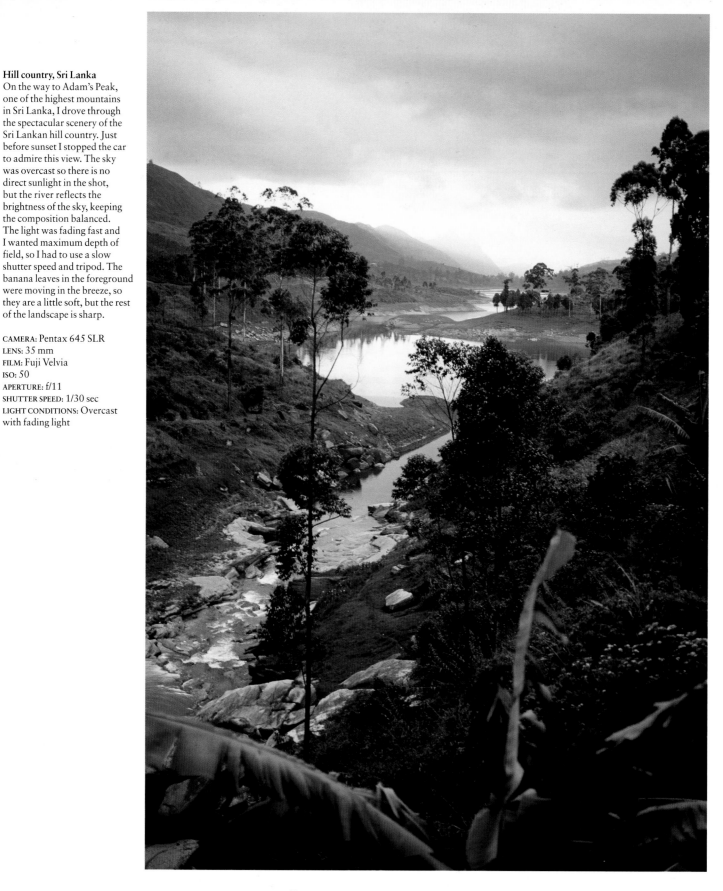

Tips for Success

1. Research your location
Read magazines, guidebooks, coffee-table books, and websites that cover the places you're going to visit. Photo library websites are especially useful to get an idea of saleable images of any location. Take advantage of the work others have done to find the best ways of capturing evocative images.

2. Get up early
However unappealing it seems, always make the effort to get up before dawn and be out and about as the sun rises, especially in the more touristy destinations of the world like Venice or the pyramids. The benefits of having any location to yourself will more than compensate for an early start, and for me, early morning light is the best for photography.

3. Shake hands
If you want to photograph people in exotic lands where you might not speak the language or understand the culture, try to introduce yourself with a handshake and a smile. In some places it can be easy to cause offence by taking photographs of people without asking, yet it can be just as easy to make friends and get great shots.

4. Hire local help
Hiring guides or drivers to take you around places you don't know can be invaluable. Not only will they show you things you might have missed, they can also act as translators and negotiators for you when you want to photograph local people.

5. Look for detail
Keep an eye out for interesting details wherever you go. Sometimes close-ups of simple and seemingly banal everyday things, such as doorways, light switches, and

6. Find a hiding place
Photographs of people sometimes work best when they're unaware they are being photographed, so when shooting crowded scenes in cities, markets, and festivals, try to merge into the background and not be noticed.

7. Think about the end result
Take time to choose subjects that will make good pictures and compose with care through the lens before taking them. Think about the things you see in the camera viewfinder and how they may work as a finished product, rather than wasting storage space and editing time.

8. Always carry a tripod
However tempted you might be to set off on a day's shoot without a tripod, don't. Many perfect photo opportunities have been missed for want of a tripod.

9. Take a spare camera body
If your main camera body is lost, stolen, or damaged, at least your trip won't be ruined.

10. Always use a lens filter for sunsets
Even the most stunning sunset is hard to capture in a photograph. Using a sunset filter is cheating, however, this is one occasion when it can be justified. The end result will be more like the sunset you see than the one the camera records.

Workshop

Taj Mahal reflection

The Taj Mahal is the most photographed building in India and trying to find a new way of shooting it is a bit of a challenge. I had been to photograph it numerous times, and on this occasion the fountains had been turned off and the water in the channel that leads up to the mausoleum was so still it made a perfect reflection. I turned my camera upside down and shot just the reflection. The morning sun in a partly overcast sky created a very sympathetic light. I realize I could have just taken the photograph with the camera the right way up and inverted the image, but somehow that would feel like cheating.

Specification

CAMERA: Mamiya 645 AFD

LENS: 35mm

FILM: Fuji Provia

ISO: 100

APERTURE: f/8

SHUTTER SPEED: 1/125 sec

LIGHT CONDITIONS: Partly overcast sky

Essential Equipment

- Mamiya 645 AFD medium format camera body

- Mamiya lenses ranging from 35mm to 200mm

- Pentax 645 medium format SLR camera body

- Pentax lenses ranging from 35mm to 80mm

- Canon EOS-1Ds camera body

- Canon EOS 300D camera body

- Canon 17mm f/2.8 lens

- Canon 17–40mm f/2.8 lens

- Canon 50mm f/2.5 DG macro lens

- Canon 100–400mm f/5–5.6 Ultrasonic lens

- Spare lithium-ion batteries

- Range of 2GB CF media cards

- Two Epson P-2000 40GB portable hard drives

- Apple iPod 60GB hard drive

- Gitzo tripod

- Collapsible light reflectors

- Air puffer

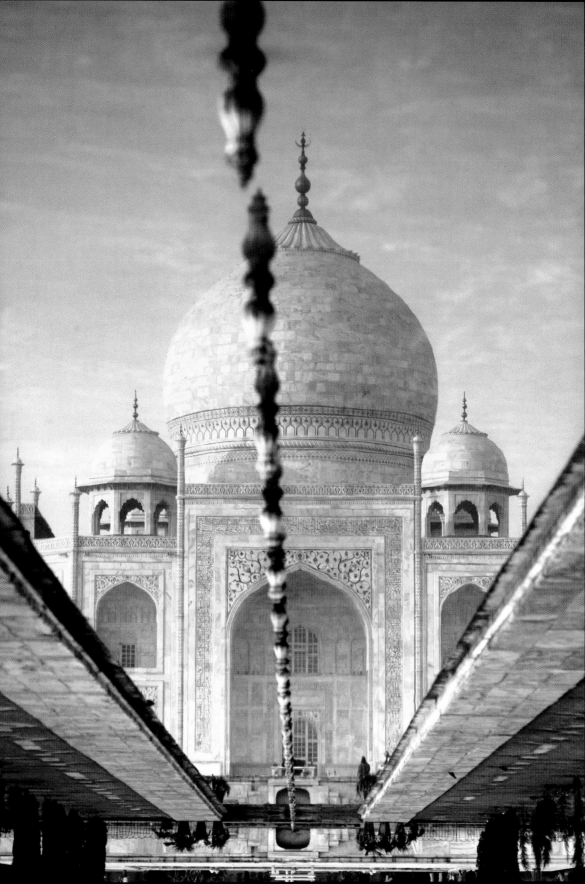

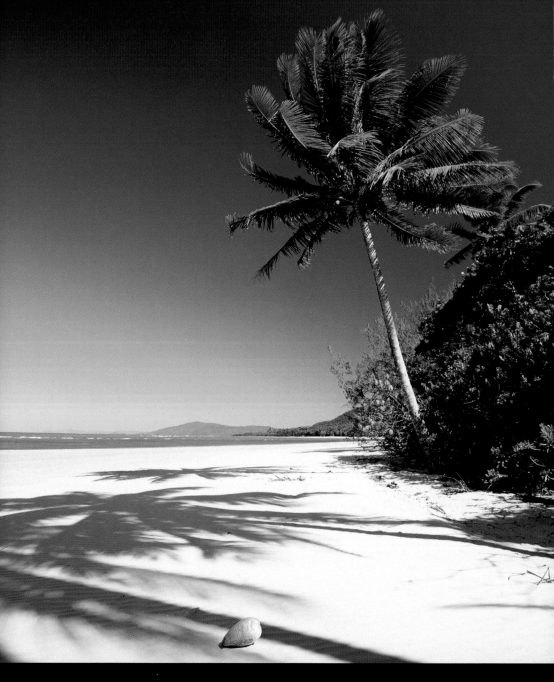

Alternative perspectives

Most travel photographers have tales to tell about their adventures, and Martin Child is no exception. "I've been chased by police for using a tripod in Rome, sunk in quicksand in Australia, and almost boiled alive in California's Death Valley at the height of summer," recalls the 45-year-old. It's all in a day's work for one of the world's most renowned travel experts, a man who is always on the move, capturing images from the remote rainforests of Queensland to the most photographed metropolis in the world, New York City. Child supplies some of the biggest stock agency names in the business, including Alamy, Digital Vision, Millennium Images, Powerstock, Superstock and, last but by no means least, Getty Images.

Such is the popularity of his work there's a good chance you will have seen his pictures in many travel publications, magazines, advertisements, and on book covers. Child says he can tell intuitively when he's taking a really successful shot. "I'll take hundreds of images of the most significant locations, but some shots give you the 'tingle factor' as you take them, and they almost always succeed."

Deserted beach
Daintree National Park, in the north of Queensland, Australia, a beautiful place where the tropical rainforest meets the ocean. In spite of the idyllic beaches, salt water crocodiles are a genuine danger in the estuaries here. This totally deserted and pristine beach was a perfect location. A wide-angle lens was used to emphasize depth and the broad band of white sand. The shadows and single fallen coconut give foreground interest.

CAMERA: Mamiya 645 Pro
LENS: 35mm
FILM: Fuji Provia
ISO: 100
APERTURE: f/16
SHUTTER SPEED: 1/125 sec
LIGHT CONDITIONS: Bright sun

AS: What was your first ever camera?

MC: My father inspired my love of photography, giving me a simple camera for my fifteenth birthday. I then purchased my first SLR at 17 —a Practica Nova—when I started art school. I loved the whole process of photography and I just wanted to keep taking pictures. This passion has never left me.

AS: Where do your ideas for innovative pictures come from?

MC: From looking and thinking—I am a very visual person. On location I move around the places I wish to photograph to alter perspectives, constantly looking for the best visual relationship between various elements. I sometimes plan an unusual shot, but often ideas occur while I'm working. The phrase "what if?" is always in my thoughts.

AS: Why did you decide not to do other types of photography, such as fashion or studio work, for example?

MC: I love to travel and explore new places. I like to be outside and I don't really enjoy the confines of studio work. For me, combining travel and photography is the ideal job.

Reichstag dome, Berlin
Sir Norman Foster's design for the dome of the Reichstag building in Berlin is very futuristic. There are two pathways spiraling to the viewing platform at the top— one for walking up, and one for descending. The central hub, which funnels light into the parliament meeting room below, is clad in mirrors which fragment the people beneath them. The figures give scale and interest to the architectural design and the national flag places it in Germany. I wanted the composition to emphasize both the organic shapes of the building, and how individuals relate to the space.

CAMERA: Canon EOS-1Ds MKII
LENS: 24–70mm
ISO: 100
APERTURE: f/9
SHUTTER SPEED: 1/60 sec
LIGHT CONDITIONS: Natural, indoor

Martin Child: Alternative perspectives

Venetian gondolas
Venice, one of my favorite places, has been photographed millions of times. This shot, taken in the early evening, sums up the place. Using a tripod and shutter speed slow enough to reveal the movement, but still showing the gondolas clearly, I captured the constant motion of the boats moored for the night. This required a very high ISO. The floodlit campanile of San Giorgio Maggiore is balanced by the lamp and its reflection. The blues and oranges of this image give it a vibrant quality.

CAMERA: Canon EOS-1Ds MKII
LENS: 24–70mm
ISO: 1000
APERTURE: f/3.5
SHUTTER SPEED: 1/2 sec
LIGHT CONDITIONS: Early evening, natural

AS: Is it fair to say, like many successful photographers, that you had a "lucky break" at some stage?

MC: I've always endeavored to create opportunities for myself. I had an exhibition of monochrome abstract landscapes at the Folly Gallery in Lancaster, and then submitted some of this work to a couple of stock agencies, who both took me on. One of them commissioned me to make a CD-ROM entitled *Bewilderness*—which featured the same style of work. Having established myself, the agencies started to take my photographs seriously.

AS: Do you shoot what you want or do others generally define what's required of you?

MC: I have the luxury and freedom to choose locations, and to photograph what I want. I sometimes get direction from agencies when I tell them where I'm traveling to, but it's really down to me to make saleable images. I research a place thoroughly and look for any gaps the libraries I supply to may have. I have a clear idea of the locations I need to visit before I arrive; how I react to these locations can be quite spontaneous, although I'm always mindful of the requirements of the different agencies.

AS: Where are you mostly based? Where are your most popular locations?

MC: I'm based in north-west England, which is a beautiful part of the world, with the Lake District, Peak District and Pennines nearby—and, of course, several airports. America is always popular. I've recently been traveling extensively in Europe and photographs from that continent are constantly in demand, so I'm working towards visiting every major European destination. Morocco is a fantastic country which has inspired me greatly, and there is great interest in photographs that I take there.

AS: Which country do you like to photograph in the most? Why?

MC: I've spent more time in Italy than any other country. It's a beautiful and diverse place which is visually rich and interesting. The culture, architecture, history, food, wine and people make a great mix, while the Dolomites, Venice, Verona, the Italian Lakes, Milan, Florence, Tuscany, Rome, the Amalfi Coast and Sicily are all fantastic locations.

AS: What things do you enjoy most about your job?

MC: I never really think of it as a job—it's something I do because I really enjoy it. Even if it wasn't my job I would take photographs, just because I love it. I still get very excited about making images, and I love sharing what I see with others, sometimes trying to show familiar landmarks in unfamiliar ways.

Eiffel Tower, early evening
The Eiffel Tower in Paris is an iconic structure, an extremely familiar and much photographed landmark. This picture only shows the base of the tower. It is taken at the optimum time when the tower is illuminated, but the sky is still blue. I set a slow shutter speed to blur the carousel and used a telephoto lens to compress the perspective and make a tight composition. I like the balance and contrast between the stillness of the tower and the movement of the carousel.

CAMERA: Mamiya 645 Pro
LENS: 300mm
FILM: Fuji Provia
ISO: 100
APERTURE: f/8
SHUTTER SPEED: 2 seconds
LIGHT CONDITIONS: Early evening, natural

Martin Child: Alternative perspectives

AS: From a technical aspect, what are the most difficult things about your photography?

MC: The most difficult thing is the weather. One key tool of any photographer is light. No matter how good you are technically, if the light is poor, or it's raining, you stand no chance. If the weather is bad you can come away from a destination with few, if any, saleable images. But with consistent good weather the job is much easier. Scaffolding and cranes are a pain, and people often just wander in front of the camera, so you need to be patient.

AS: How would you describe your personal style or technique of photography?

MC: My degree is in graphic design and I'm drawn towards graphic elements in images, often leaving empty spaces in compositions for text. I love the sense of drama which extreme wide lenses can give, but I try not to employ this technique too often. I'm always looking for an unusual take on a subject.

AS: What's in your kit bag? Which camera system do you use and why?

MC: I use a Canon EOS-1Ds MKII because it has a full-frame sensor which enables large, RAW files to be produced—ideal for stock photography. I have a couple of bodies, 16–35mm, 24–70mm and 70–200mm lenses, a 2× teleconverter, a couple of extension rings, an angle-finder, and a spare, fully charged battery. It's essential to take all my lenses as I never know which one I may need. I mainly confine the carbon-fiber tripod to evening shots, or for taking pictures with a slow shutter speed. I use two 4GB CF cards which can each hold up to 250 RAW files. In addition, I have a couple of portable Epson P2000 40GB hard-drive viewers to save work to; these also enable me to review the day's work each evening, which helps me to decide if I need to return to any location. If it's a long trip I take a laptop.

Coast of Dalmatia
The beautiful Dalmatian coast in Croatia has a myriad islands and inlets. I was driving along the coastal road from Dubrovnik to catch the ferry to Korcula. Unfortunately, some heavy cloud built up and I presumed there would be no photographic opportunities. Suddenly, the clouds thinned and shafts of light spotlit patches of sea. I quickly pulled in and took a series of photographs. This is the one which worked best, with the foremost islands silhouetted against the light.

CAMERA: Canon EOS-1Ds MKII
LENS: 70–200mm
ISO: 100
APERTURE: f/10
SHUTTER SPEED: 1/400 sec
LIGHT CONDITIONS: Thin cloud

Framed geraniums
This is a very simple photograph. The island of Burano, near Venice, is a magical place where the majority of the buildings are painted in very bright colors.

What struck me about this house was the contrast between the organic shape of the plant, the red flowers, the stark white rectangle, and the vibrant blue of the building. The composition gives the image an abstract feel.

CAMERA: Canon EOS-1Ds MKII
LENS: 70–200mm
ISO: 100
APERTURE: f/8
SHUTTER SPEED: 1/100 sec
LIGHT CONDITIONS: Bright, natural

AS: Do you try to make sure your work appeals to the widest possible audience?

MC: I take photographs which I believe in, and I often vary my technique to ensure I have familiar views: close-up detail, local color, and some more quirky, graphic photos. In cities, for example, I'll photograph all the important landmarks, and also some more generic street scenes, such as cafés, food and drink, markets, local crafts, souvenirs, local people, and anything that reflects the uniqueness of the place. I employ a variety of strategies, including wide aperture for selective focus, small aperture for large depth of field, and slow shutter speed for showing movement.

AS: When are the busiest times of the year for you?

MC: I work mostly in the northern hemisphere and I'm generally traveling from February to October. I'm always very busy. Photography doesn't stop once the shutter is pressed—images need to be edited, prepared, key-worded, and marketed, so a lot of time has to be spent in the office.

AS: Which places do you dislike traveling to?

MC: Some places inspire me more than others, but I've never traveled to a bad destination.

AS: What types of pictures do you find the most difficult to take?

MC: Popular landmarks which tourists want to pose in front of. The type of work I do requires a great deal of patience, and some luck. I don't have the luxury of directing the world, so I often have to wait a long time for the right elements to come together—the best light, the right colored car, the right type of person, or the moment when the view is clear.

AS: Which do you prefer—digital or film—and why?

MC: A good photograph is a good photograph—no matter which technology is used. For travel photography, digital is so versatile. I can quickly change ISO speed without having to change film backs, and I can shoot over 200 full-sized RAW files in one CF card, as opposed to 16 shots on one roll of film, which enables a more fluid approach.

The implicit tower
Entering the Campo dei Miracoli in Pisa always takes my breath away. It's like walking onto a movie set. One challenge facing any travel photographer is to frame the familiar in unusual ways. Looking for a different slant, I noticed this reflection in a pair of sunglasses lying on the grass. The curve of the lenses makes the tower lean more than ever. The narrow depth of field was critical for this shot. This is an image I particularly like, as it is implicit rather than explicit.

CAMERA: Canon EOS-1Ds MKII
LENS: 24–70mm
ISO: 100
APERTURE: f/4
SHUTTER SPEED: 1/80 sec
LIGHT CONDITIONS: Bright sunshine

Slippers for sale

I always look out for color and pattern when I travel—and you can't get a much more intense hit of local color than in the souks of Marrakech, which are mind-blowing in their richness, with the beautiful displays of high-quality craftsmanship and produce. Around every corner there is something interesting to photograph. This is a simple shot of traditional slippers in rows, which is indicative of the culture and lifestyle of this exotic location.

CAMERA: Canon EOS-1Ds MKII
LENS: 70–200mm
ISO: 100
APERTURE: f/5.6
SHUTTER SPEED: 1/50 sec
LIGHT CONDITIONS: Bright sunshine

Right: **Golden Gate Bridge**
This wide shot of the Golden Gate Bridge in San Francisco uses a polarizing filter to emphasize the color contrast between the bright red of the bridge and the deep blue of the sky. Choosing a close view looking up at the tower, gives an indication of the scale of the structure. I saw the potential for this photograph while driving over this amazing landmark. Recently, this image was used on the cover of a *Time Out* guide to San Francisco.

CAMERA: Mamiya 645 Pro
LENS: 35mm
FILM: Fuji Provia
ISO: 100
APERTURE: f/11
SHUTTER SPEED: 1/60 sec
LIGHT CONDITIONS: Bright sunshine

: How much of your work do you manipulate using
aging software?

: I keep it to the minimum. I often digitally sweep streets
d also clean off chewing gum. I remove obvious brand names,
e odd crane that spoils a skyline, or even the odd person
hey detract from the image.

: What have been your greatest photographic achievements?

: Creating bodies of work I'm proud of and ones which
e continually in demand. It's always pleasing when I see my
otographs on the cover of travel guides and books—these
ages define the destination.

AS: What does the future hold for you?

MC: More travel—there's still plenty more to do in Europe,
and I want to get to China, India, and back to the USA.

Chimneys of Casa Mila
With this shot I intended to
show the humanistic element
of the chimney cowlings on the
rooftop of Gaudi's Casa Mila
(La Pedrera) in Barcelona.
These strangely ornate shapes
are all different, and take on
their own personalities. The
tight composition has given
them the appearance of medieval
knights in helmets gazing into
the distance. The strong light
emphasizes the sharpness
and sculptural quality of the
modeling, while the deep
Mediterranean blue sky
contrasts well with the sandy
color of the chimneys.

CAMERA: Canon EOS-1Ds MKII
LENS: 70–200mm
ISO: 100
APERTURE: f/9
SHUTTER SPEED: 1/500 sec
LIGHT CONDITIONS: Bright
sunshine

Desert landscape
Joshua Tree National Park
is an extraordinarily beautiful
desert landscape, close to
Palm Springs in California.
The afternoon light was very
harsh so I waited until dusk
for the best photographs. This
silhouette shot emphasizes the
iconic shape of the Joshua tree.
I saw the potential for this image,
set up the camera on a tripod,
and waited patiently for the
right moment, when the sun was
just above the horizon, behind
the tree trunk. The glow of the
sun on the distant mountains
suggests the heat of the desert.

CAMERA: Mamiya 645 Pro
LENS: 150mm
FILM: Fuji Provia
ISO: 100
APERTURE: f/16
SHUTTER SPEED: 1/60 sec
LIGHT CONDITIONS: Sunrise

Tips for Success

1. Research your location
Try to go at the best time of year, and find out what the essential places to see are. When you arrive, visit local tourist offices or speak with the concierge at the hotel about the best photographic opportunities. Familiarize yourself with the locations by looking at travel and stock websites.

2. Use the time of day
Early morning and dusk are often the most productive times of day, giving the most interesting light. They can also be the quietest times, with few tourists—so be prepared for very long days.

3. Stay in central locations
Even though central hotels can be more expensive, they enable much more productivity, as you can often quickly get to your destination.

4. Ask for a room with a view
I have lost count of the number of saleable images I have taken from hotel balconies and windows!

5. Use public transport
In cities take taxis, trams or buses between locations—save your energy for photography by letting someone else do the legwork.

6. Photograph the local color
Look at markets, crafts, souvenirs, food, drink, and architectural detail. Take advantage of all the subjects on offer.

7. Take lots of pictures
Take lots of shots, exploring the many different aspects of any given subject, but then be selective—only choose the very best to be seen by others. The more pictures you take, the more chance you have of selling them.

8. Be prepared
Buy insurance and, if possible, take a backup camera. Accidents can happen—especially when you have to work fast. On location, if you're shooting digitally, always ensure the images are saved in two places.

9. Be aware of exactly what is in the viewfinder
Try to compose your shot within the frame as much as possible, rather than relying on a crop—the strongest images usually require no cropping.

10. Practice
If you can't get to an exotic destination, photograph a local landmark, finding the best time of day and the best angle. Don't forget to enjoy yourself. Have a sense of fun and wonder—this will come across in your photographs.

Urban abstract

I noticed the underside of this walkway over a busy road in New York was clad in curved, highly reflective, metal. The distorted reflection of a yellow cab and other vehicles makes a fairly abstract image of this urban scene. The shapes of the road markings help to make this an unusual and satisfying composition. To me this sums up the busy and exciting city of New York. Taken before 9/11, this walkway was very near to the World Trade Center—so it's likely that it doesn't exist any more.

Specification

CAMERA: Mamiya 645 Pro

LENS: 80mm

FILM: Fuji Provia

ISO: 100

APERTURE: f/8

SHUTTER SPEED: 1/60 sec

LIGHT CONDITIONS: Bright, natural

Essential Equipment

- Two 35mm Canon EOS-1Ds MKII camera bodies

- 16–35mm f/2.8 lens

- 24–70mm f/2.8 lens

- 70–200mm f/2.8 lens

- One 2× teleconverter

- Lens hoods for all lenses

- Spare lithium-ion batteries

- Two 4GB and one 1GB CF media cards

- Two Epson P-2000 40GB portable hard drives

- Pentax lens cleaner

- Cell phone

- Waterproof backpack

Martin Child: Alternative perspectives

Up close and personal

David Doubilet's underwater adventures have taken him to the deepest corners of the oceans, resulting in an astonishing 60-plus photographic commissions from *National Geographic* magazine. Born in 1946 in New York, the son of a doctor, David began shooting underwater at just 12 when he successfully married a Brownie Hawkeye camera with a rubber anesthesiologist's bag, from his father's hospital. "It just about kept the water out," he chuckles. As is the case with the cream of the world's photographers, David is at his best observing subjects up close and personal. Completely at home on a coral reef, dive wreck, in a dark fjord or among the giant creatures of the sea, he has relentlessly pursued the many hidden surprises our oceans continue to hide. "There is nowhere on this planet that you can be weightless in an environment that is so extraordinarily beautiful, and alien at the same time." Hardly surprising, therefore, that he is saddened by the world's increasing pollution and scarcity of resources, and his pictures remind us of these facts. But he is also aware of the challenges ahead. "We as a planet are warming up and you'd be mad to say it's not inherently linked to human activity. It's not a case of asking 'can we make a difference?' any more—we will have to make a difference."

Interview

AS: What was your first ever camera?

DD: A plastic Brownie Hawkeye. My first SLR was a Nikon F1, with Oceanic housing, developed by Bates Littlehales.

AS: Where do your ideas for innovative pictures come from?

DD: For me, the underwater world is a constant source of inspiration; each dive brings about new ideas and new ways of achieving unique photographs.

AS: Why did you decide not to do other types of photography, such as fashion or studio work, for example?

DD: I wanted to be an underwater photographer and there was no other interest. To make pictures underwater is a complete challenge and joy, and from time to time a total surprise.

AS: Is it fair to say, like many successful photographers, that you had a "lucky break" at some stage?

DD: I had a lot of lucky breaks and a lot of good people helped me out. I sold my first photograph when I was 15, which gave me confidence, but my first real breakthrough was shortly after my first visit to the Red Sea—my pictures were published in *National Geographic* magazine. My first commission from *National Geographic* was in 1969, when I photographed the Great Lakes.

AS: Do you shoot what you want or do others generally define what's required of you?

DD: I suggest about 80–90 percent of the things I want to shoot and developing story ideas is probably the most difficult thing in my job. Each story has to have new techniques behind it because there are a lot of competitive photographers. Underwater photography is a fairly homogenous place, however, and there are always many new and interesting things to shoot.

AS: Where are you mostly based? Where are your most popular locations?

DD: I work and live with my partner, Jen Hayes, in New York state on the St Lawrence River—it's on the border between the US and Canada, near Lake Ontario. I have a lot of wildlife on my doorstep and the water is very clear. We like to travel and we also have a home in South Africa, which is wonderful photographically. It has the richest seas in the world because it's the meeting place of two great oceans.

AS: Which country do you like to photograph in the most? Why?

DD: There isn't one such place—I like everywhere. I go where the work takes me.

AS: What things do you enjoy most about your job?

DD: I love the adventure of going to faraway places. The extraordinary thing about my life is that underwater is like nowhere else on earth. There are many unique things to see. It's an array of color and dimension, but I also shoot black-and-white, to record new life-forms on the planet from a unique perspective. My job is a challenge that's as great and complex as any photographer could possibly have.

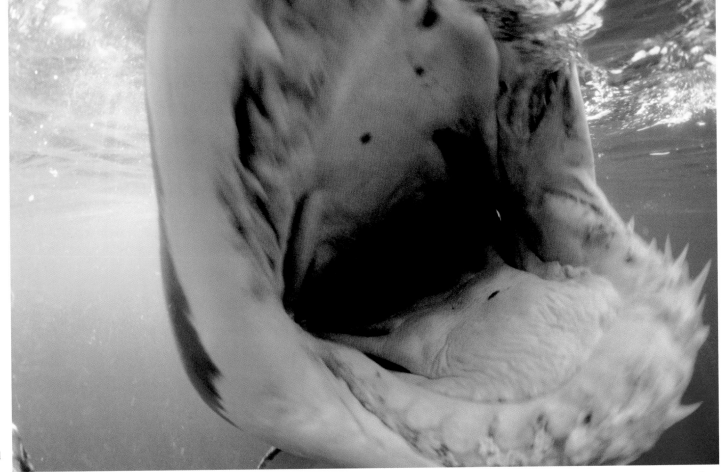

reat White bite, Gansbaai, uth Africa

reat white sharks have a werful grip on the human yche. The challenge here was w to make this image. With lp from Joe Stancampiano, *ational Geographic* photo-gineer, we constructed a pole mera with a remote trigger, d a lipstick camera that oked through the viewfinder. e journeyed to the white shark pital of the world—Gansbaai South Africa—to work with gendary shark wrangler ndre Hartman. He found active and aggressive shark, e he calls a 'player,' and we oceeded to set up a 'bait-and itch-trick' in which we changed different types of it at the last second. Making e image was like a dance: ark follows bait, shark opens outh, switch camera for bait, ll camera out—all before the ark closes its mouth.

AMERA: Nikon N90s
NS: 16mm fisheye
LM: Fuji Provia 100
PERTURE: f/5.6
HUTTER SPEED: Shutter Priority
AMERA HOUSING: Nexus
GHT CONDITIONS: Clear, natural
A CONDITIONS: Calm

ray reef sharks, iputa Pass, Rangiroa Atoll, rench Polynesia

ray reef sharks ride the coming currents in Tiputa ass at Rangiroa Atoll. To make is image in the stiff currents, e dove to 130ft (c. 40m) and und shelter in a coral alcove. he gray ghosts soar like eagles, hile divers and photographers ruggle to stay still. To get this waited for a perfect squadron f sharks to fly past and captured e image with a 24mm lens nd strobes at half-power. After 5 minutes we pushed out of ur alcove and rode the current, hrough walls of sharks, into the iant lagoon of the atoll.

AMERA: Nikon F4
ENS: 24mm
LM: Fujichrome Velvia 50
PERTURE: f/8
HUTTER SPEED: 1/15 sec
AMERA HOUSING: Nexus F4
ith 8in dome
GHT CONDITIONS: Artificial/ robes
EA CONDITIONS: Strong currents

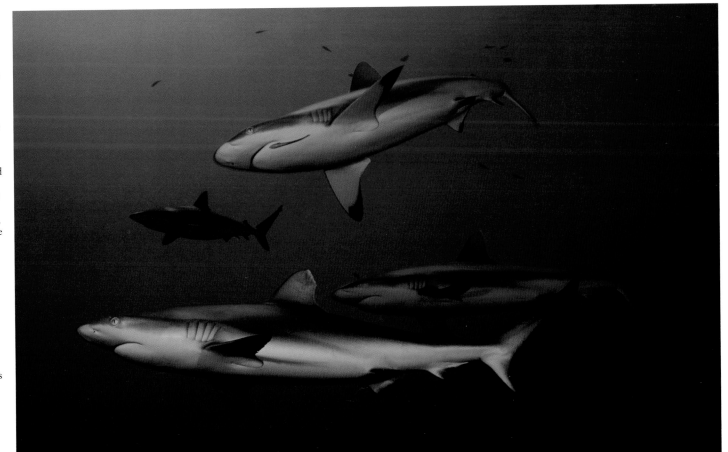

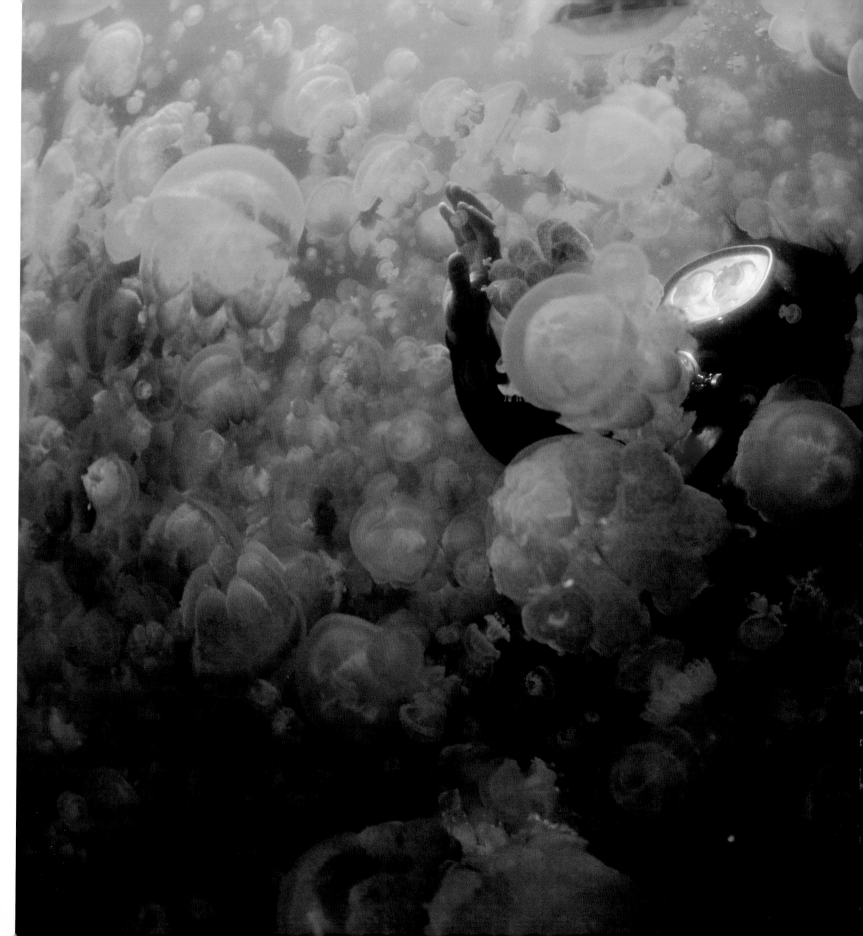

Jellyfish Lake, Eil Malk, Republic of Palau
Jellyfish Lake lies in the jungle-covered island of Eil Malk. The mini, isolated ocean is home to creatures called Mastigias jellyfish. Isolated from their normal predators, these fragile creatures have lost their ability to sting and are harmless food factories, processing sunlight for nutrients. Huge shoals of jellyfish follow the sun, moving like clouds across a sky. I arrived early one morning and snorkeled to the far eastern corner where the first rays of sun would reach the lake. Swarms of jellyfish began to collect in a pool of light and in minutes I was engulfed by the gentle beating orbs—it was a studio straight out of a science-fiction movie.

CAMERA: Nikon F
LENS: 16mm fisheye
FILM: Kodachrome 64
APERTURE: f/8
SHUTTER SPEED: 1/60 sec
CAMERA HOUSING: Ocean Eye
LIGHT CONDITIONS: Sunny, natural
LAKE CONDITIONS: Calm

AS: From a technical aspect, what are the most difficult things about your photography?

DD: Technically, everything about underwater photography is difficult, but working with light and color are the two most challenging aspects. And there is no way any diver is going to see the secret life of fish—you are alien and they will try to escape from what must seem like a noisy fire engine coming down the street.

AS: How would you describe your personal style or technique of photography?

DD: If I have one, and people say I do, it's based on the way light goes into the water. Here light works in far different ways than on land. Color disappears after three or four feet, so you have to be able to light subjects and restore the spectrum; to do this I use light strobes. With these I create the concept of an underwater studio, and I place them on the end of two specially made moveable arms.

AS: What's in your kit bag? Which camera system do you use and why?

DD: I currently use digital D2x or D200 Nikon cameras, though I also have a D70 as backup. I ensure each stays dry and I have a bespoke underwater housing for each camera. My strobes are manufactured by Sea & Sea in the US—they're very robust. Importantly, Sea & Sea also makes 7-volt NICAD rechargeable batteries that give me about 150 flashes from a full charge. To see things in a photograph that you would otherwise see through your mask, you have to get close to your subjects, and extreme wide-angle lenses are the bread and butter of underwater photography. The basic focal length of my Nikkor lenses starts at 10.5mm, though I also use a 12–24mm zoom, 17–55 zoom and Tokino 10–17mm zoom. From time to time I like to shoot with an 18mm lens. With macro photography I have 60mm and 105mm lenses, and I also use teleconverters for special things, such as small creatures. I also use a thing called a dome. Underwater optics are very difficult to design because water magnifies everything by 25 percent: if you want to produce a wide-angle picture, you have to get rid of that magnification. To do that you have to construct a supplementary lens, or build a dome port—it's a hemisphere in front of the lens. This will correct the magnification.

David Doubilet: Up close and personal

**Baby green sea
turtle, Maurutea Atoll,
French Polynesia**

A baby green sea turtle, even
smaller than the palm of my
hand, paddled steadily towards
the open sea. As it surfaced it
noticed my camera and swam
directly at me, peering into the
dome of my housing. To make
a split image of this tiny ancient
mariner, I used a high aperture
to hold the depth of field, and
set the strobes at half-power.

CAMERA: Nikon F4
LENS: 14mm
FILM: Fujichrome Velvia 50
APERTURE: f/22
SHUTTER SPEED: 1/30 sec
CAMERA HOUSING: Nexus F4
LIGHT CONDITIONS: Sunny, with
strobes giving fill-light
SEA CONDITIONS: Calm

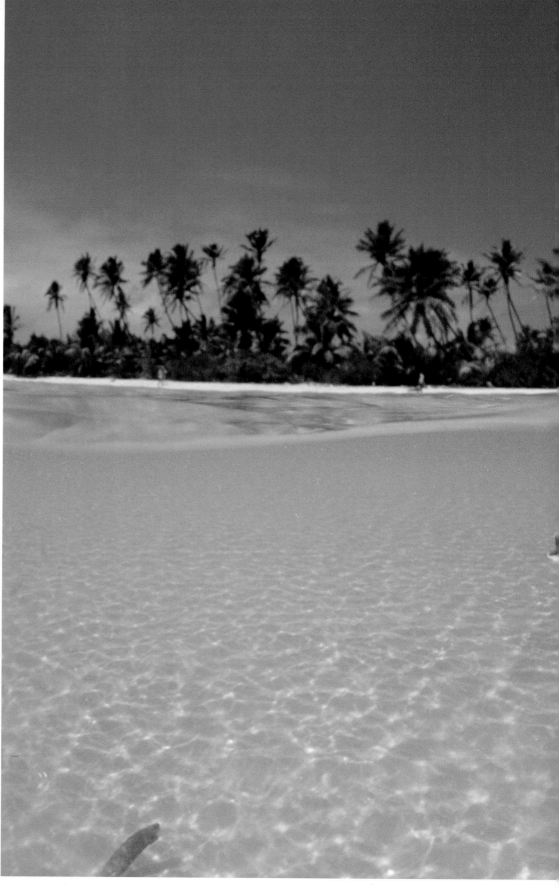

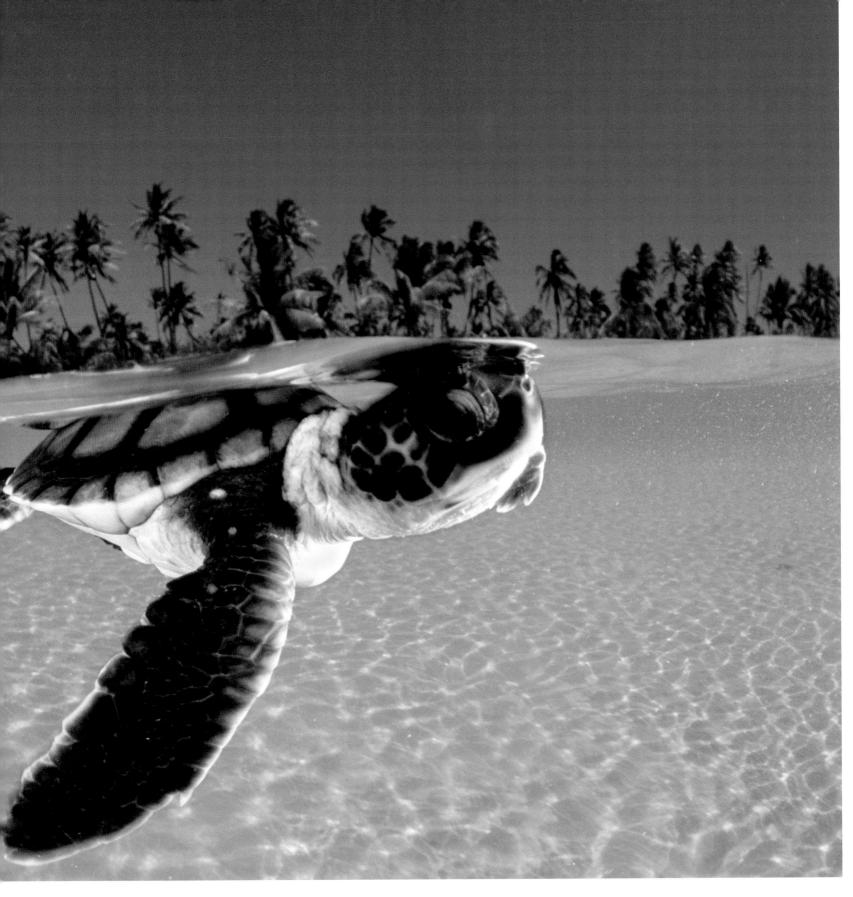

David Doubilet: Up close and personal

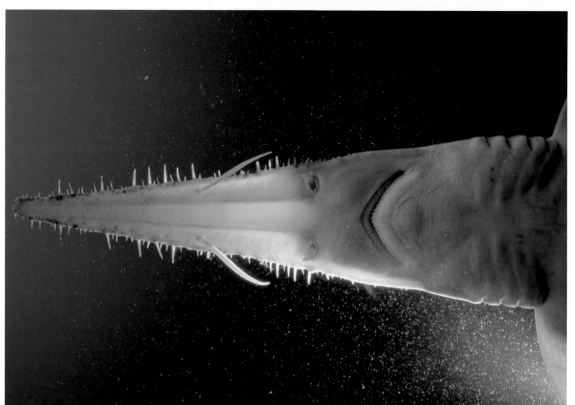

Left: **Shortnose saw shark, Tasmania, Australia**
Shortnose saw sharks are endemic to the waters of South Australia and Tasmania. In the spring females come into the shallow bays to give birth. It is a rare moment to encounter and photograph these elusive creatures. The shark's unusual snout or rostrum is a wonderful design. The underside resembles a scary face, with two dark nostrils suggesting brooding eyes. To make this portrait I backlit the shark with a 300-watt movie light.

CAMERA: Nikon F4
LENS: 28mm fisheye
FILM: Fujichrome Provia 400
APERTURE: f/5.6
SHUTTER SPEED: 1/60 sec
CAMERA HOUSING: Nexus
LIGHT CONDITIONS: Artificial/ 300-watt light
SEA CONDITIONS: Swells

Weedy sea dragons, Tasmania, Australia
Weedy sea dragons are strange and wonderful creatures that remind me of beautiful, vintage tin toys created from someone's vivid imagination. In reality they are ornate relatives of the seahorse that are native to the cool and temperate waters of Tasmania. These colorful dragons live secretive lives, hunting for tiny crustaceans and zooplankton in seaweed beds. After many close-up images using a 60mm lens, I chose a wide-angle 16mm lens to capture the light streaming through the canopy of kelp.

CAMERA: Nikon F4
LENS: 16mm fisheye
FILM: Fujichrome Velvia 50
APERTURE: f/16
SHUTTER SPEED: 1/8 sec
CAMERA HOUSING: Nexus
LIGHT CONDITIONS: Artificial/ strobes
SEA CONDITIONS: Calm

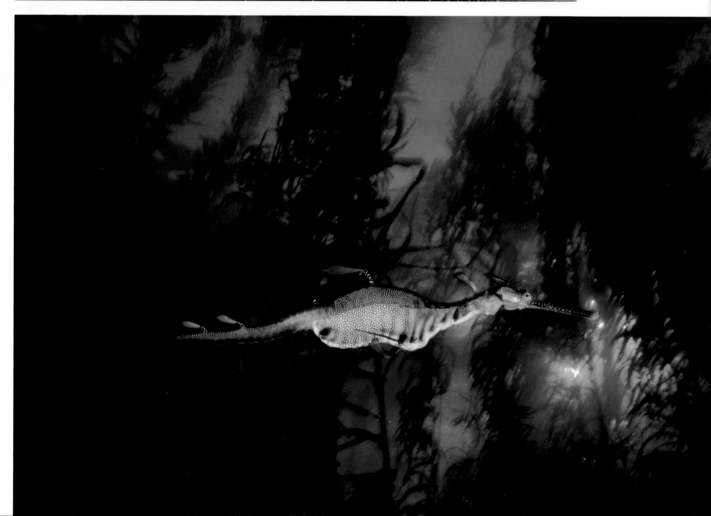

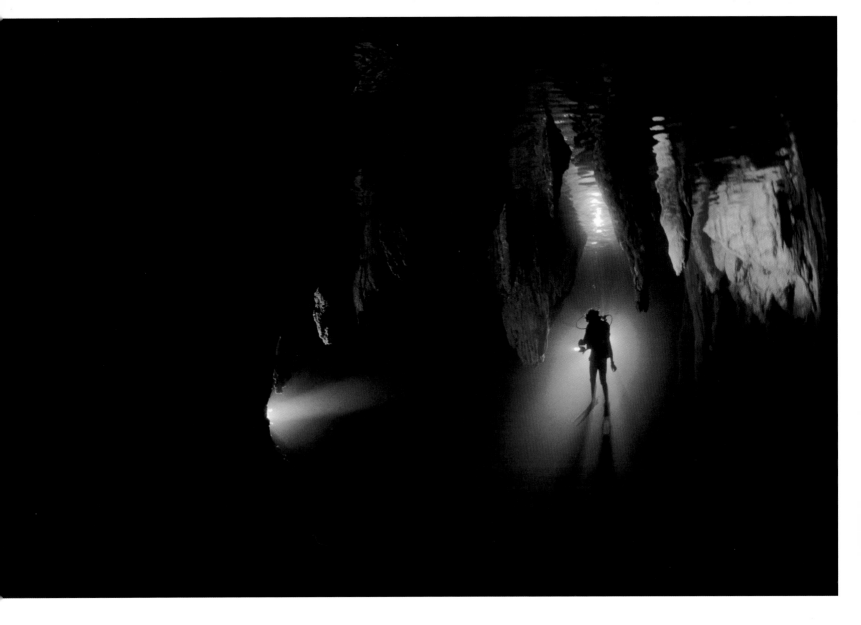

AS: Do you try to make sure your work appeals to the widest possible audience?

DD: I produce images that are sophisticated: they work for themselves. I don't think I'm ever working for the general public.

AS: When are the busiest times of the year for you?

DD: Every year it varies. I go where the seasons take me and I'm constantly aware of weather patterns around the world.

AS: Which places do you dislike traveling to?

DD: There's really no place I dislike traveling to. There are lots of places I would love to go to more than others, such as Scandinavia, of which I have only seen a small part. In my line of work I don't let politics prevent me from going anywhere.

Chandelier Cave, Republic of Palau

Chandelier Cave in the Republic of Palau is a sea cave with huge, snaggle-toothed stalactites. In one place they resemble a monstrous, ugly Victorian chandelier. The cave entrance is only 30ft (c. 9m) deep and at no point in the winding passages does light totally disappear. We lowered 1200-watt HMI movie lights, connected to 200ft (c. 60m) of cable, into the water and swam them into the cave. We flipped the generator switch and the lights flickered and then burst into beams of clear blue light. I found natural shelves in the walls and set the lights to crosslight the cave. The dirty limestone walls looked like a Hollywood set filled with elongated, surreal shadows.

CAMERA: Nikon F4
LENS: 16mm
FILM: Fujichrome Velvia 50
APERTURE: f/2.8
SHUTTER SPEED: 1/30 sec
CAMERA HOUSING: Nexus F4 with 8in dome
LIGHT CONDITIONS: Artificial/ 1200-watt HMI lights
SEA CONDITIONS: Calm

David Doubilet: Up close and personal

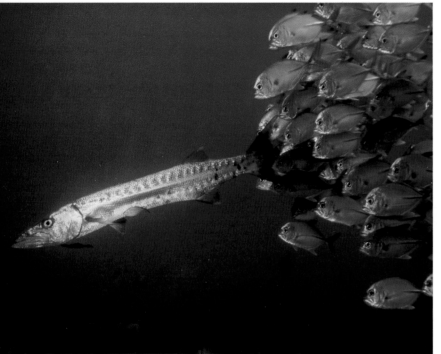

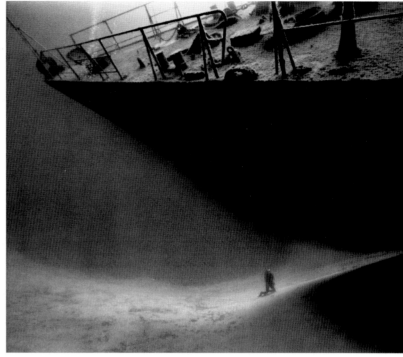

AS: What types of pictures do you find the most difficult to take?

DD: Pictures made in the Caribbean Sea. It's the target for many clear-water photographers and, for me, making new and intriguing images is remarkably difficult.

AS: Which do you prefer—digital or film—and why?

DD: A digital RAW file is basically a negative—it's the beginning of an image. I use digital cameras because they suit the way Jen and I work, mainly because of their speed, but they do also offer an alterable piece of work. If you shoot a 4 × 5 film image, for example, in color, what you have, if done correctly, is a complete, original and unalterable piece of work. A digital photograph isn't one that records pictures in the true sense of the word. Digital is also incredibly laborious and has put many photographers in a situation where they have to do the job the lab used to do, with film. And you have to buy the equipment the lab used to have.

AS: How much of your work do you manipulate using imaging software?

DD: I increase contrast and colors simply because shooting underwater makes things much flatter. If you're a land photographer using longer lenses, you'll need to do the same thing because you're shooting from further back, which means your contrast will be lower.

Left: **Horse-eye jack counter-attack, Grand Cayman**
During an afternoon dive on the Oro Verde wreck located off Grand Cayman Seven Mile Beach, I watched this barracuda size up a hovering shoal of horse-eye jacks. The very old, but not wise, barracuda decided to make a run for the jacks in broad daylight. The shoal's response was a full-on counter-assault. The jacks chased the barracuda off the wreck and into the blue.

CAMERA: Nikon F4
LENS: 24mm
FILM: Kodachrome 64
APERTURE: f/11
SHUTTER SPEED: 1/30 sec
CAMERA HOUSING: Aquatica 4
LIGHT CONDITIONS: Artificial/
strobes
SEA CONDITIONS: Calm

Above: **Russian destroyer 356, Cayman Brac**
The Russian destroyer 356, launched in 1984, quickly became a stepchild of the Cold War, retiring to rust in Cuba. In 1998 it was purchased by the Cayman Island government and renamed the MV Tibbetts. It sank and became an artificial reef off Cayman Brac. The wreck lies on a bed of perfect wide sand in 60ft (c. 18m) of clear water. As I was swimming around the wreck to choose the best angle to capture the slumbering giant, my partner Jennifer appeared at her bow and gazed up at the massive hull, with sun reflecting in her mask. Sometimes the perfect plan is no plan; Jennifer's posture at the bow emphasized the size and sleekness of this perfect shipwreck.

CAMERA: Nikon F4
LENS: 15mm with orange filter
FILM: Kodak 400CN
APERTURE: f/6
SHUTTER SPEED: 1/125 sec
CAMERA HOUSING: Nexus F4
with 8in dome
LIGHT CONDITIONS: Sunny,
natural
SEA CONDITIONS: Calm

AS: What have been your greatest photographic achievements?

DD: I was nominated as an Honorary Member of the Royal Photographic Society, which was wonderful. Winning the Lennard Nielsen Award for Scientific Photography, in 2001, is also one of the outstanding achievements of my career. I've also received a Wyland NOGI Award and been named BBC Shell Wildlife Photographer of the Year.

AS: What does the future hold for you?

DD: To continue working as an underwater photojournalist for *National Geographic* and to continue being taken seriously in the photographic world.

The Passage, Gam Island, Raja Ampat
A 2-mile (3.2km) long passage less than 160ft (50m) wide winds between the islands of Waigeo and Gam, in the heart of the Raja Ampat, a mini-archipelago just off the tip of the Bird's Head Peninsula, Indonesia. In one secret alcove there is a small forest of giant sea fans. My goal was to find a wide-angle view that would allow me to demonstrate this rare environment, where the reef meets the rainforest.

CAMERA: Nikon F100
LENS: 16mm fisheye
FILM: Fujichrome Velvia 50
APERTURE: f/11
SHUTTER SPEED: 1/15 sec
CAMERA HOUSING: Nexus
LIGHT CONDITIONS: Artificial/strobes and natural
SEA CONDITIONS: Calm

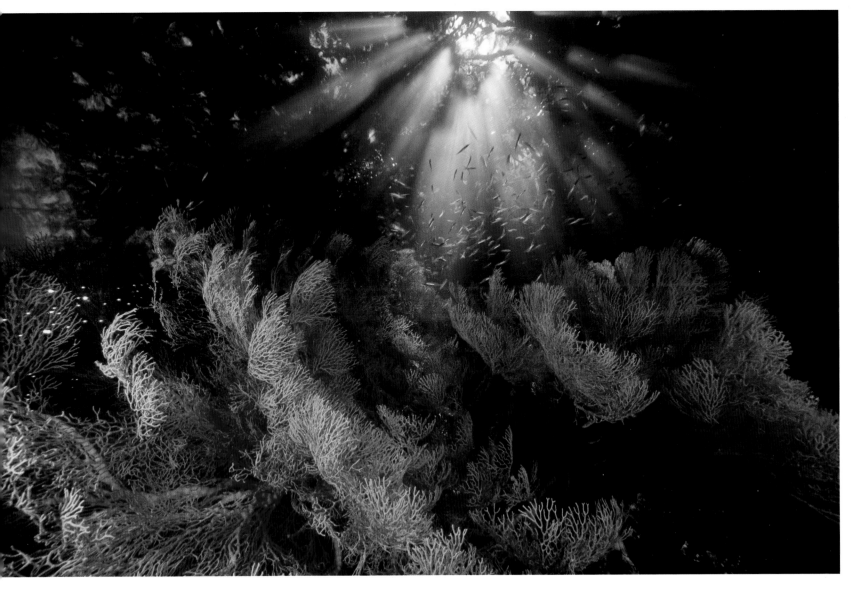

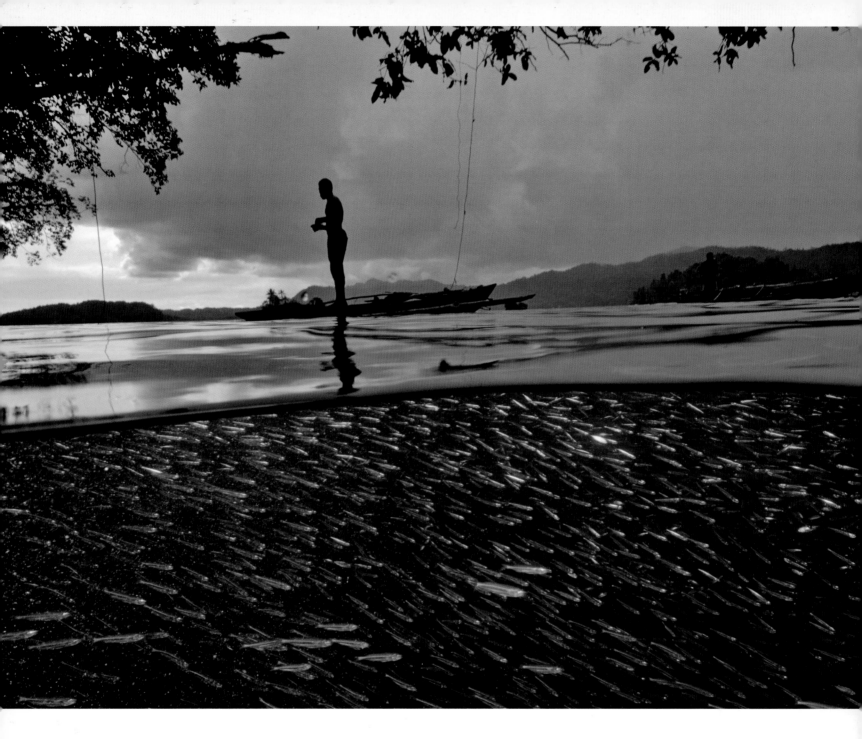

Fisherman over baitfish, near Kri Island, Raja Ampat
We were in our boat on our way back to Kri Island, in a light rain, and we stopped next to a mushroom-shaped islet to watch some local fisherman. The entire islet was encircled by an immense shoal of silvery baitfish. The sides of the island were deeply undercut and the top was a miniature rainforest.

Fishermen tied their canoes and outriggers to an overhanging limb and stood like statues while they fished. I slid into the water, trying not to scare the baitfish. I held the camera housing half in and half out of the water, constantly checking for droplets on the dome. I swam slowly into the shoal until it formed a perfect arc under the fisherman, then took the picture.

CAMERA: Nikon D2x
LENS: 12–24mm
ISO: 100
APERTURE: f/20
SHUTTER SPEED: 1/25 sec
CAMERA HOUSING: Sea Cam
LIGHT CONDITIONS: Artificial/ strobes
SEA CONDITIONS: Calm

Tips for Success

1. Buy the necessary equipment

There are no shortcuts in underwater photography. You have to spend the money and have good equipment to get the right pictures, and to get the control. If you go to a faraway place and your camera housing comes apart, or if you do something stupid, which everybody does, then you'll be out of business.

2. A good picture is an intimate picture

You have to be on the same level as fish, or any other sea creature. Although you can't be inconspicuous underwater, you can still try to adapt to their world.

3. Be patient

Just like other wildlife photographers, you have to be patient, even though you'll have less time because your air tanks have limited time.

4. Work with a partner

The biggest risk with underwater photography is drowning, so it's safe to have someone watching you. You can also help with each other's equipment.

5. Trust your local guide

The most important part of image-making is to truly be friends with people you're working with. Trust them, pay them and be fair with them.

6. It's all about lighting

Underwater photography is all about getting the lighting right. You have two strobes normally—some underwater photographers use one—but you can't use it to light your subjects like a paparazzo in a night club. You need to think about how to use it, by balancing it with natural light, which means longer exposures.

7. Be creative

Why take pictures if you're not creative? Do you want to work in a passport office? Try out different things; to create and suggest drama in a picture is to create emotion and an image that's striking to the viewer.

8. Respect the environment

Don't provoke animals. You don't go wandering in Botswana with a camera on a tripod, do you? You'd be eaten. The same applies with dangerous animals underwater, such as attracting sharks to a cage, to photograph them.

9. Pack with loss in mind

When you pack, take more than one underwater camera system. Everything you take should be self-contained, so if you lose one bag, it won't become a wasted trip.

10. Shoot as much as you possibly can

It's a numbers game, to some extent. Although underwater photography is a specialist field, the more pictures you take, the better chance you'll have of printing the perfect one.

Sand bar, North Sound, Grand Cayman

Clear waters spill over the barrier reef at North Sound to flood a perfectly raked white sand bar. My strategy was to arrive early and leave late, watching how the light changed and waiting for a visual moment as the southern stingrays soared around this perfect ocean studio. Even in this digital age I often shoot black-and-white film using natural light, because of the combination of light, white sand and stingrays. The biggest challenge shooting a split black-and-white image is to select the best filter for the light conditions. I chose a split filter with a red top to separate the clouds, and an orange bottom to increase contrast underwater.

Specification

CAMERA: Nikon F4

LENS: 15mm with split filter

FILM: Kodak 400CN

APERTURE: f/16

SHUTTER SPEED: 1/125 sec

CAMERA HOUSING: Nexus F4 with 8in dome

LIGHT CONDITIONS: Clear sky, natural

SEA CONDITIONS: Calm

Essential Equipment

- Nikon F4 camera body
- Nikon D2x camera body
- Nikon D200 camera body
- Nikon D70 camera body (backup)
- Bespoke camera housings
- Bespoke light strobes
- NICAD 7-volt rechargeable batteries for strobes
- Underwater movie lights
- 10.5mm Nikkor fisheye lens

- 14mm Tamron lens
- 16mm Nikkor fisheye lens
- 18mm Nikkor lens
- 12–24mm Nikkor zoom lens
- 17–55mm Nikkor zoom lens
- 10–17mm Tokino extreme wide-angle lens
- 60mm Nikkor macro lens
- 105mm Nikkor macro lens
- Supplementary dome lens

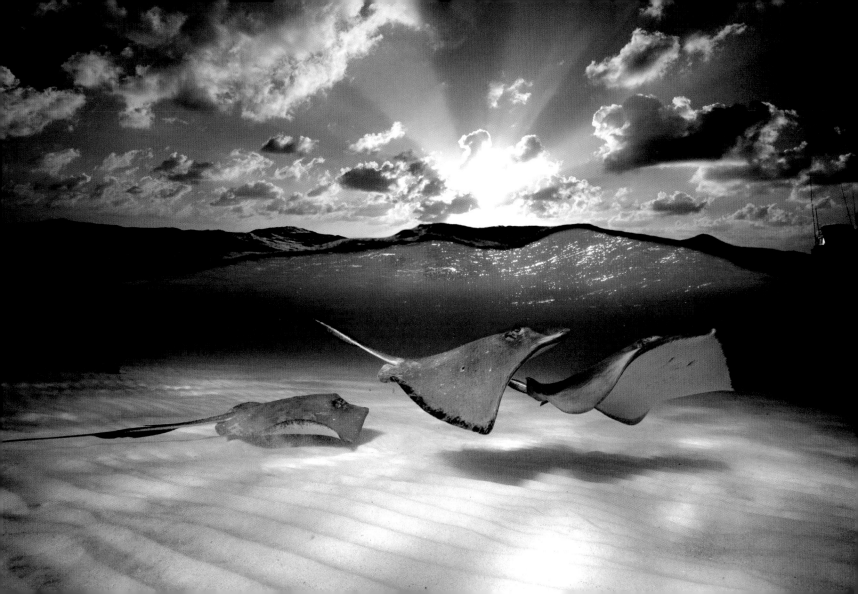

Lee Frost

Panoramic views

No photographer is more passionate about their vocation, as Lee Frost testifies. "The things that keep me inspired are the need to experiment and evolve. I just love making photographs and trying new ideas. Traffic jams and commuting are things that happen to other people." Lee, born in 1966, near Barnsley, England, became interested in photography at 15, when he was presented with a Zenith SLR. A keen hiker and backpacker at the time, he was immediately attracted to landscape photography, and although this remains a passion and the genre for which he is best known, he loves the art of creating imaginative images, regardless of subject.

In 1988, while still an amateur, Frost entered and won a travel photography competition, marking the start of his professional career. In 1992, after working as assistant editor on *Photo Answers* and *Practical Photography* magazines, he decided to pursue a career as a freelancer. He has written 15 books on photography and his striking images have been published in every leading UK-based professional photography title.

g Chebbi region, Morocco
ve visited this region of the
hara several times and I never
ase to be inspired—the desert
ndscape is constantly changing.
s well as shooting wide-angle
ews, I enjoy using a telezoom
ns to capture the wonderful
ay of light and shade on the
unes, to create simple, abstract
nages. This is one of a whole
ries of pictures taken from the
dge of a high dune above my
mp in the desert. Climbing up
almost killed me—but it was
orth it for the views.

AMERA: Nikon F5
NS: 80–200mm with
olarizing filter
LM: Fuji Velvia 50
PERTURE: f/11
HUTTER SPEED: 1/15 sec
GHT CONDITIONS: Bright
unlight

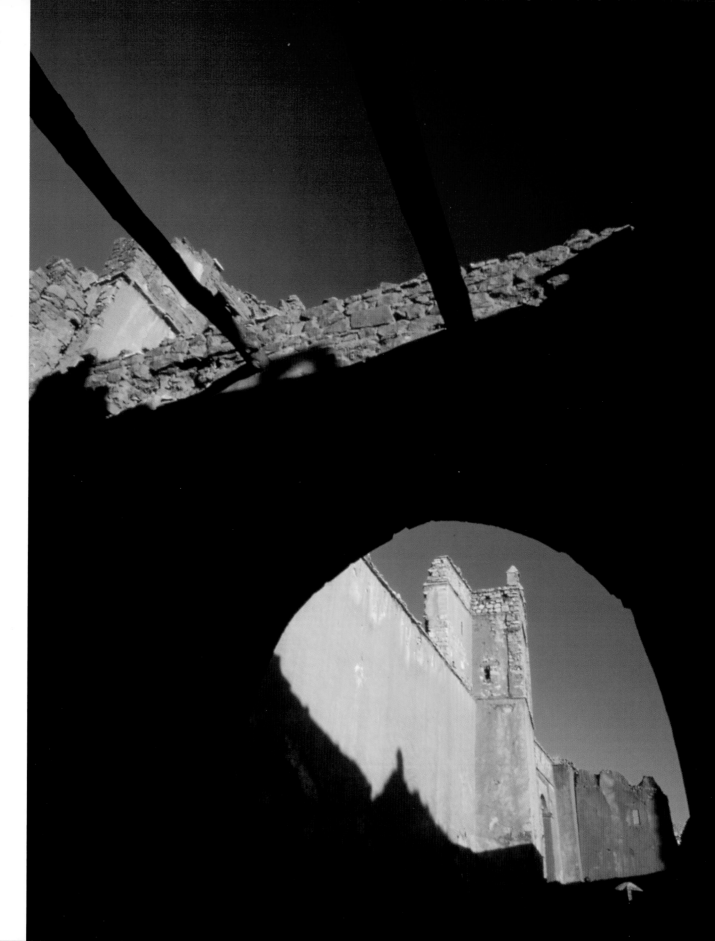

: Kasbah Telouet

s crumbling old kasbah
s once the home of a Glaoui
ef who ruled the High Atlas
.on of Morocco. Today it's
wly falling into ruin and is
l amazing place to explore
l photograph. This picture
ws one of the gateways into
 kasbah compound. The old
e (mud) walls were bathed
vening light, and by getting
vn low with a wide-angle
s, I was able to capture the
 timber beams against
 blue sky.

MERA: Nikon F5
.s: 20mm with
.arizing filter
M: Fuji Velvia 50
.RTURE: f/16
.TTER SPEED: 1/8 sec
.HT CONDITIONS: Late
.ernoon sunlight

AS: What was your first-ever camera?

LF: A Zenith EM SLR, given to me at Christmas when I was a teenager.

AS: Where do your ideas for innovative pictures come from?

LF: I respond to a location, the light, and how I'm feeling at the time. I like to keep an open mind and be receptive to new ideas. I may set out with a specific shot in mind but later find something else catches my eye, and I suddenly find myself moving in a completely different direction—I'm all for the unpredictable. The type of equipment I use influences the way I work and the type of pictures I take. If I'm shooting 35mm, for example, I'm more likely to be working hand-held and on the move, so the pictures are more active, spontaneous and adventurous. When I use a 6 × 17cm panoramic camera, it's always on a tripod and the shots I take are more technical and considered, because I work at a slower pace.

AS: Why did you decide not to do other types of photography, such as fashion or studio work, for example?

LF: I've always loved travel and being outdoors, so I naturally drifted into landscape and travel photography.

AS: Is it fair to say, like many successful photographers, that you had a "lucky break" at some stage?

LF: Absolutely. In 1988 I managed to win a travel photography competition and I was whisked off to Turkey for a week, to shadow a professional travel photographer. That got me known to some photography magazines and, months later, an assistant editor on one of them went freelance and a vacancy was available. I was offered the job. Working in publishing gave me experience of how the industry works from the inside, which was invaluable. That was 15 years ago and I've managed to make a living from photography ever since. I'm totally obsessed and more excited by it now than ever before.

AS: Do you shoot what you want or do others generally define what's required of you?

LF: I usually photograph what I want, when I want. I've supplied picture libraries with images since my amateur days, and once I went freelance, I traveled to places such as the Maldives and Seychelles specifically to shoot stock. These days much of my travel is defined by the workshops and photographic tours I do through my company, Photo Adventures. I do take pictures on these trips and I still send them to photo libraries, but I don't try to shoot commercial stock images any more—I shoot pictures that inspire me and, if a library accepts them, it's a bonus.

ght: **Cuban tobacco farmer**

ove photographing people
en I'm traveling—they
veal so much about the
.ace. This farmer was 98
.en I photographed him.
.ust turned up at the farm
.here he lived, deep in Cuba's
.nales Valley, and spent
.veral hours photographing
s family. He was quiet and
.gnified and didn't mind being
.otographed. His face was
.st so full of character.

CAMERA: Nikon F5
LENS: 80–200mm
FILM: Fuji Velvia 100F
APERTURE: f/4
SHUTTER SPEED: 1/125sec
LIGHT CONDITIONS: Open shade in sunny weather

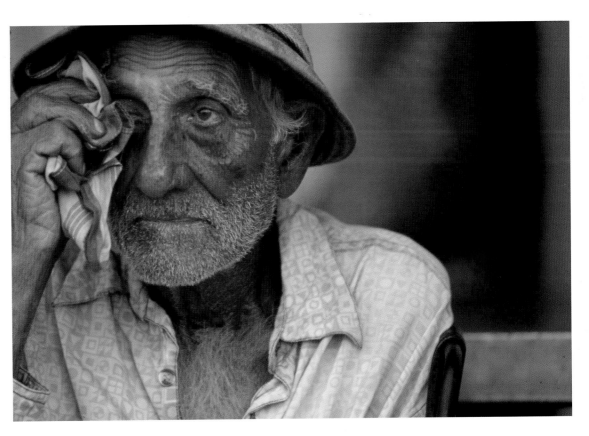

Lee Frost: Panoramic views

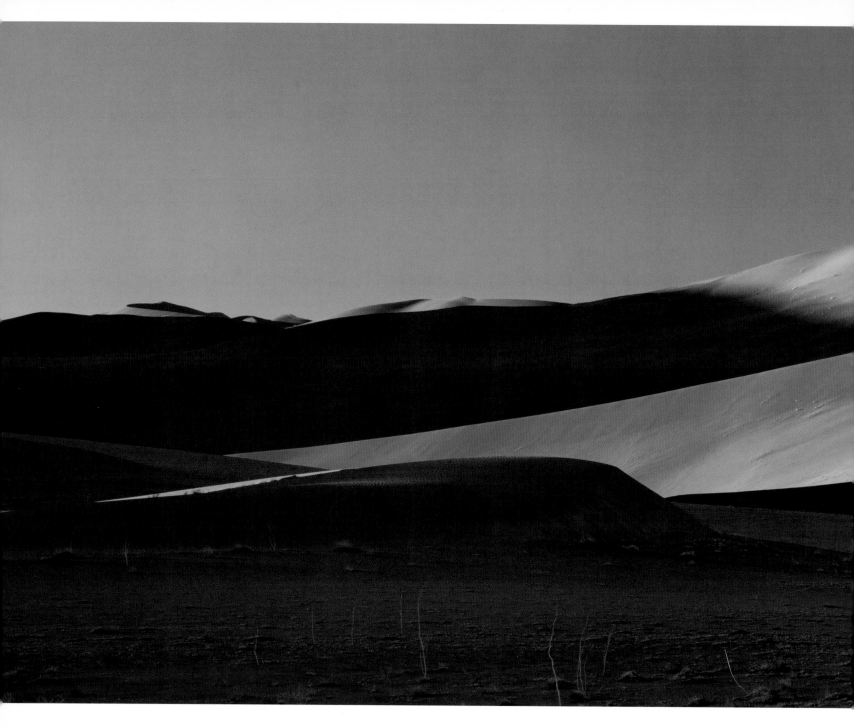

Sossusvlei, Namib Desert, Namibia

Deserts and sand dunes are at their best at the end of the day, when the sun is low and the raking light accentuates their wonderful shapes and textures. From a practical point of view it's also a lot cooler—the Namib Desert can hit 50°C in the day.

This was an evening shot. I started photographing the scene with a 90mm lens so that I could include ripples in the foreground sand, but as the sun dropped, the foreground fell into cool shade. I switched to a longer lens and focused my attention on the distant dunes, where the evening light performed magic.

CAMERA: Fuji GX617
LENS: 180mm with polarizing filter
FILM: Fuji Velvia 50
APERTURE: f/22
SHUTTER SPEED: 1 second
LIGHT CONDITIONS: Low evening sunlight

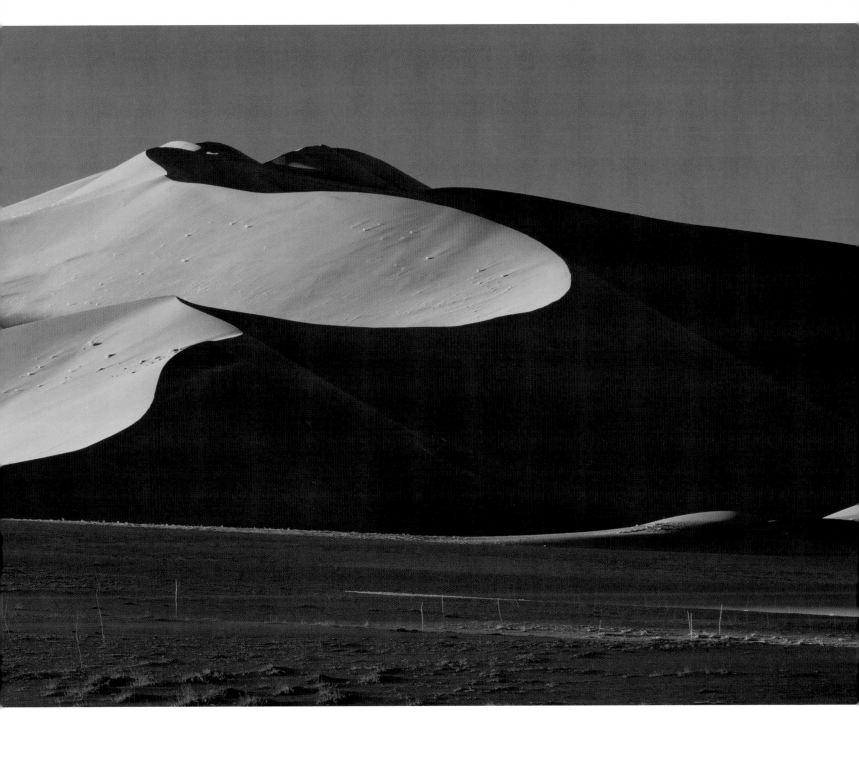

Lee Frost: Panoramic views

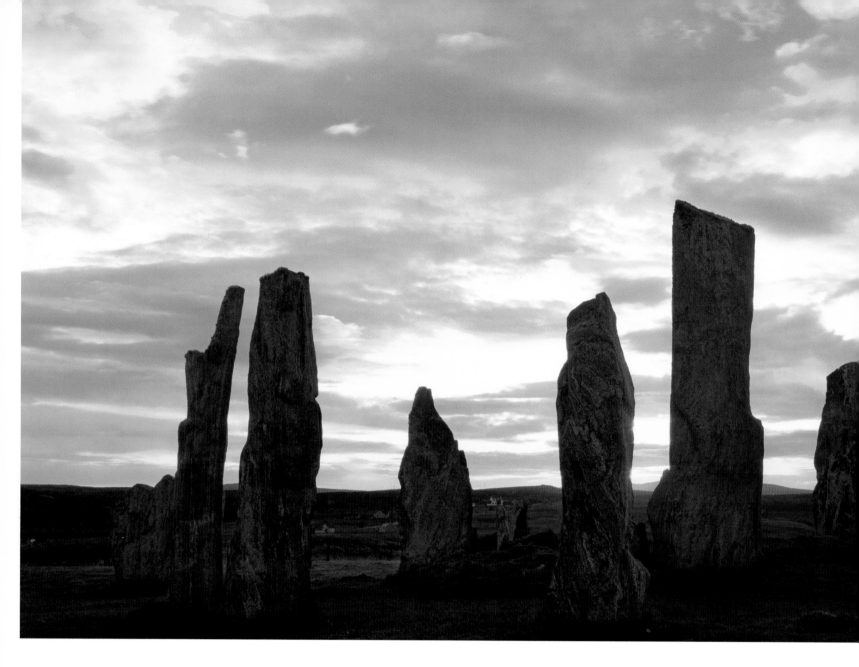

Standing stones of Callanish
I drove to Callanish, on the Isle of Lewis in the Outer Hebrides, well before sunrise, hoping for a good dawn. I set up the camera and waited. Nothing happened, and it seemed that sunrise had come and gone behind cloud. But then color started to seep into the sky and within minutes it was on fire. It was amazing. I frantically started exposing film, wondering how I could record the color in the sky without the stones recording as silhouettes. Because grad filters were out of the question, I bracketed exposures and hoped for the best. I later had one of the trannies professionally scanned and then tweaked the image in Photoshop, selecting each stone in turn and adjusting levels to reveal a little detail.

CAMERA: Fuji GX617
LENS: 90mm with ND filter
FILM: Fuji Velvia 50
APERTURE: f/22
SHUTTER SPEED: 2 seconds
LIGHT CONDITIONS: Late summer sunrise

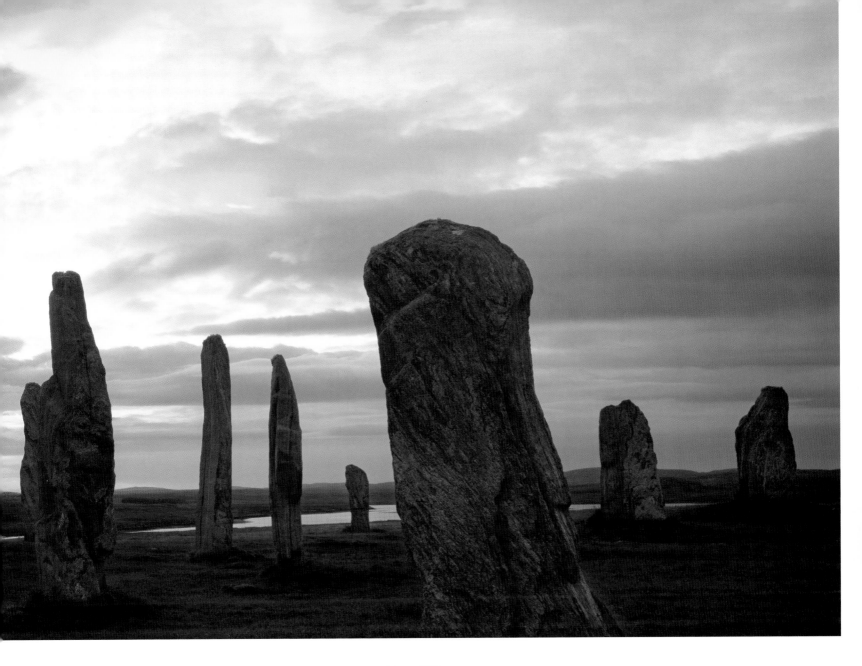

AS: Where are you mostly based? Where are your most popular locations?

LF: I'm based near the coast of Northumberland, England. A decade ago I supplied photography for a coffee-table book about Northumbria and my wife and I fell in love with the area. Overseas, my favorite locations include the sandstone landscapes of Utah and Arizona, and Cuba and Morocco.

AS: Which country do you like to photograph in the most? Why?

LF: The UK—coastal landscape photography is my main passion and I have easy access to what is the best coastline in the UK. I also love the rugged north Cornish coast and northern Scotland, especially the Outer Hebrides.

Lee Frost: Panoramic views

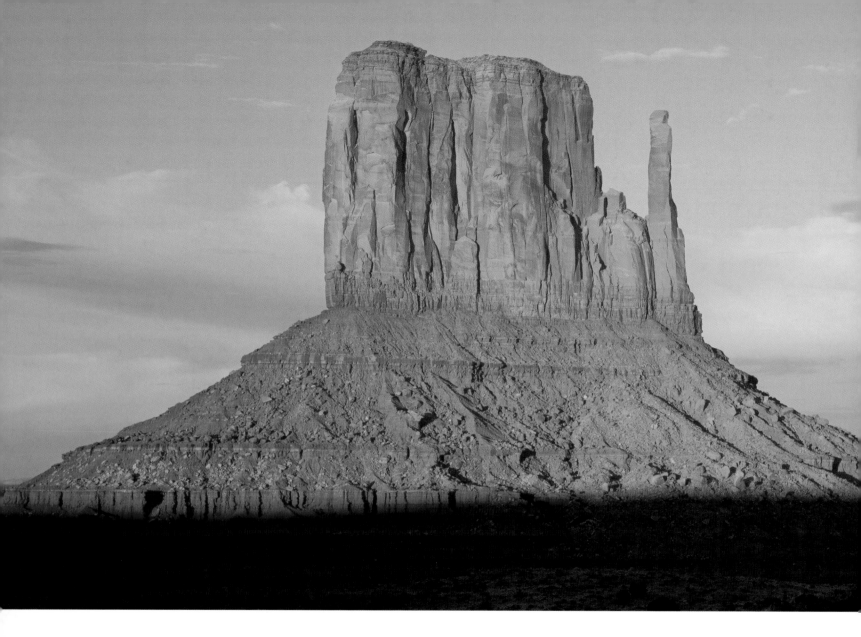

Lower Antelope Canyon, Utah
I visited Antelope Canyon in 2005—I was blown away by the beauty of the place and the way the light creates an amazing palette of color and shadow. The Lower Canyon is less popular than the Upper Canyon, so it's quieter, but it is just as photogenic. I took this shot at the bottom end during late morning, with the sun overhead and beaming down. I couldn't decide where to point my camera first because there were just so many possibilities. Simplicity is the key, otherwise compositions can be cluttered and confused. A tripod was essential as light levels were very low.

CAMERA: Fuji GX617
LENS: 180mm
FILM: Fuji Velvia 50
APERTURE: f/22
SHUTTER SPEED: 8 seconds
LIGHT CONDITIONS: Reflected daylight

AS: What things do you enjoy most about your job?

LF: Earning a good living while pursuing my hobby and being able to spend so much time outdoors. I love the flexibility I have with time. My office is at home and I spend lots of time with my family. I would hate to have a job with a boss and a routine and, heaven forbid, a suit.

AS: From a technical aspect, what are the most difficult things about your photography?

LF: Embracing digital technology because it's not a medium that interests me. It's made photography more complicated, though there are obvious benefits.

AS: How would you describe your personal style or technique?

LF: When I shoot panoramic landscapes I want drama, color and impact; I try to capture the essence of a scene. I'm in full control and I work in a slow, considered way. I anticipate the light and try to be on location early, so I'm ready. When I travel I shoot more graphic images and capture familiar subjects from unusual angles. I experiment, take more risks, and work quickly and instinctively to react to the light I'm presented with.

Cuban number plate
Having visited a region or country several times I find myself looking for something different, often capturing details that are symbolic of where I am. In this case, the number plate says as much about the location as the whole car would, but it's less obvious, while the wonderful early morning light adds impact and atmosphere. I tend to work quickly and more instinctively with 35mm gear compared to, say, my 6 × 17cm panoramic, so the results are different—more spontaneous and energetic.

CAMERA: Nikon F5
LENS: 80–200mm
FILM: Fuji Velvia 50
APERTURE: f/2.8
SHUTTER SPEED: 1/30 sec
LIGHT CONDITIONS: Early morning sunlight

Car in Havana
Cuba is one of my favorite places. It's so sultry, sexy and full of atmosphere, and the people there are so resourceful. Nowhere is this more evident than the streets of Havana, where hundreds of old American cars still trundle around; some in a far better state than others. I spotted this fine example on an early morning stroll through Havana Centro. The bright red paintwork was gleaming in the morning light, while the crumbling, faded wall behind created a perfect backdrop.

CAMERA: Hasselblad Xpan
LENS: 45mm
FILM: Fuji Velvia 50
APERTURE: f/16
SHUTTER SPEED: 1/2 sec
LIGHT CONDITIONS: Early morning sunlight

AS: What's in your kit bag? Which camera system do you use and why?

LF: For landscape work I usually carry two camera kits—a Fuji GX617, for panorama shots, and a Mamiya 7 II 6 × 7cm rangefinder. Both take 120 roll film. For travel work I have a similar set-up. For 35mm film photography I carry a Hasselblad Xpan, for panoramas, and a couple of Nikons (an F5 and F90X). The Xpan is a fantastic camera with amazing lenses. I can use it hand-held and it's suitable for a wide subject range, including portraits. For the Fuji GX617 my main lens is the 90mm because it gives a broad angle of view, similar to an 18mm focal length in 35mm photography—perfect for dramatic, panoramic landscapes. The 180mm lens is good for more selective images, while the 300mm is ideal for specific types of landscapes, such as deserts. For the Mamiya I have 43mm, 80mm and 150mm lenses. The 43mm is great for emphasizing foreground interest and offers loads of depth of field at f/16 and f/22 apertures. With the Xpan I favor the 45mm lens for general use, but the wider 30mm comes into its own for dramatic landscapes and interiors. The 90mm is used less frequently, but when I do use it, nothing else will do. For the Nikons I carry a 20mm f/2.8, 28mm f/2.8, 50mm f/1.4 and an 80–200mm f/2.8 zoom.

AS: Do you try to make sure your work appeals to the widest possible audience?

LF: No—I try to please myself and hope others will agree! If a photograph has drama, impact or emotion, it will force a second look and hold one's attention, giving it broad appeal.

AS: When are the busiest times of the year for you?

LF: The quietest time is summer, in particular July and August. That's when I kick back, put the cameras away and catch up with writing, planning workshops, thinking about new projects and spending time with my family. The rest of the year is busy.

AS: Which places do you dislike traveling to?

LF: I don't travel to places unless they inspire me. I'm not a big city person. London drives me nuts. That said, I do love cities with character, such as Havana. Venice is also an amazing place.

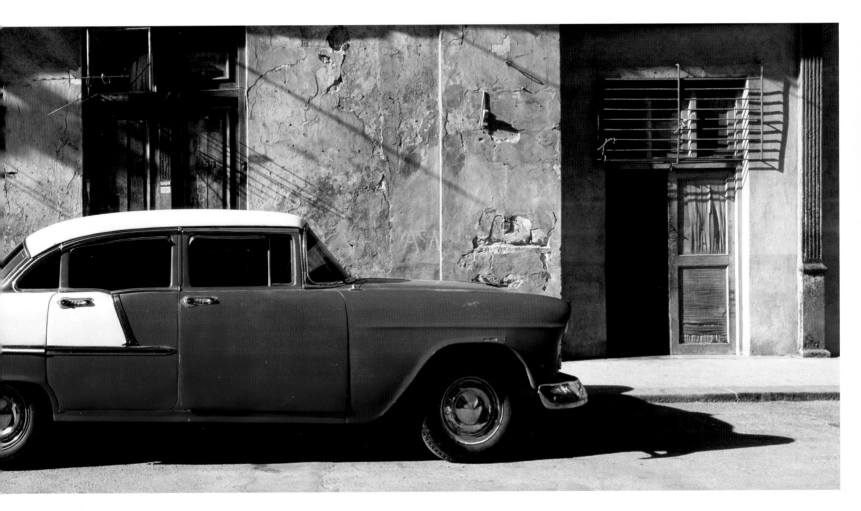

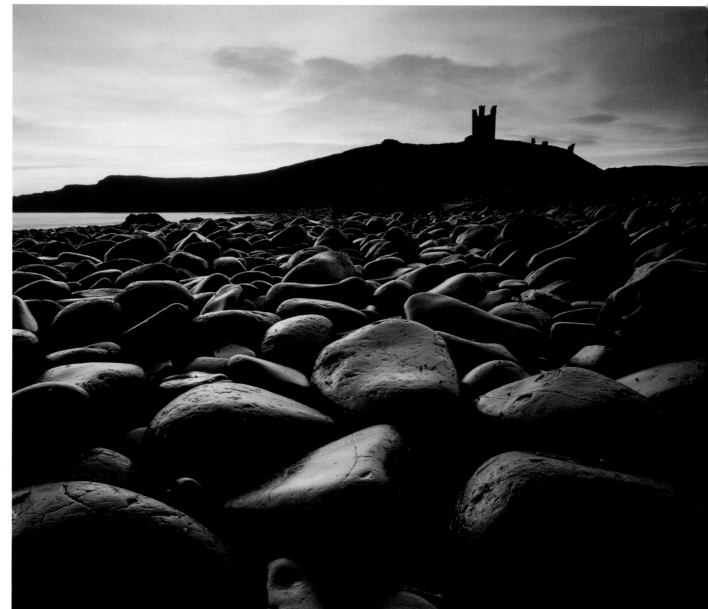

Embleton Bay
I live on the Northumbrian coast, so locations such as this are easily accessible—though I don't get to visit them as often as I'd like. This shot was taken at dawn during winter. The tide had not long receded, so the basalt boulders were wet and reflecting the colors in the sky. I was lucky with the sunrise—so often the sky is overcast and gray. I'm a firm believer that if you keep going back to a particular location, eventually you'll get the right shot.

CAMERA: Mamiya 7 II
LENS: 43mm with ND filter
FILM: Fuji Velvia 50
APERTURE: f/22
SHUTTER SPEED: 4 seconds
LIGHT CONDITIONS: Winter sunrise

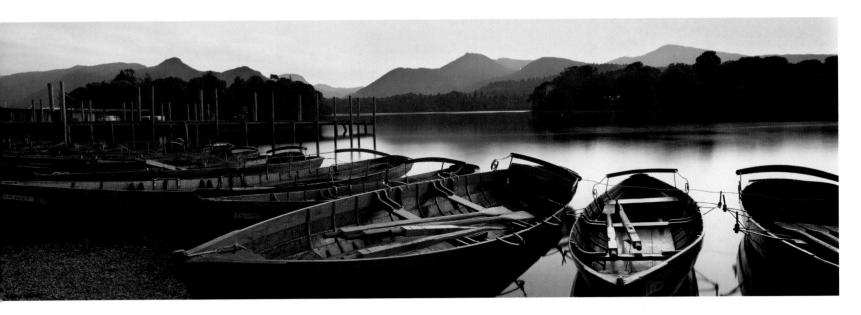

rwent Water at twilight
nditions for this shot were
rfect—the water was calm
d tranquil. As twilight fell,
t colors filled the sky and
lected from the water. The
ats on the gravel beach were
tionary, so taking a long
posure wasn't a problem.
cording the scene was
aightforward once I was
ppy with the composition—
etered for the boats in the
eground and used an ND
rd grad filter to hold color
the sky.

MERA: Fuji GX617
NS: 90mm with ND filter
M: Fuji Velvia 50
ERTURE: f/32
UTTER SPEED: 8 seconds
HT CONDITIONS: Fall twilight

AS: What types of pictures do you find the most difficult to take?

LF: I see every photo opportunity as a challenge to do well, produce a great image, discover something new. I never struggle to find inspiration and I enjoy being put on the spot; I like to perform and come up with the goods.

AS: Which do you prefer—digital or film—and why?

LF: Film. I have a six-megapixel digital compact for family snaps and that's as far as I've taken digital capture. Long-term I have to accept digital capture will be unavoidable, because, as film sales fall and labs shut down, the cost of film and processing will rise and it will cease to be cost-effective. However, until that day comes, I'll continue to work with film.

AS: How much of your work do you manipulate using imaging software?

LF: Though I shoot everything on film, I do have selected images professionally scanned, and I also scan some of my own work. Any manipulation carried out on scans is usually to correct things such as color balance, or to adjust contrast. I'm not into making major changes to an image. The way I take it is the way I like it to remain.

AS: What do you consider your greatest photographic achievements to date?

LF: Having my first photographs published when I was 17 was a major achievement. Winning my first photo competition was really a catalyst in my whole career, as was being commissioned to write my first book in 1992. I'm about to give my first proper exhibition at the Biscuit Factory in Newcastle upon Tyne, and hopefully produce my first self-published book.

AS: What does the future hold for you?

LF: I'd like to become more involved in selling limited-edition prints of my work, self-publishing my books and, when my children are older, open a gallery in Northumberland where I can sell my work and the work of other photographers in the region.

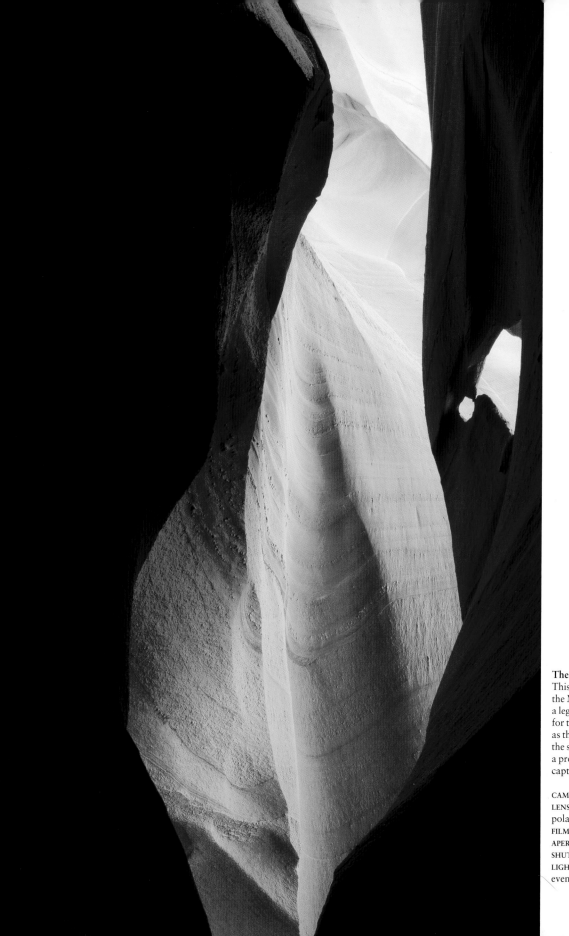

The Mittens, Monument Valley
This is late evening light on
the Mittens; a classic view of
a legendary landscape. I waited
for the light to become warmer
as the sun dropped lower in
the sky, thereafter shooting
a progression of images that
captured the changing light.

CAMERA: Fuji GX617
LENS: 180mm with
polarizing filter
FILM: Fuji Velvia 50
APERTURE: f/22
SHUTTER SPEED: 1 second
LIGHT CONDITIONS: Warm
evening sunlight

Tips for Success

1. Get up early, stay out late

My best photographs are generally taken at the very fringes of the day when the light is magical and the landscape—whether urban, rural or coastal—is at its most beautiful. I like to be on location at least 30 minutes before sunrise for dawn shots. In the evening I'll usually arrive an hour before sunset and stay until twilight.

2. Learn how to use neutral density filters

The filters I use more than any others are neutral density (ND), which let me control the contrast between sky and landscape. They're essential, and mastering their use will transform your photography.

3. Master depth of field

Being able to control what's in and out of focus in any photograph is essential. The hyperfocal focusing technique is invaluable for landscape photography, where front-to-back sharpness is usually required. Stopping down to an aperture of f/22 and hoping for the best isn't the solution.

4. Take risks

Don't be afraid to try different techniques. Experiment with unusual camera angles, use long exposures to record motion, and shoot in different types of light and varying weather conditions.

5. Keep going back

It's unlikely you'll get the best shots the first time you visit any location. They may be good but the chances are they will also be obvious—once you've got the obvious ones in the bag you can delve deeper and produce more original photographs.

6. Don't wait for good weather

Fair-weather photographers rarely produce the best work because good weather lacks drama and atmosphere. Be prepared to brave the elements. Venture out when the weather is bad. Bad weather makes great pictures.

7. Look for detail

As well as shooting grand views and iconic scenes, also look for interesting details that reveal the character of a place. This is a great ploy in dull weather because small details often benefit from softer light.

8. Compose in camera

In this digital age it's easy to be lazy and take a sloppy approach to composition, knowing that you can always improve a picture later. Once you get on this slippery slope, however, it's hard to get off, so always set your sights high, and try to make the moment of exposure the final stage in the creation of an image.

9. Do your homework

When you're traveling to a new destination, especially overseas, do plenty of research. Check websites for ideas and inspiration, look through books, speak to other photographers—try to build a picture of what to expect.

10. Try harder

Photographers never reach a point in their careers where they have produced their best work and see no room for improvement. You can always get better. Your best pictures should be the ones you still haven't taken.

Namib Desert, Namibia

I arrived during late afternoon with the intention of taking a classic shot—one half of the frame lit by the sun and the other in deep shadow. Unfortunately earlier visitors had scrambled up the ridge of the dune, leaving obvious footprints and ruining my shot! Wandering around I noticed this backlit tree standing out against the shadow side of the dune, and the narrow band of bright orange sand running diagonally down the scene. I had my shot—a simple, graphic composition making use of color and tone.

Specification

CAMERA: Fuji GX617

LENS: 300mm with polarizing filter

FILM: Fuji Velvia 50

APERTURE: f/32

SHUTTER SPEED: 1/2 sec

LIGHT CONDITIONS: Strong afternoon sunlight

Essential Equipment

- Fuji GX617 panoramic camera (120 roll film)

- Lenses for GX617: 90mm, 180mm and 300mm lenses

- Mamiya 7 II 6 × 7cm rangefinder camera (120 roll film)

- Mamiya lenses ranging from 43mm to 150mm

- Hasselblad Xpan camera (35mm film)

- Hasselblad lenses ranging from 30mm to 90mm

- Nikon F5 (35mm film)

- Nikon F90X (35mm film)

- Nikkor 20mm f/2.8 lens

- Nikkor 28mm f/2.8 lens

- Nikkor 50mm f/1.4 lens

- Nikkor 80–200mm f/2.8 lens

- Selection of ND filters

- Gitzo carbon-fiber tripod

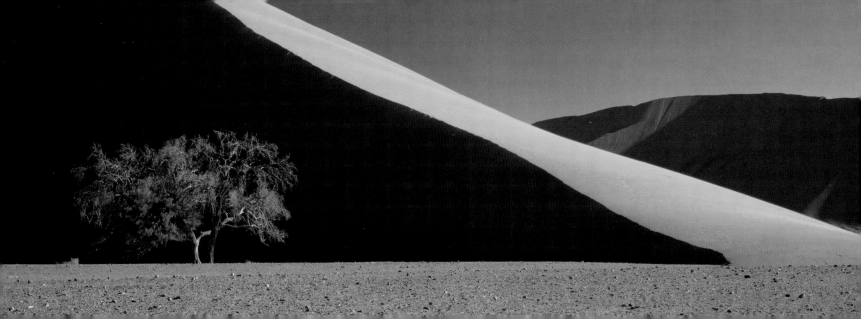

Experimentation and evolution

"Studio photography doesn't interest me," says Sally Gall, "because I like to be outdoors. Being able to travel and take photographs gives me the scope to get away from urban claustrophobia." Born in Washington DC in 1956, Sally's academic history suggested that she would one day reach the highest echelons as a photographer: in 1978 she was awarded a BSc in Fine Arts Photography at Rhode Island School of Design. Building on her academic strengths she traveled throughout Europe, before landing a role as assistant curator at the Contemporary Arts Museum in Houston, Texas, for three years. This presented her with a huge dilemma, however. "I was always making photographs—I just didn't know how to make a living from them!"

Later in her career Sally worked at the Commercial Cronin Gallery, also in Houston, while teaching photography classes at the city's university and at the Museum of Fine Art. "But I wanted to be where the art was happening and I wanted to travel more, so I moved to New York City in 1988." She now makes a living from selling her photographic prints, borne from worldwide travel, as well as from commissions from well-known clients such as Adidas, Electrolux and *New York Times* magazine.

olumn d'Or, Saint Paul-de-
nce, Provence, France
vas on a holiday with family,
aying at a hotel in Saint Paul-
-Vence. It was the end of
not day and I went for a swim.
I got out of the water I noticed
ow beautiful the two floating
hite rings looked against the
ack-bottomed pool. I used
y Diana camera, a non-fine
tical camera with no exposure
otions that sees the way the
man eye sees. I find the slight
nnel vision inherent in this
nd of lens interesting.

AMERA: Diana
NS: Fixed, c. 50mm
LM: Kodak Tri-X 120 roll film
ERTURE: N/A
UTTER SPEED: N/A
GHT CONDITIONS: Bright
vening sunshine

Interview

AS: What was your first ever camera?

SG: A Kodak Box Brownie. My first interchangeable lens camera was a Minolta SLR, which my parents bought for me when I was at high school.

AS: Where do your ideas for innovative pictures come from?

SG: From interacting with the world. Traveling and being out in nature inspires me. I used to live in the city all the time and I couldn't wait to get out into the mountains or forests. I've always been this way and, even now, I can't wait to get back to nature when I'm living in any city.

AS: Why did you decide not to do other types of photography, such as fashion or studio work, for example?

SG: Almost all of my work is done outdoors. Money is not the motivating factor—it's difficult because I don't make as much money as photographers in other genres, such as those who are masters of the studio and fashion field. It's a life I chose and I've become a travel artist who exhibits work in galleries. I do, however, occasionally undertake commercial work, even though I'm not a commercial photographer.

AS: Is it fair to say, like many successful photographers, that you had a "lucky break" at some stage?

SG: My career has been slow but steady. I've always had the motivation to build up to where I'm satisfied with the photographs I produce. I have had a perfectly defined career without any one-off event, in which I've been in the right place, at the right time. It's been a gradual process.

AS: Do you shoot what you want or do others generally define what's required of you?

SG: I shoot what I want—as an artist I sell or exhibit that work. When I do commercial shoots I try to produce whatever brief I am given. Someone who approaches me commercially, however, comes to me because they want my style for their product or service.

AS: Where are you mostly based? Where are your most popular locations?

SG: New York City—but I travel the world. I might go to Central America for a year and then go somewhere else the following year. I've been almost everywhere except Australasia. Asia and the East includes India, Indonesia, Japan, Thailand, Myanmar (Burma) and Cambodia; my travels to Central and South America include Panama, Costa Rica, Belize, Chile, Mexico and Brazil; Europe comprises France, Italy, Germany, Spain, Portugal, Denmark, Norway, Sweden, Ireland, England, Scotland, the former Czechoslovakia, Austria and Switzerland. I've also been to Hawaii—a favorite of mine!

AS: Which country do you like to photograph in the most? Why?

SG: It changes with each job I do. But when I complete a project in any one place or country I usually don't go back. The world is a big place and there's always more to discover. Northern Scotland, Tuscany in Italy, and Hawaii, though, are three such places that break this run: each is very compelling and calls me back to photograph it.

AS: What things do you enjoy most about your job?

SG: I'm always going into unknown situations and my job keeps me learning. I love exploring and seeing new things I've never seen before; having a vocation in which I can see the world is very important to me. I can pick a place on a map, knowing I've never been there before, and I can explore it and photograph it. I go to these places because I want to—not because I see the potential of commercial sales.

Vernal Falls, Yosemite National Park, USA
Vernal Falls is an assignment for the Agfa Corporation's annual report, whose chosen theme was 'the power of wate[r]' I traveled to Yosemite, home o[f] some very powerful waterfall[s] and took this picture of one of the most famous in the park— Vernal Falls. The spray was illuminated by the sun in a ver[y] beautiful way. I had a friend hold an umbrella over my hea[d] as I approached the fall to shie[ld] my camera from the intense spray. I then tried to create in my print the feeling of standin[g] in front of the waterfall, by lo[ts] of darkroom manipulation.

CAMERA: Hasselblad 503CW
LENS: 60mm
FILM: Kodak Tri-X 400
APERTURE: f/11
SHUTTER SPEED: N/A
LIGHT CONDITIONS: Natural, bright sunshine illuminated with moisture

AS: From a technical aspect, what are the most difficult things about your photography?

SG: I photographed caves for my body of work, *Subterranea*, and I did it all using natural light—quite a feat when you consider they're such dark places. I was going into situations with lots of darkness, which meant taking long exposures. The longest exposure I took was about three hours. Physically and technically it was uncomfortable. Such low levels of light force you to become more involved in reciprocity laws—the relationship between aperture and shutter exposure.

AS: How would you describe your personal style or technique?

SG: I am a black-and-white person and I want to present photography to the world in this way. Black-and-white is already an abstract medium away from reality—color is not. I don't want to simply record the real world, I want to create another world from my camera.

AS: What's in your kit bag? Which camera system do you use and why?

SG: I've got a Hasselblad 503CW, a mechanical, medium format SLR. It's part of the Hasselblad system which covers interchangeable lenses—I have 150mm, 100mm, 60mm, and 80mm—and has a waist-level viewfinder. I always use Kodak Tri-X 400-speed film because it's better at showing low-light situations than with any other fast film. The byproduct is the grain level, but if you develop it properly, you can minimize this. Occasionally I use a Toyo 45 (4 × 5 film size) field camera, and a cheap, plastic Diana camera that produces abstract pictures. I always travel as light and compact as possible and I don't want to carry much—it makes it easier to move around. The most important thing is your eye; you can take a good picture with almost any camera. I use all lenses equally, depending on the situation I'm presented with. I don't have a favorite.

AS: Do you try to make sure your work appeals to the widest possible audience?

SG: It's nice to have a wide audience but I don't really think about it. I'm creative and I think about the photograph through my vision, not the audience.

AS: When are the busiest times of the year for you?

SG: There's a part of the world that always has warm weather. I don't have a schedule. Six months is the longest time I've been traveling but usually I go away for one or two months.

AS: Which places do you dislike traveling to?

SG: I like some places less than others but there's nowhere, as a travel photographer, that I dislike. Sometimes I get sent to places by travel magazines that fail to live up to expectations.

AS: What types of pictures do you find the most difficult to take?

SG: Long exposures are technically challenging. But some of the commercial shoots I've been on make me feel very uncomfortable. How do you take a picture when you're standing in the middle of a scenario, with everybody staring at you? I find it quite hard to take natural pictures if I don't feel normal. Some photographers find it easy, others don't.

AS: Which do you prefer—digital or film—and why?

SG: I've used digital because it was requested by a client. I prefer film because it's my style; I'm neither for or against digital, however.

Sally Gall: Experimentation and evolution

Heaven, sinkhole, Yucatán Peninsula, Mexico
This photograph is of a sinkhole in the Yucatán Peninsula. I entered through one cave opening and climbed straight down into the earth, only to walk along and find another, similar to a skylight, directly overhead. I set the camera on a tripod so the lens was parallel to the opening, and I photographed overhead into the bright sky. Because the cave interior was so dark, I chose a very long exposure to fully capture shadow areas.

CAMERA: Toyo 45 field camera
LENS: 150mm
FILM: 4 × 5 large format
APERTURE: f/8
EXPOSURE TIME: c. 20 minutes
LIGHT CONDITIONS: Natural, low light

Thirst tree, Yucatán Peninsula, Mexico
I found these long tree roots reaching into an underground river, through a sinkhole. The only light illuminating this giant underground cavern came from an opening around the tree roots. The camera exposure was about one hour and involved lots of experimentation, as the interior was very dark. Exposures in these situations were basically guesses and I spent more than a full day taking many negatives of the same image to ensure I had exposure coverage.

CAMERA: Toyo 45 field camera
LENS: 150mm
FILM: 4 × 5 large format
APERTURE: f/5.6
EXPOSURE TIME: c. 1 hour
LIGHT CONDITIONS: Natural, low light

Above: **Mother, beach, Florida**
While I was standing on a beach in Florida with my mother, in the bright sun, looking at other family members swimming in the ocean, I was struck by the shapes of my mother's white hat and beach umbrella, as well as her white shirt which contrasted with the dark ocean. I liked her stance looking out to sea, and I photographed her from behind, hoping to give viewers the sense of standing on that same beach in the hot sun.

CAMERA: Diana
LENS: Fixed, c. 50mm
FILM: Kodak Tri-X 120 roll film
APERTURE: N/A
SHUTTER SPEED: N/A
LIGHT CONDITIONS: Bright sunshine

Above right: **Andrea, quarry, New Hampshire, USA**
I was photographing kids swimming in a quarry on a bright but flat and overcast day. I love photographing in this type of gray light, which lends a soft quality to the photograph because there are no bright highlights or deep shadows. I noticed this young woman, resting quietly in the water. She appeared to be floating but was in fact lying on a rock ledge. I liked her meditative state and the way her body merged with the natural elements.

CAMERA: Hasselblad 503CW
LENS: 60mm
FILM: Kodak Tri-X 400
APERTURE: f/8
SHUTTER SPEED: N/A
LIGHT CONDITIONS: Natural, bright sunshine

AS: How much of your work do you manipulate using imaging software?

SG: None. But I do produce hand-crafted prints in my darkroom. I manipulate images through burning and dodging, although black-and-white photography is already abstract in its nature, so I don't alter it radically. The key is to make something look more interesting.

AS: What have been your greatest photographic achievements?

SG: Earlier in my career I received a Rockefeller Foundation Grant. more recently, my books *The Water's Edge* and *Subterranea*.

AS: What does the future hold for you?

SG: I'd like to work in color a bit more. There's no particular reason—it's just a natural progression of my career. Of course I'd like to travel to places I haven't seen, which always boils down to time and money.

Geometry lesson,
Moonhole, Bequia

While staying at an artist's
colony on the island of Bequia,
I took this photograph of my
and my boyfriend's bodies
during a midday nap. We were
inside on a hot day, under the
mosquito netting, with the
summer light of the Caribbean
coming in through the windows.
I noticed triangles were formed
by our resting bodies, so I got
the camera, brought it inside the
netting and took the picture.

CAMERA: Hasselblad 503CW
LENS: 60mm
FILM: Kodak Tri-X 400
APERTURE: f/8
SHUTTER SPEED: N/A
LIGHT CONDITIONS: Natural,
bright indoor light

Sally Gall: Experimentation and evolution

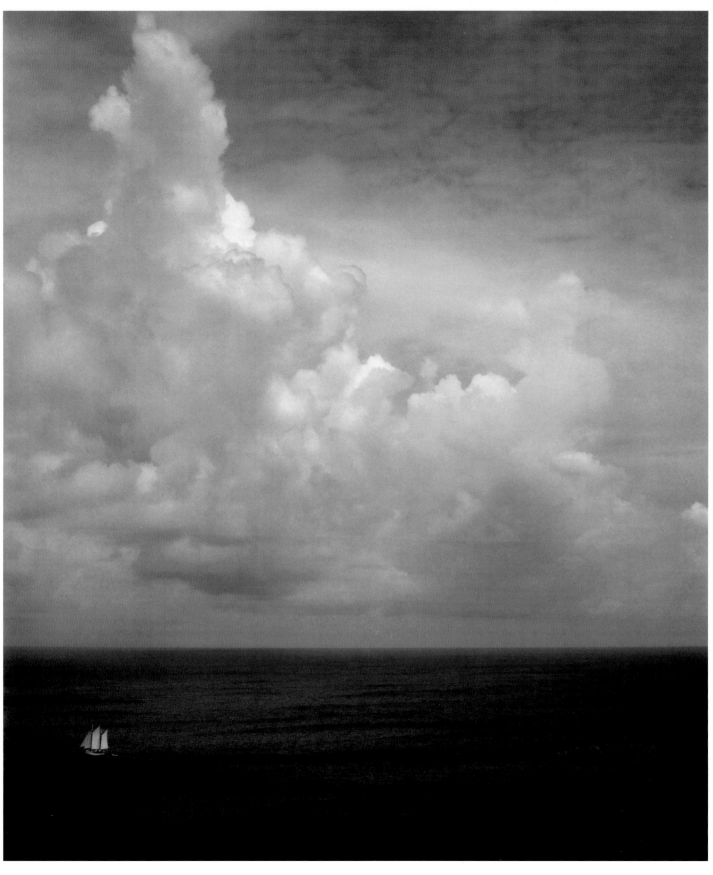

Left: **Evidence of wind, Bequia**
I was staying in Bequia, standing
on a cliff looking out to sea, and
I spotted this beautiful sailboat
in the distance. The small white
sails on the dark ocean next to
the large fluffy defined clouds,
creates a sense of a vast, almost
unreal scale. Standing high
above the ocean added to the
sense of unreality.

CAMERA: Hasselblad 503CW
LENS: 60mm
FILM: Kodak Tri-X 400
APERTURE: f/16
SHUTTER SPEED: N/A
LIGHT CONDITIONS: Natural,
sunny

Right: **Wave, Tanah Lot,
Bali, Indonesia**
I often photograph waves,
trying to capture their motion
forming as opposed to a static
image. I was walking on a cliff
above a famous surfing beach,
Tanah Lot, in Bali. The day
was bright but overcast, with
diffused light and no sky
definition, which added to the
abstract quality of the image.
I chose to photograph only the
water itself, avoiding land or
any other indication of place,
to focus the viewer's attention
on the wave, and mother nature.

CAMERA: Hasselblad 503CW
LENS: 60mm
FILM: Kodak Tri-X 400
APERTURE: N/A
SHUTTER SPEED: N/A
LIGHT CONDITIONS: Natural,
low light

133

**Rio, botanical garden,
Rio de Janeiro, Brazil**
This is an overgrown, slightly
unkempt botanical garden in
Rio. I liked the formality of
the garden with its fountains,
balustrades, and geometric
shapes all juxtaposed with
the overgrown and luxurious
rainforest foliage. Shot on
a bright day—in the midday
sun—the thick foliage acts as
a screen that diffuses the sun,
and thus the light glows and
reflects on all the various plant
matter and leaves.

CAMERA: Hasselblad 503CW
LENS: 80mm
FILM: Kodak Tri-X 400
APERTURE: f/11
SHUTTER SPEED: N/A
LIGHT CONDITIONS: Natural,
bright sunshine

Tips for Success

1. Take a unique approach

What can you achieve in your photograph that no one else has, even though it may be of the same scene or a similar subject? Think about how to change the composition, angle and point of view.

2. Use different kinds of natural light

Photograph in different kinds of light—don't just go for traditionally beautiful mornings, or late afternoons and evenings. Experiment with bright, contrasty light, in the middle of the day, and try shooting into the sun.

3. Overcast conditions can be beautiful

Overcast and gray weather creates a certain mood and atmosphere, bringing interesting qualities of abstraction because of the lack of shadows and bright highlights, particularly in black-and-white photography.

4. Try printing your own work

Black-and-white photography allows you to manipulate the tonal quality of prints in the darkroom. Color is much more tied to reality, and doesn't allow for the same tonal manipulation. In the darkroom, or with Photoshop, you can alter the look and feel of your prints.

5. Take your camera wherever you go

Often the best images are created on the spur of the moment. Using your intuition and reacting spontaneously to a given situation can create memorable pictures.

6. Choose different camera angles

Choose different camera angles—don't just photograph at eye level. Point your camera up or down, crouch low, stand on a ladder.

7. Don't just document a scene, say something with your work

The subject matter of photography is not something to be merely recorded, but is a starting point for moods, emotions, and concepts.

8. Keep looking

Allow the photograph to evolve from a situation and stay with it. Spend 30 minutes—not three minutes—making a picture, refining the composition, looking at your subject matter. The picture you take after 30 minutes may be very different and possibly much better.

9. Photograph something you wouldn't necessarily think about

You don't need to make photographs of dramatic, grand, beautiful, or unusual things. Photograph the small and everyday things—the insignificant. Make them significant by drawing attention to them.

10. Make a statement

Try to build a body of work with pictures that strengthen each other. The total can be a visual and conceptual statement, with powerful meaning.

Ravello, Amalfi Coast, Italy
I was working on a series of
photographs of formal garden
and visited this famous garden
in Ravello. I was struck by the
juxtaposition of the umbrella
pine, the large pot, and the
sculpture. I positioned myself
in a way so the scale of the
pot was exaggerated in
relation to the sculpture,
making the pot seem almost
the same scale as the tree,
creating a sense of unreality.
I used a cheap, plastic Diana
camera, which I felt emulated

Sally Gall: Experimentation and evolution

Michael Kenna

Long exposures

Photography was first and foremost for Michael Kenna a means of financial survival. "My personal work was just that," he remembers, "a passionate hobby which I did in my spare time. If I'd known the success-to-failure ratio I might not have been naive enough to go for it." His perception changed when he visited New York City in 1976 and saw exhibitions of photographic prints for sale. It was a revelation and I knew immediately what I wanted to do." Michael's first serious effort to become a professional photographer was made when he was 18, when he studied the medium at the Banbury School of Art in Oxfordshire, England.

He has come a long way since his college days, and today, as one of the foremost landscape photographers in the world, the Oregon-based specialist is well known for his intense black-and-white images. He uses unusually long exposures, often several hours at a time, and he usually works at night, or at the first light of dawn. His traditional printing methods and fine art photographic style are among some of the most famous globally, and Michael is the first to admit he has yet to embrace digital capture.

ckchairs, Bournemouth,
rset, England
rrived late in the afternoon
lowing a coastal rainstorm.
e tide was high, the sky full
atmosphere. I decided to
ce my camera on a tripod
d use a red lens filter to make
e clouds look more dramatic.

MERA: Nikon F3
NS: 24mm with red filter
M: Kodak Panatomic-X 25
mm
POSURE TIME: c. 60 seconds
HT CONDITIONS: Natural,
w afternoon light

Interview

AS: What was your first ever camera?

MK: A plastic Diana camera, received as a Christmas present when I was 11.

AS: Where do your ideas for innovative pictures come from?

MK: All sorts of places. There has to be a basic foundation of curiosity and a drive to express something, but I don't think inspiration can be boxed, cataloged or described. It's a multi-faceted, constantly changing, enigmatic and elusive gift that has to be consciously appreciated, acknowledged, exercised, and exorcised. And then there's the work ethic—possibly the most important factor.

AS: Why did you decide not to follow other types of photography, such as fashion or studio work, for example?

MK: Initially I studied and practiced many aspects of photography to make a living: fashion, advertising, editorial, sports, still life, and photojournalism. I really didn't know about the rich tradition of landscape photography until I was a few years into my photographic career.

AS: Is it fair to say, like many successful photographers, that you had a "lucky break" at some stage?

MK: I've had many lucky breaks. There is a Latin saying, "fortune favors the brave." As it turned out I was ultimately able to give up most commercial photography and concentrate solely on the fine art aspect. I've been fortunate and it has been a great journey so far.

AS: Do you shoot what you want or do others generally define what's required of you?

MK: I mostly decide what, when and where I photograph. Sometimes I take on commercial projects in which I become a "hired gun." I love to work alone, though, and a smart and creative director will give me a lot of freedom.

AS: Where are you mostly based? Where are your most popular locations?

MK: I'm often asked why I don't photograph locally, in the northwest US. For me, the answer is spontaneity. I like to work with as few time limits as possible—nobody watching or asking questions, and no phones. When I go to any location I don't know if I'll be there for five minutes or five days. Inspiration depends on light, atmosphere, subject matter, and how the photographer responds.

Pont des Arts, Paris, France
I wanted to capture the reflection of the bridge on this particular morning and the water was calm enough to do so. The red filter—one of my favorite methods for creating effects in black-and-white photography—meant the exposure time needed was slightly longer, in this case about 60 seconds.

CAMERA: Hasselblad 500CM
LENS: 250mm with red filter
FILM: Ilford Pan F 25 120 roll film
EXPOSURE TIME: c. 60 seconds
LIGHT CONDITIONS: Natural, early morning mist

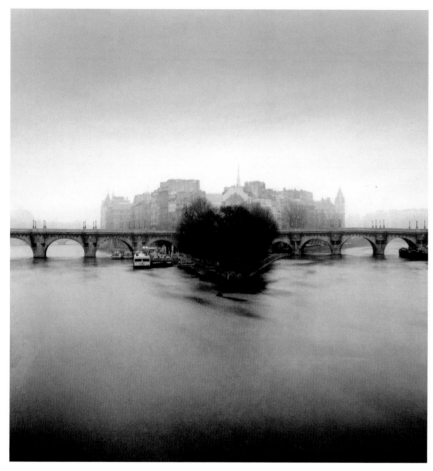

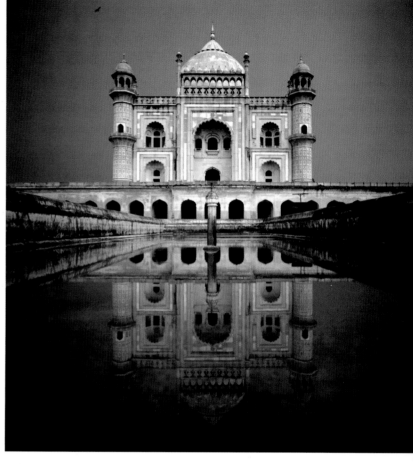

Above: **Ile de la Cite,
Paris, France**
An early morning photograph
of the Ile de la Cite, nestled in
the heart of Paris. An 80mm lens
was used and exposure time was
about 30 seconds. I placed my
camera on a tripod—essential
in low-light conditions.

CAMERA: Hasselblad 500CM
LENS: 80mm
FILM: Ilford Pan F 25 120 roll film
EXPOSURE TIME: c. 30 seconds
LIGHT CONDITIONS: Natural,
early morning mist

Above right: **Safdar Jang,
Delhi, India**
Following a rainstorm the
night before, I went out early to
record the calm of the morning
in the beautiful, natural light.
India is an amazing place and
its architecture is no exception.
The reflection in the water
created the perfect composition.
The light was strong enough not
to rely on a tripod—I took this
one hand-held.

CAMERA: Hasselblad 500CM
LENS: 40mm with red filter
FILM: Kodak Tri-X 400
EXPOSURE TIME: 1/60 sec
LIGHT CONDITIONS: Natural,
bright, partly cloudy

Right: **Quixote's Giants,
Consuegra, La Mancha, Spain**
This was an early morning
shoot. To take advantage of
the mood and clouds, I decided
to use a red filter on the lens to
produce a darker sky. Although
the main focal point is the cluster
of windmills, the sky is just
as interesting, adding a sense
of scale to the background.
A long exposure—about five
minutes—was required.

CAMERA: Hasselblad 500CM
LENS: 250mm with red filter
FILM: Agfa APX 25 120 roll film
EXPOSURE TIME: c. 5 minutes
LIGHT CONDITIONS: Natural
morning light, overcast, snow

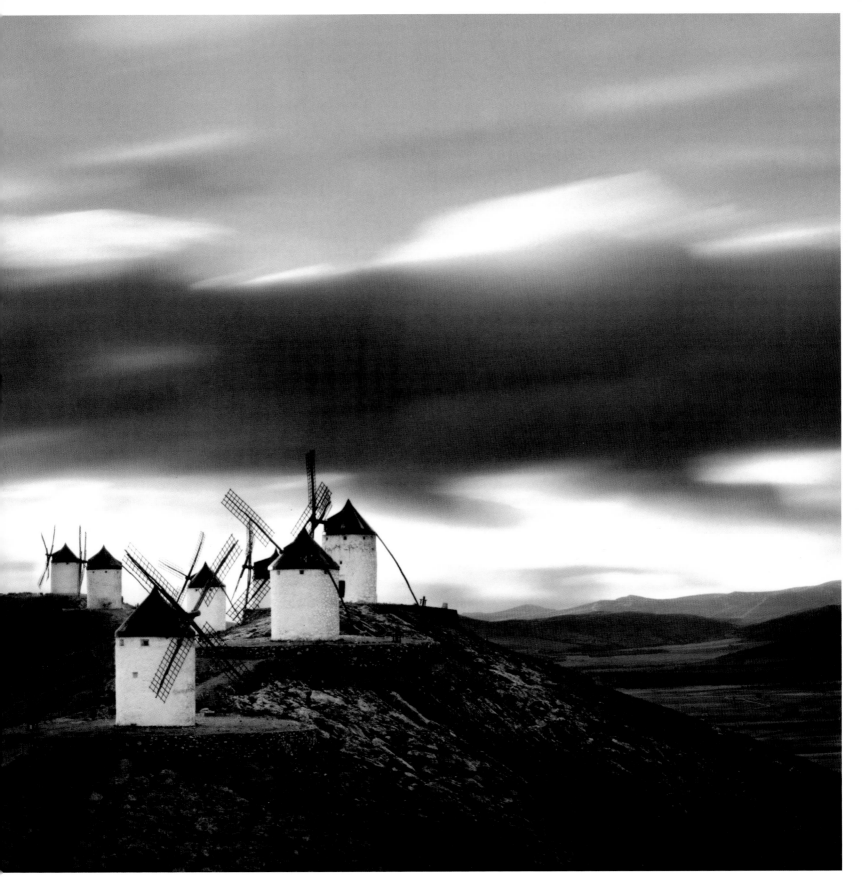

Michael Kenna: Long exposures

AS: Which country do you like to photograph in the most? Why?

MK: It's hard for me to pick a single most popular country, as each one has unique and very worthy aspects. I've photographed in Argentina, Brazil, Canada, China, England, France, India, Italy, Japan, Mexico, Scotland, South Korea, UAE, USA, and Wales. Japan has been the place I've spent the most time recently. There are characteristics of the landscape that remind me of England. There's a powerful sense of atmosphere that resides in the Japanese soil, which I identify with.

AS: What things do you enjoy most about your job?

MK: Imagine being out at night, alone, under starry skies, watching the world slowly move, all senses alive, thinking, listening, imagining, dreaming. The camera is recording, creating, documenting, and seeing what the eye cannot see. Traveling, searching, image-making, seeing the first contact sheets, printing, exhibiting, making books, everything. I am a very lucky person.

AS: From a technical aspect, what are the most difficult things about your photography?

MK: The technical aspects of photography are overrated. It's really not a very difficult medium to master, and now that most of everything is digital, it's just a matter of getting over the learning curve. I believe anybody and everybody can master photographic techniques.

AS: How would you describe your personal style or technique of photography?

MK: There's nothing unconventional in the way I photograph and medium format seems to be my best option. I walk a lot, find places that seem interesting. Perhaps my use of very long exposures is a bit odd: I sometimes leave cameras out on tripods and expose from five minutes to 12 hours. My film is processed normally, usually in labs I trust, and I still prefer to make all my own prints because it's an integral part of the creative process.

AS: What's in your kit bag? Which camera system do you use and why?

MK: I use old, battered Hasselblads. They're full manual, no batteries, no digital displays, and no fancy bells or whistles. They can function in extreme conditions and are reliable. Hasselblad cameras are versatile and don't weigh too much, which are important considerations. I get a decent sized negative from the film, which I can print whole frame or crop as required. Until the digital revolution dictates no more traditional film or printing paper is manufactured, I will stay with my friendly workhorses. I usually work with five lenses, ranging from 40mm to 250mm telephoto. I can't say with certainty which is the most used.

AS: Do you try to make sure your work appeals to the widest possible audience?

MK: I feel great when my work appeals to a lot of people—who wouldn't? But it's dangerous to analyze why that is, and pursue a direction that tries to satisfy a wide audience. I believe it's most creative to do what comes naturally and keep your fingers crossed that others will like it and support your efforts.

AS: When are the busiest times of the year for you?

MK: I spend most winter months photographing, and most of the summer printing. I'm generally busy all year.

AS: Which places do you dislike traveling to?

MK: Busy places, crowded places, commercial places.

AS: What types of pictures do you find the most difficult to take?

MK: Photographs of people.

White Copse, Wakkanai, Hokkaido, Japan
I took this photograph very early in the morning, following a windy, snowy and cold night. I used a tripod to prevent blur and exposed the film for about a second. The speed of the film was rated at ISO 25, to ensure the image retained as much fine detail as possible. For me, the picture gives a feeling of serenity and calm.

CAMERA: Hasselblad 500CM
LENS: 250mm
FILM: Agfa APX 25 120 roll film
EXPOSURE TIME: c. 1 second
LIGHT CONDITIONS: Natural morning light, overcast, snow

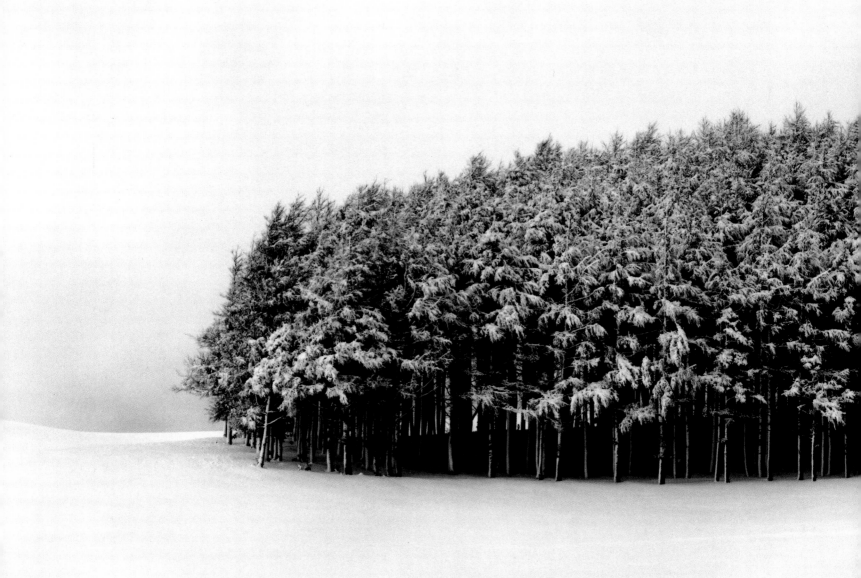

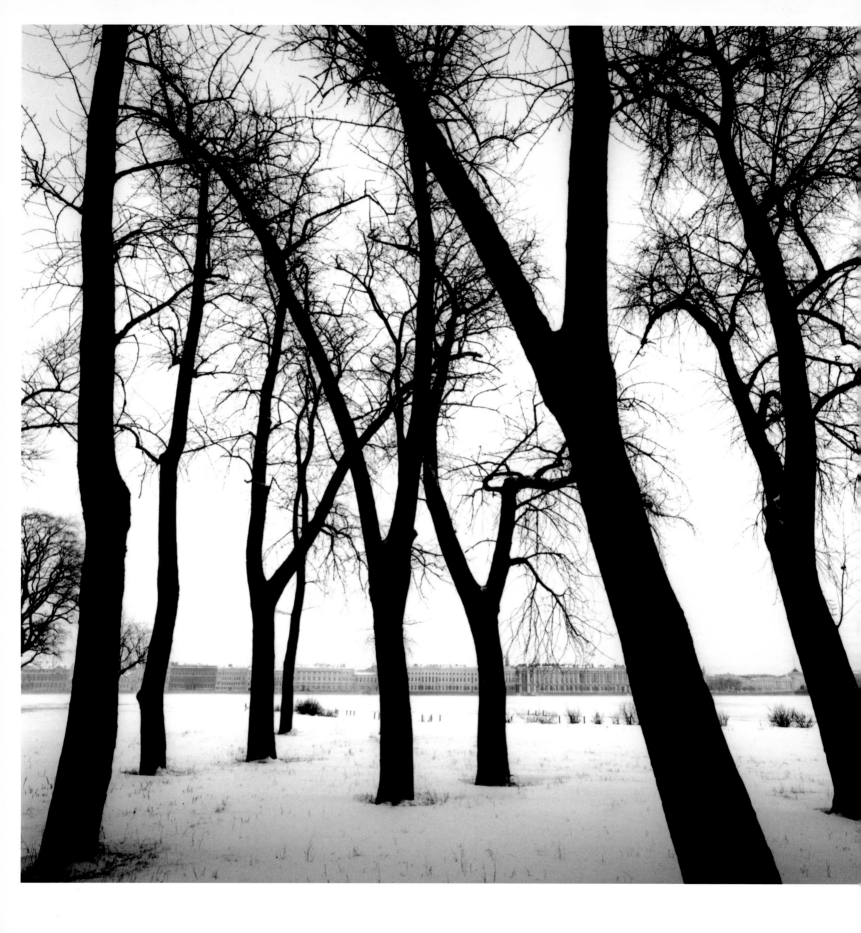

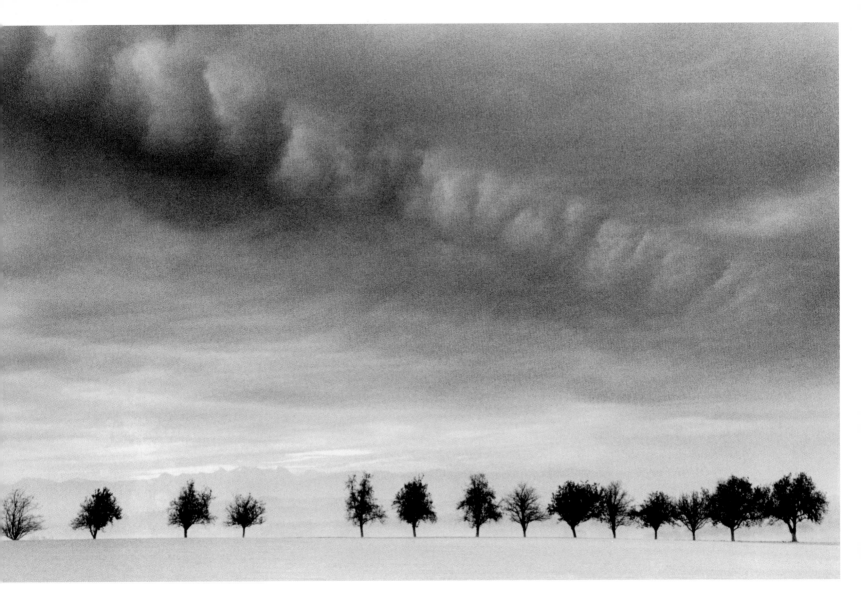

ft: **Peter and Paul Island, Petersburg, Russia**
sed a 40mm lens for this
oto, with faster film, rated
ISO 400. The trees stand out
autifully against the white
ckdrop of snow, almost like
ilhouette, while the building
ds interest to the frame.

MERA: Hasselblad 500CM
NS: 40mm
M: Kodak Tri-X 400
POSURE TIME: Unknown
GHT CONDITIONS: Natural,
dday, overcast

Above: **Fourteen trees, Marbach, Austria**
I took this hand-held, using
a Leica rangefinder camera—
one from the manufacturer's
famous M series. The faster
speed of the film accentuates
the grain, adding mood to the
fast-approaching storm.

CAMERA: Leica M5
LENS: 135mm
FILM: Kodak Tri-X 400 35mm
EXPOSURE TIME: c. 1/25 sec
LIGHT CONDITIONS: Natural,
morning, overcast and stormy

AS: Which do you prefer—digital or film—and why?

MK: These days I feel like a dinosaur because everybody's
moved to digital. But I still prefer film because I know it so well.
I completely understand that digital retouching can replicate
in a matter of minutes what takes me hours in the field, or in the
darkroom. It has provided a vast array of technical possibilities for
an artist to explore and I believe there is huge potential for
creativity, in the right hands.

AS: How much of your work do you manipulate using
imaging software?

MK: None of my fine art work. Commercial work is different.
I've always thought photography's most powerful asset is its
connection to reality. For some reason we used to believe that
a photograph was real. With digital photography that connection
is irreparably severed.

Michael Kenna: Long exposures

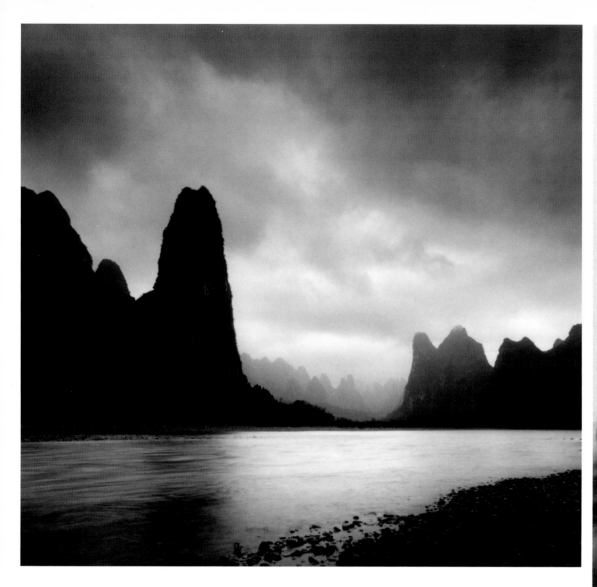

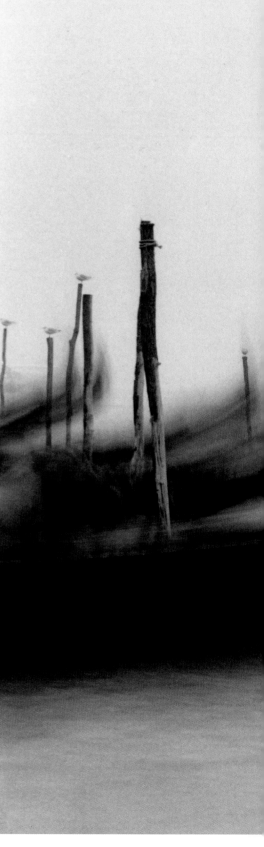

AS: What have been your greatest photographic achievements?

MK: Perhaps the most difficult was the study I made on World War II concentration camps in Europe. The whole project took 10 years and I visited about 30 camps, some several times. I donated all the prints and negatives to an institution in France. Other particular projects include The Rouge, Ratcliffe Power Station, Le Notre's Gardens, Monique's Kindergarten, Easter Island, Mont St Michel, and Japan.

AS: What does the future hold for you?

MK: To photograph in places that have continued appeal: China, France, India, Italy, Japan, and Korea. There are not enough years in a lifetime to do everything that one would like. The possibilities are endless and being a photographer means I can go hunting for experiences.

Above: **LiJiang River, Guilin, China**
I used a red filter to emphasize the location's dramatic clouds. The river provides a foreground, leading the viewer into the photograph, while the rocks, leading into the distance, create a nice backdrop. Film speed was ISO 100, to capture as much fine detail as possible, and I exposed it for about 10 seconds.

CAMERA: Hasselblad 500CM
LENS: 40mm with red filter
FILM: Kodak T-Max 100
EXPOSURE TIME: c. 10 seconds
LIGHT CONDITIONS: Natural, midday, with rain and mist

Gondolas, Venice, Italy
Venice always offers plenty
of options for the photographer.
I planned my exposure for
around 30 seconds—just
enough time to blur the
movement of the gondolas
on the water's surface. I used
a tripod to ensure everything
else was pin sharp.

CAMERA: Mamiya 645 AFD
LENS: 50mm
FILM: Kodak Tri-X 400
EXPOSURE TIME: c. 30 seconds
LIGHT CONDITIONS: Natural,
morning, fog and drizzle

Michael Kenna: Long exposures

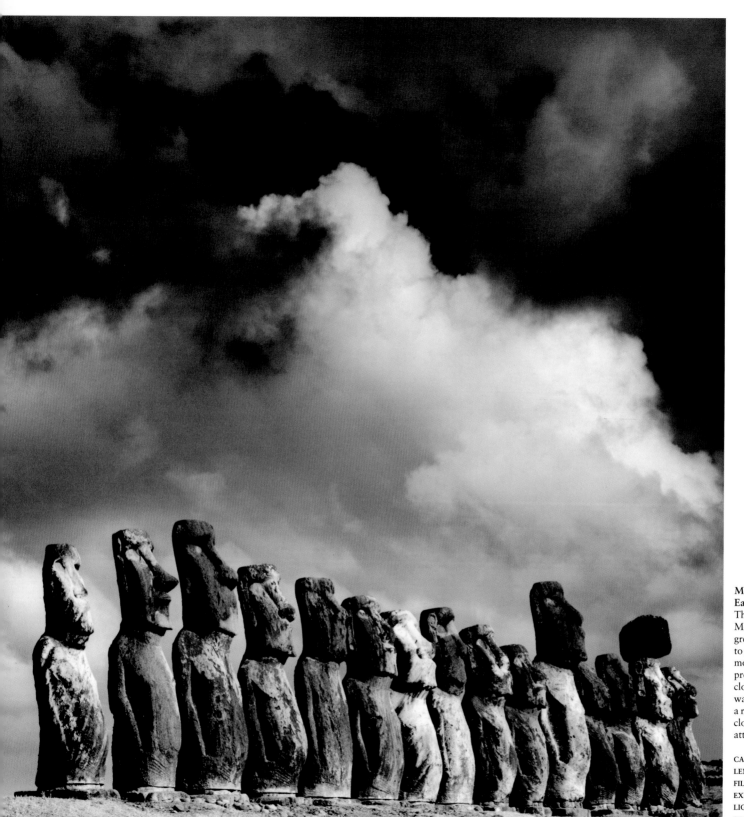

**Moai, Ahu Tongariki,
Easter Island**
The impressive row of
Moai is one of the world's
great landmarks. I went out
to photograph it early in the
morning, with natural light
provided by the bright and
cloudy conditions. Exposure
was about a second and I used
a red filter for more dramatic
clouds, with my Hasselblad
attached to a tripod.

CAMERA: Hasselblad 500CM
LENS: 250mm
FILM: Agfa APX 25 120 roll film
EXPOSURE TIME: c. 1 second
LIGHT CONDITIONS: Natural,
sun with cloud

Tips for Success

1. Experiment
Don't be afraid to experiment—the more you try, the better you'll become. Experiment with different camera settings, different lighting, different camera angles. Try to find what works for you.

2. Work to the potential
Follow leads, work on half-chances, half-thoughts, come to dead-ends, accept failures, and retrack.

3. Concentrate on the job
It's important to be focused, which for me usually means being solitary and away from distractions. I like to go into the "zone"—a point of total concentration and relaxation. It can be a satisfying and productive state of mind.

4. Creativity is key
Being creative often means photographing things in ways that might seem completely ordinary at the time, but later turn out to be extraordinary. Photograph with an open mind and listen to what comes from within.

5. Use a camera system you're comfortable with
I have used Hasselblad cameras for the past 20 years. It is important to understand your camera and the way it works in order to gain full control of your photography.

6. Enjoy your environment
I love to travel and I love to photograph; I've been taking pictures for long enough to know what I like about my work, and where I like to do it. Your enjoyment will show in the final product.

7. Think medium format
If you want to make money from your photographs, you will stand a better chance if you own a medium format camera. This is because these cameras produce a much larger negative than with a 35mm SLR. The negative will produce higher quality prints.

8. Use a tripod
If you want sharper images, invest in a tripod. Ask any professional and they will tell you the difference a tripod can make. A must for low-light, landscape photography.

9. Try a wide-angle lens
These lenses do just the job when you are looking at panoramic views. Useful for landscapes and certain types of architecture.

10. Frame your subject
Look for ways of naturally framing a shot: framing accentuates the main subject.

Eiffel Tower, Paris, France

Paris is both beautiful and atmospheric at night, emphasized in this picture by the low cloud and drizzle. The bare trees add a sense of scale to the Eiffel Tower, which was illuminated by artificial light. I used a tripod—one has to for a long exposure, to record the correct amount of light—and I left the camera shutter open for about 60 seconds.

Specification

CAMERA: Hasselblad 500C

LENS: 40mm

FILM: Kodak Tri-X 400

EXPOSURE TIME: c. 60 seconds

LIGHT CONDITIONS: Natural and artificial, nighttime

Essential Equipment

- Hasselblad 500CM medium format camera body

- Hasselblad lenses ranging from 40mm to 250mm

- Mamiya 645 AFD medium format camera body

- Mamiya lenses, from wide-angle to telephoto

- Nikon F3 camera body

- Nikkor lenses ranging from wide-angle to telephoto

- Selection of 35mm and 120 roll films

- Gitzo tripod

- Wet weather gear

Michael Kenna: Long exposures

Natural instinct

Gerhard Schulz set himself the project of mapping some of the world's most beautiful places, which he judged to be in Europe and the US, and in so doing started to photograph animals in their most natural habitats. In this he is no stranger to winning awards. In 2003 the naturalist from Hamburg was presented with one of the photographic industry's most prestigious accolades—the BBC's Wildlife Photographer of the Year title—for his unusual shot of a gorilla. In 1999, his striking image of an osprey won him the Rosenheim-based Glanzlichter der Natur competition, recognized as Germany's leading wildlife photographic event. "It really gives you confidence when something like that happens," he says. "It made me want to pick up my camera and get out in the wilds even more." Gerhard's enthusiasm for the natural environment began in childhood, during which time his fascination for animals and plants evolved with his technical skills behind the lens. "My first trip to Kenya in 1987 gave me the inspiration to capture my wildlife experiences on camera. Since then I've been taking pictures of free-living animals, plants, and natural landscapes." Gerhard's photographs have been published in magazines including *Das Tier* and *Kosmos* (Germany), *Oasis* (Italy), *Outdoor* (Japan), *National Wildlife* (USA) and *Professional Photographer* (UK).

andrill
wanted to take a portrait of
is wonderful-looking monkey,
e mandrill, to show the various
lors of its face. One evening
ere was the ideal warm light
Tampa Zoo, Florida, and
e monkey sat in the perfect
sition for me.

AMERA: Canon EOS-1V
NS: 600mm
LM: Fuji Sensia 100
ERTURE: f/8
UTTER SPEED: 1/250 sec
GHT CONDITIONS: Evening
nlight

AS: What was your first ever camera?

GS: A Canon F-1 35mm film camera—an old and reliable workhorse.

AS: Where do your ideas for innovative pictures come from?

GS: I read books and nature magazines, and I also visit many nature photography exhibitions. From time to time I take a look at interesting websites, to gain ideas.

AS: Why did you decide not to do other types of photography, such as fashion or studio work, for example?

GS: My passion is nature photography, first and foremost, though I sometimes like to take pictures of beautiful cities and urban environments. Fashion and studio work is not my focus.

AS: Is it fair to say, like many successful photographers, that you had a "lucky break" at some stage?

GS: Most of my pictures are created from my knowledge and experience about the way animals behave. A lucky break, however, must be on your side sometimes, too.

AS: Do you shoot what you want or do others generally define what's required of you?

GS: The way I work means I always shoot what I want. Others never define requirements. That is not and will never be an option for me.

AS: Where are you mostly based? Where are your most popular locations?

GS: I am mostly based in Germany, and my most popular photographic locations are throughout Europe and the USA.

Left: **Common water skater**
I was photographing common tree frogs when I saw these tiny water skaters. I wasn't quite sure how to photograph them in the wild, so, after a short while I decided to take pictures of the animals at a small aquarium. I used a macro lens with very short focal length and wide aperture to capture them close-up and in focus.

CAMERA: Canon EOS-1D MKII
LENS: 100mm macro
ISO: 100
APERTURE: f/2.8
SHUTTER SPEED: 1/40 sec
LIGHT CONDITIONS: Natural, indoor light

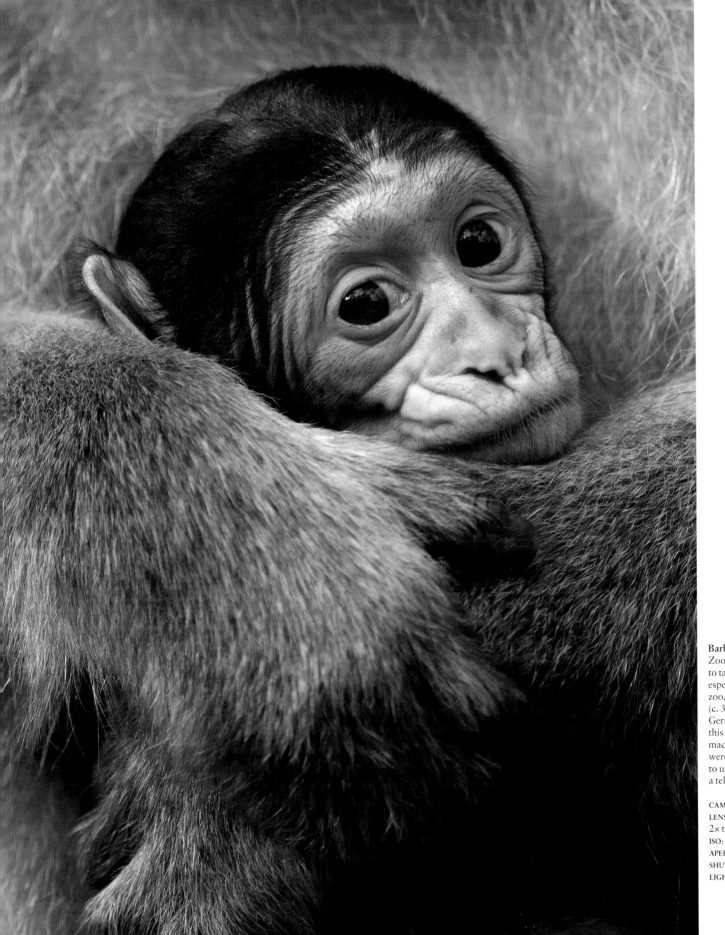

Barbary macaque with baby
Zoos are always good places to take portraits of animals, especially newborns. This zoo, Neumünster, about 60km (c. 37 miles) from my home in Germany, allowed me to take this picture of a baby barbary macaque. The mother and baby were quite far away, so I had to use a long 600mm lens with a teleconverter.

CAMERA: Canon EOS-1D MKII
LENS: 600mm with 2× teleconverter
ISO: 320
APERTURE: f/8
SHUTTER SPEED: 1/250 sec
LIGHT CONDITIONS: Overcast

AS: Which country do you like to photograph in the most? Why?

GS: I like Germany because there are many beautiful places, especially the Wadden Sea National Park, which is only 100km (c.60 miles) from my home. I can get there very easily. Photographically I like the USA because there's a wide variety of landscapes, subtropical environments, and deserts. I always try to take better pictures than anybody else when I visit. If I don't, it limits the chance I have of selling my pictures when I get back.

AS: What things do you enjoy most about your job?

GS: Taking pictures of natural places and organizing my own schedule. I also, of course, like to travel to different countries.

AS: From a technical aspect, what are the most difficult things about your photography?

GS: Nature photographers only have a short amount of time to capture the shots they like, especially action pictures of animals which need a lot of patience and precision. I actually fed an osprey with fish for five years to get good shots of it catching prey.

AS: How would you describe your personal style or technique?

GS: Before I go on any assignment, I always have an idea of the picture I want in my mind. I'm never satisfied until I think the picture I have taken is perfect—even if it takes days to do so.

AS: What's in your kit bag? Which camera system do you use and why?

GS: I use a Canon EOS-1D MKII. My most popular lens is a 100–400mm, used for long-range shots, so I don't disturb the animals I'm working with. I also like to use a wide-angle lens when I go through fields or woodland, when I'm simply looking for some good, spontaneous pictures. For me, a tripod is the most important piece of equipment. For animal behavior shots and for landscapes, I mostly use my Canon 100–400mm and 600mm lenses. I also often use a macro lens, for close-up frames, or a wide-angle 16–35mm unit.

Common tree frog
I was with my wife on the island of Rügen, Germany, when we saw this tree frog sitting on a yellow water lily. I didn't want to disturb it, so I used a long 600mm lens with 2× teleconverter to compose the image.

CAMERA: Canon EOS-1V
LENS: 600mm with
2× teleconverter
FILM: Fuji Sensia 100
APERTURE: f/8
SHUTTER SPEED: 1/125 sec
LIGHT CONDITIONS: Overcast

Edible frog
I didn't have an underwater camera but it was always my intention to take a photo of a frog half under, half over the surface of the water. I chose to use a similar lens and approach as I did to photograph the water skaters, with a short macro lens, so I could get up close and personal.

CAMERA: Canon EOS-1D MKII
LENS: 100mm macro
ISO: 3200
APERTURE: f/8
SHUTTER SPEED: 1/80 sec
LIGHT CONDITIONS: Overcast

Gorilla and boy

I was at Miami Zoo taking
pictures of a baby gorilla when
I saw its mother stand directly
in front of me, behind the glass,
to place her arm on a rock with
a very cool manner. At this exact
moment a small boy leaned
on the glass in the background
and looked up at the gorilla.
I immediately recognized this
could be a special shot. I knew
the scene wouldn't last long,
so I fired off a few frames.
I couldn't believe it won me
the BBC Wildlife Photographer
of the Year Award in 2003.

Sometimes you have to be
in the right place at the right
time, with a little luck.

CAMERA: Canon EOS-1V
LENS: 600mm
FILM: Fuji Sensia 100
APERTURE: f/8
SHUTTER SPEED: 1/500 sec
LIGHT CONDITIONS: Sunshine

Gerhard Schulz: Natural instinct

AS: Do you try to make sure your work appeals to the widest possible audience?

GS: I think this is one of the main rewards of photography. It feels good to know people are pleased by my pictures.

AS: When are the busiest times of the year for you?

GS: April, through to October, is the busiest period of my year.

AS: Which places do you dislike traveling to?

GS: There is no such place, although places or countries with war are environments I generally try to avoid.

AS: What types of pictures do you find the most difficult to take?

GS: For me, the most difficult thing about my job is to shoot the unique behavior of animals in action, such as birds catching prey, or animals fighting. Taking pictures of gorgeous landscapes, while using available light to add mood and creating a perfect composition, is also sometimes challenging.

European otter catching trout
The otter is a species I've been engaged with for a long time. I decided to offer this one bait, and built a net in which I placed the trout. I waited, with my camera hidden by camouflage, and eventually the otter came to feed. The shutter speed is quite fast but just slow enough to show motion blur in the flecks of water.

CAMERA: Canon EOS-1V
LENS: 600mm with 1.4× teleconverter
FILM: Fuji Sensia 100
APERTURE: f/5.6
SHUTTER SPEED: 1/500 sec
LIGHT CONDITIONS: Late afternoon sunshine

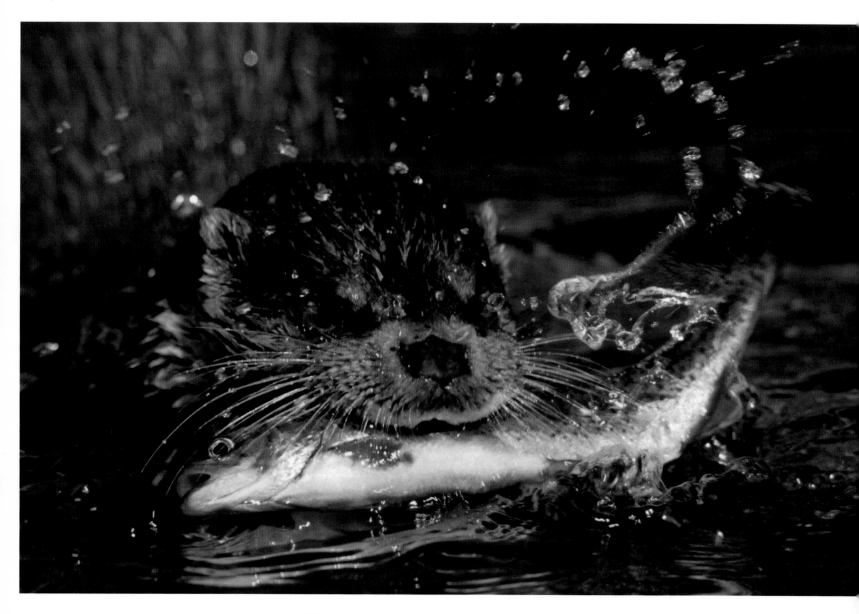

Great egret

Hundreds of wading birds, including pelicans, herons, and great egrets gather at the Ding Darling National Wildlife Refuge in Florida. I decided to drive along a sandy trail that took me to the last pond at sunset. The water was colored with this beautiful glowing, evening red that the great egrets stalked through. This shot won me a runner-up spot in the international Gesellschaft Deutscher Tierfotografen photo competition.

CAMERA: Canon EOS-1V
LENS: 600mm with 1.4× teleconverter
FILM: Fuji Sensia 100
APERTURE: f/5.6
SHUTTER SPEED: 1/100 sec
LIGHT CONDITIONS: Sunset

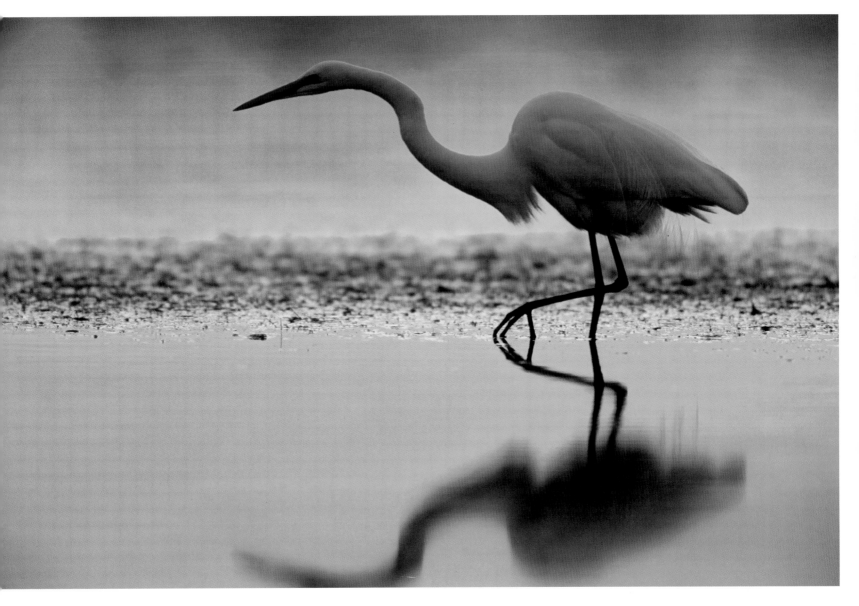

Gerhard Schulz: Natural instinct

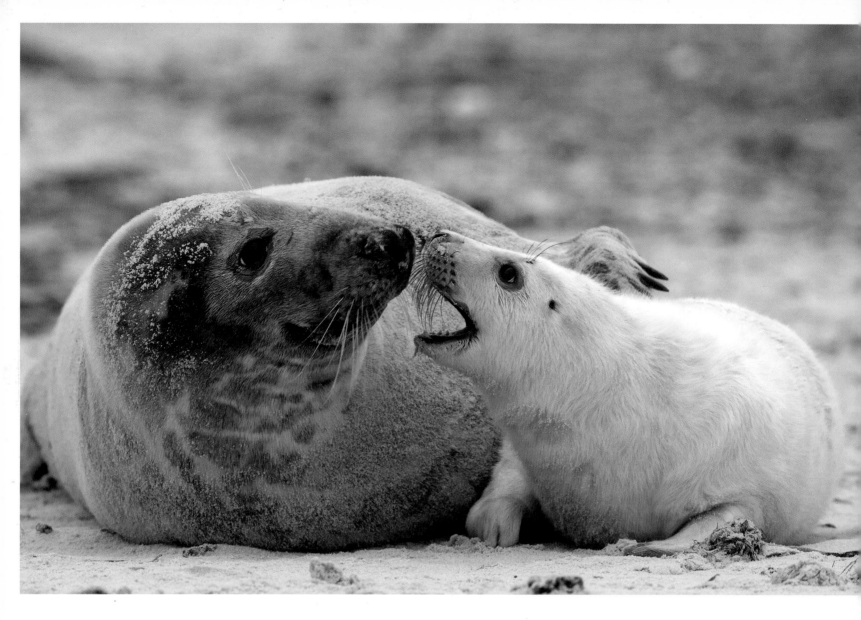

AS: Which do you prefer—digital or film—and why?

GS: Digital, because I can review my photographs on-screen immediately; the quality of digital is so advanced nowadays and it suits the type of work I do better than any other format. The only thing I don't like about digital photography is the time it takes to process my images on a computer, after a shoot.

AS: How much of your work do you manipulate using imaging software?

GS: All of my images are simply converted from RAW to TIFF files, with small adjustments to color and contrast, if required. None of my images are manipulated.

AS: What have been your greatest photographic achievements?

GS: Winning the BBC Wildlife Photographer of the Year 2003 title was, to me, similar to an actor winning an Oscar.

AS: What does the future hold for you?

GS: To continue where I am—shooting great pictures, staying in good health, enjoying my travels and, just as importantly, winning more awards.

Gray seal and pup
In winter, at the end of December, baby gray seals are born far out in the North Sea on the Heligoland dunes. In 2006, 35 gray seals were born. When I heard the news I headed to Heligoland for a few days, traveling by boat. I was pleased with the results, in particular this photograph in which I've used a relatively shallow depth of field to focus the viewer on the seal and pup.

CAMERA: Canon EOS-1D MKII
LENS: 600mm
ISO: 320
APERTURE: f/8
SHUTTER SPEED: 1/100 sec
LIGHT CONDITIONS: Overcast

Tips for Success

1. Consider the natural environment
Try to keep your distance so you don't upset the natural habitat of any animal. Capturing pictures of animals behaving normally and unaware of the photographer is always best.

2. Be patient
If you've been waiting to photograph an animal near its home and it doesn't appear for 20 minutes, there's a good chance it knows you're there. It's best to leave it alone and try to find another that won't be so shy.

3. Brush up your knowledge
It's very important to research the behavior of your subjects. Talk to experts in the field and spend time observing the places in which you want to take pictures. This will help create new ideas for your photography.

4. Think about photographing at the zoo
Photographing at a zoo often enables you to get closer to animals, enabling some of the very best close-up portraits. But taking pictures here isn't easy—it's hard capturing detail and there's more skill required than you might think. Every type of animal and zoo is not appropriate for enclosure photography, however.

5. Aquarium pictures are great
It's possible to take great, unique pictures of small invertebrates at the aquarium. It's like having your own, personal studio, and small aquatic animals behave normally in a very short space of time.

6. Compose your pictures correctly
Composition is a key factor in taking strong pictures. You'll need to analyze the behavior and habitat of your subjects, as well as paying particular attention to light conditions, positioning, time of day, and choice of lens. You need more than just an idea for a picture—you need to action that idea.

7. Develop your ideas
Although you may gain ideas from other photographers, don't copy their work. Try to develop your own product. It's very boring if dozens of photographers have the same images, even if they're technically good.

8. Photograph close to home
Although most like to travel, working close to home often produces great pictures because you're already familiar with the surroundings, light, and feel of the natural habitat. What's more, you can reach your destination in a short space of time—and at a low cost.

9. Take part in photo competitions
It may sound a little ambitious, especially if you've just purchased your first SLR camera, but entering photography competitions is a wonderful way to improve your skill behind the lens. Try to find out what makes some pictures so successful. What do they consistently do that captures the imagination of the judges? Is there a special trick or technique? Study your own shortcomings, train your eyes, and be objective.

10. Try shooting in manual mode
Try turning your camera's auto features off. Suddenly you're in charge again; you decide where to focus, what shutter speed would be correct, and how much depth of field you want. You're the photographer.

Osprey catching fish

I am obsessed with ospreys in Florida—
they breed frequently, they're not shy, and
the sky in this part of the world is very
blue almost every day. On this occasion
I narrowly missed a picture of an osprey
catching prey, so I decided to feed it with
dead fish. I tried hundreds of times to pull
off the right shot, and then, on a stormy
day when the water was rough, the osprey
took the bait. It was very difficult to
track the bird with my camera's viewfinder
because these birds move so fast. This
photograph won me the 1999 Rosenheim-
based Glanzlichter der Natur competition.

Specification

CAMERA: Canon EOS-1N

LENS: 300mm with
1.4× teleconverter

FILM: Fuji Sensia 100

APERTURE: f/5.6

SHUTTER SPEED: 1/1250 sec

LIGHT CONDITIONS: Bright,
early morning

Essential Equipment

- Two 35mm Canon EOS-1D
 MKII camera bodies

- 16–40mm f/4 lens

- 24–70mm f/2.8 lens

- 100mm f/2.8 macro lens

- 100–400mm f/4–5.6 lens

- 300mm f/4 lens

- 600mm f/4 lens

- Lens hoods for all lenses

- Spare lithium-ion batteries

- 4GB CF cards

- Sachtler tripod

- Gitzo tripod

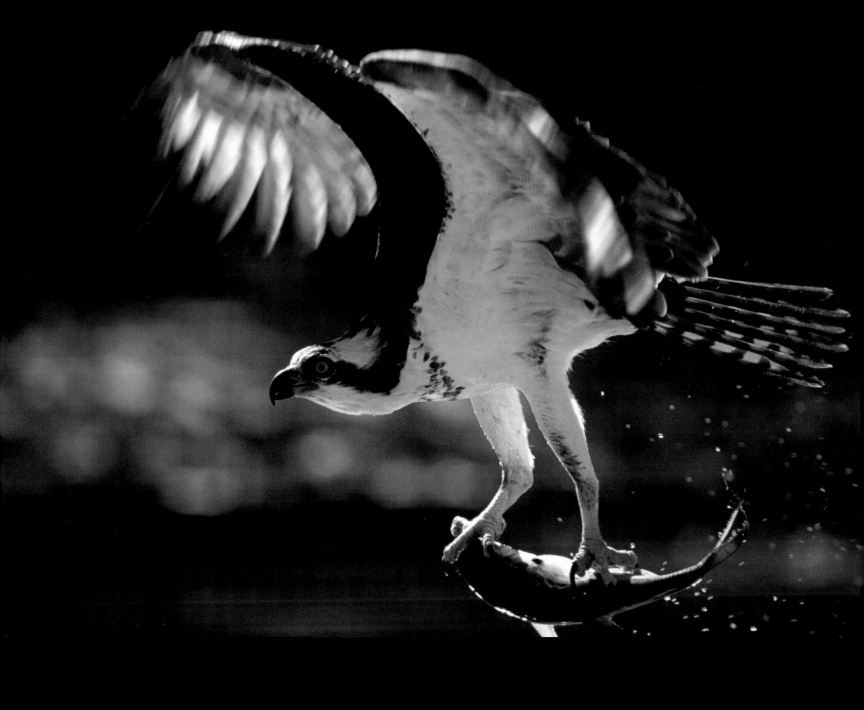

Gerhard Schulz: Natural instinct

Heather Angel

© Heather Angel/Natural Visions
www.naturalvisions.co.uk

Steve Bloom

© Steve Bloom
www.stevebloom.com
www.spiritofthewild.org

Martin Child

© Martin Child
www.martinchild.com

Sue Bishop

© Sue Bishop Photography
www.suebishop.co.uk

Chris Caldicott

© Chris Caldicott/Axiom Photographic Agency
www.axiomphotographic.com

David Doubilet

© David Doubilet
www.daviddoubilet.com

Lee Frost

© Lee Frost
www.leefrost.co.uk
www.photoadventures.co.uk

Michael Kenna

© Michael Kenna
www.michaelkenna.com

Sally Gall

© Sally Gall
www.sallygall.com

Gerhard Schulz

© Gerhard Schulz
www.schulz-naturephoto.com

Index

Acknowledgments

I offer sincere thanks to all who have helped make possible
the publication of this book, in particular the 10 photographers
whose work continues to educate the lives of many others.
It couldn't have been written and completed on time without
their knowledge and expertise, as well as their understanding
of meeting tight deadlines.

I'd also like to extend my sincerest thanks to the people cited
here: Sue Bishop, for her tireless work and good humor; Steve
Bloom, for giving so much of his time while trying to arrange
his many travels and exhibitions; Martin Child, who is possibly
the easiest person I have ever worked with; and Chris Caldicott,
whose amazingly colorful images were the inspiration for me
to write this book.

I must give special thanks to Lindy Dunlop at RotoVision
for her excellent communication, while acting as liaison
between author and publication, and to Jon Ingoldby, who
meticulously edited the book and in the process suggested
several useful revisions.

And, finally, lots and lots of love to my family for their never-
ending guidance and warmth, during what have been the
most difficult two years of our lives.

Andy Steel